Praise for the Leatherpage E

"Bravo! Bravo! Bravo! I was thrilled For The Ambitious Leather Contest Ji *was well thought out and well stated. 1 current and future judges."*
-Walter Klingler, Chicago

"Bravo for having the guts to say the things you did in your article (The Metaphor of Leather). *You point out feelings that probably many or most of us have had all or in part at some time in our Leather experience. ...expect a backlash. It will come as you stepped on multitudinous pinkies."* **- Dave Rhodes,** publisher, Leather Journal

"I just finished reading your DeBlase memories (A Night With The Doctor) *... you write so well and as usual I got lost in the pictures."* **-Phil Ross**, publisher, LeatherWeb.com

"Thanks for your articles! They seem to be filled with some good common sense that we sometimes lack on these things. I know I will be gleaning from your latest installment (When Good Events Go Bad) *from now on every time we put on another event."* **-Larry Everett,** IML 1995

"As always, you seem to get to the heart of the matter (Advice For The Ambitious Leather Titleholder). Very insightful column and humorous at the same time. Thanks for putting into words what a lot of us feel and have experienced." **-Lenny Broberg,** IML 1992

The more I read your writing, and the better I get to know you, the better I like you. You are a hidden treasure in our leather community, please know that you are loved, and appreciated." **-Jim Raymond,** American Leatherman 1997

"I appreciated your writing Passing The Bar: A Guide To Painfully Correct Leather Bar Behavior. *May I post the article in the Eagle for all to read?"*
-Alan Kachin, owner, The Ft. Lauderdale Eagle

"Wow Wow Wow. (In Leather We Are Family...Then Again, So Were The Borgias) *Brilliant. Wonderful. Just perfect."*
-Danny Williams, Palm Springs

PAINFULLY OBVIOUS

An Irreverent and Unauthorized Manual for Leather/SM

By Robert Davolt

Daedalus Publishing Company
Los Angeles

Published by
Daedalus Publishing Company
2140 Hyperion Ave.
Los Angeles, CA 90027
USA
http://www.daedaluspublishing.com

Cover Design by Steve Diet Goedde

ISBN 1-881943-19-4

Printed in the United States of America

Table of Contents

Introduction: The Voice Of Experience

by Steve Lenius, Lavender *Magazine*

One of the things that makes a tribe, community or nation cohesive is its press. A community's press is its voice, both *for* itself and *to* other tribes, communities and nations.

Leather has enjoyed a press with a long and distinguished history. Somewhere back in the murkiness of the 1970s a certain critical mass was reached and *Drummer* Magazine was born, published by and for gay leathermen. When it first came on the scene it was unlike anything else being published at the time, but other magazines sprang up over the years to compete with it and to supplement it: *The Leather Journal, International Leatherman, In Uniform* for uniform aficionados, *Bear* and other bear magazines, even *Roundup* for gay rodeo enthusiasts and *Bunkhouse* for cowboy enthusiasts. Oh, and *Foreskin Quarterly.*

But, for better or worse, the nature of the leather press has changed in the last decade. Where are *Drummer, International Leatherman, Bear* and all the other magazines I used to read? Gone. Davolt had the "honor" of being the last one to turn off the lights at *Drummer,* about which you'll read in this book. (You'll have to wait for his next book for the whole story, however.)

All that's left today of the once-noble leather press is *The Leather Journal*—which itself morphed from a subscription magazine into a giveaway newspaper—and various porn magazines. This means that one no longer has to profess to read these magazines "for the articles." (It's more honest that way, and leather has always valued honesty.) The only other print media the Leather community currently has are local leather columnists (like yours truly) writing for predominantly non-leather publications.

If it was the coming of the World Wide Web that stilled the voices of the leather magazines (and it was, but only in part), it is also the Web that has taken up the slack left by their demise. A big leather "thank you" goes to Joe Gallagher, IML '96, for creating Leatherpage.com, where one can find most of the local print columnists and many web-only columnists collected in one spot for your reading pleasure and edification. It's one-stop shopping at the leather marketplace of ideas. And it's all-volunteer, too.

One of the writers you'll find at Leatherpage.com is Robert Davolt. He, like any good writer, wouldn't let a little thing like the disappearance of his magazine stop him. Here are a few dozen pieces that originally appeared at Leatherpage.com, many of which have won my personal "Gee, I wish I'd written that" award.

We each have our gifts to give our community. There are quite a few leathermen who can strip and look hot for the camera. (Thanks heavens, and the more the merrier.) Much rarer, unfortunately, is the leatherman who knows how to spell, punctuate, write a coherent sentence, illustrate a point and develop an argument. The fact that Davolt knows how to do all those things (and with such wit and style, no less) makes him a rare leatherman, and a welcome one, indeed.

If each writer contributes a unique voice to his or her publication, Davolt's would have to be first and foremost the voice of experience. Davolt has been there, done that, and has the scars to prove it:

• When he offers tips on running a leather business, he's writing from personal experience—he has been in the position of earning a paycheck by producing a product for the leather community.

• When he offers advice to budding leather columnists, he offers credentials in the form of this book and in the fact that he has in the past taught journalism. (Don't believe that stuff about "Those who can't do, teach"—at least not in this instance.)

• He has been involved in all aspects of leather contests. When he writes advice to prospective contestants, contestant sponsors, judges, titleholders or contest promoters, he knows what he's writing about because he's been in all those roles at one time or another.

• And he has certainly spent enough time in leather bars to be able to write authoritatively about "painfully correct leather bar etiquette."

Therefore, Robert Davolt merits your attention, respect and credence. You may not always agree with him or with his point of view, but listen to what he has to say. He's been there. And he's willing to speak his mind and pulls no punches, since he has no advertisers to worry about offending.

Although these columns were written predominantly for gay leathermen, this book is certainly worthwhile reading for leather lesbians and kinky heterosexuals too. Davolt has always prided himself on being, in his words, an "equal-opportunity curmudgeon." Whoever you are, you'll find a lot of leather wisdom (and just plain wisdom, too) in these pages.

Be glad he's willing to share.

About The Author: *Robert Davolt*

By Henry B. (Boy Henry) Wilson

Robert Davolt was an unlikely possibility to become a commentator of the leather lifestyle. Raised by conservative, protective parents to be a fundamentalist minister, he ran away to sea at 17 and joined the Navy. His family's perfect black sheep, he fulfilled their every horror: A political renegade, agnostic, gay, profane, outspoken, into leather and SM and worst of all. . . .now a Californian.

That's not to say that he has always been embraced by the worldwide subculture known as the International Leather Community, either. A heretic among heretics and a contrarian's contrarian, he has been asked to step outside life's banquet more often than a cigar smoker at a Green Party fundraiser. He just keeps sneaking back in.

It was early on that his writing received notice and began to annoy people. He was publishing an advertising-supported neighborhood newsletter by the time he was 15. In his high school newspaper, he broke a major labor story before any other newspaper in the state, winning reluctant praise from the large metropolitan dailies that got scooped. He wrote propaganda for the Navy— and was disciplined for selling travel features and bawdy fiction on the side. In the 1980s, his columns and political cartoons won mention and awards from the Washington Press Association. He taught journalism for a time, promoted and developed job training and placement programs, wrote and designed sales material, sold suits, tended bar. His brief (12-minute) career as a strip dancer was San Diego legend for a time.

Exiled to the Midwest, he served as a founder and club officer, educator, community board member and titleholder. In 1996, Davolt was approached to work for *Drummer* Magazine. Eager for a chance

to return to the West Coast and even more hungry for the chance at something as seminal as *Drummer*, he took it.

The publication, which had been a powerhouse of creative and sexual energy, was in serious trouble. *Drummer*, which defined (some say invented) leather publishing since 1975, did not have anyone on staff trained in either leather or publishing. From the moment Davolt arrived in San Francisco to the very last magazine and contest, there was nearly constant controversy. Davolt explores the commercial and personal journey in a yet-to-be-published manuscript nicknamed by Joseph Bean: *GotterDrummerung: Twilight of the Odds*. The results, however, were remarkable: The company's annual losses dropped from a quarter-million dollars to zero in three years. The International Drummer Contests were produced at a profit (a rare occurrence in their 21-year history). The magazine was once more in touch with the community. His efforts merely delayed the inevitable, however, and *Drummer* magazine ceased operation in 1999. The experience changed him forever and flung him firmly and irretrievably onto the international scene.

Since the demise of *Drummer*, Davolt retired to what he thought would be a much quieter, background part of local San Francisco life as a writer, graphic designer, publisher and media consultant. That is until Joe Gallagher, publisher of LeatherPage.com (an online collection of leather community columns from around the country) gave him an outlet for his single-tailed sarcasm. *The Metaphor Of Leather*, his first essay for the website, appeared in 2000. His writing comes from his own experience in the rough and tumble of gay leather community business and politics, including his year as San Francisco Leather Daddy XIX.

The result is a dinosaur's last roar before extinction, the scribbled notes and editing marks left in the margin of leather history, the ravings of an over-caffeinated curmudgeon or, as one critic put it, "Andy Rooney on poppers." Free of the constraints of advertisers, cautious editors and fickle subscribers, his LeatherPage.com

columns give full vent to irreverent takes on the world of masters, slaves, daddies, boys, perpetual adolescents, pompous asses, traditions, rules, outlaws, contests, politics, fashion and passion. Hailed as "the Mark Twain of the Leather Community," he pillories heroes and villains equally and chief among them, his funniest and most flawed literary target: Robert Davolt.

Foreword: Publisher's Notes

by Joe Gallagher

These columns first appeared on LeatherPage.com, a website out of San Francisco, California. Joe Gallagher, International Mr. Leather (IML) 1996, is the founder and publisher of LeatherPage.com a website that focuses on current writings about SM and leather. Joe's website has become the "web site of record" for the leather and SM community both nationally and around the world.

LeatherPage.com: A History

LeatherPage.com started in 1997. I had just finished my year as IML and looked around at ways to give something back to the leather folk I had met. I needed a thing that would allow me to work from home, and be in control of my own time and I realized that there was not much serious information about leather and SM available on the web. The Internet was still *very* young, and what could be found on SM, fetish and leather on the web was mainly porn and jack-off material. I thought I should provide a site that had:

- News about the leather and SM scene on a national as well as local level
- A comprehensive club and organization listing
- Thoughtful writing that had less to do with contests, focused on personal fulfillment with SM

The name came from my love of reading the editorial pages of just about any newspaper. LeatherPage.com filled the need with a name that gave the feeling of real information and not just fluff. So LeatherPage.com came to be a site with News, Opinions, Club Listings, and Event Listings.

As LeatherPage.com grew, it went from 600 visitors a month to over 60,000 visitors a month. Not the exponential growth one expects

from a porn site, but a very good rate for a site that makes you think. Starting with Mr. Marcus (Marcus Hernandez) from the *Bay Area Reporter* in San Francisco, my second column was Lolita's (Lolita Wolf) *Predictions and Predications*, an e-mail newsletter from New York City.

At first I added anyone I found who was writing about leather or SM. Eventually I came to see that too many columns were written purely about leather contests and had nothing to do with what I saw as the leather community. I started to weed out the columns that were consistently bitchy, small-minded or just badly written. I have found that I can let anyone become a LeatherPage.com columnist and then see how well they do. After some time, the ones who cannot write or are just petty burn themselves out anyway. I do not like to edit columnists, either for content or for bad writing. I will repair their writing a few times but not indefinitely. I am not running a classroom for writers, so if they continue to need help with the basics, columns were dropped.

It is really hard to gauge the impact of LeatherPage. I often get e-mail telling me what a great site it is and how much it means to the guy who is trying to discover SM in rural Kansas or South Africa or Japan. As much as I love porn, I think the main benefit is to show folks there is more to the leather world than just contests or porn.

Robert's Columns
Like many people, my first association with Robert Davolt was when he had first joined *Drummer* magazine. It was some months after some very poorly-chosen and badly printed photos of me had appeared on the cover of the magazine, so I have always told him that I promote his writing hoping that maybe he will stay away from layout and art decisions. Please do not tell him that I actually I enjoy reading what he writes.

Originally, Robert's columns on the LeatherPage were reprints of

his publisher's column in *Drummer*, each dealing with a topic that was the theme fetish of that issue (uniforms, pain, slaves, etc.). Since the *Drummer* website was in a state of perpetual reconstruction, it seemed like a proactive, reasonable, mutually-promotional arrangement. Finally, in 1999 I got an email saying that that the *Drummer* columns could no longer run on LeatherPage, making me one of the very first people to be informed that the end was near. I was sure that the magazine was going under and, very sad about that, I thought that the owners of *Drummer* were selfish and childish to not continue what had been a remarkable recovery.

After a very public, onstage resignation at the 1999 International Drummer Contest in San Francisco, Robert disappeared for many months. Many people assumed he was beaten and had left town, but in early 2000, he came back swinging. He sent me his first independent, post-Drummer essay— an angry, bitter denunciation called *The Metaphor of Leather* (which follows this introduction). It showed what was possible without partners, editors, community correctness or advertisers to censor and second-guess what needed to be said. I wanted to publish it and wondered if he could write a regular column for LeatherPage. Robert was astounded; he still assumed that I had never forgiven him for the horrible Drummer cover (Again, please don't anyone tell him otherwise. Fear and guilt are such great motivators.)

To test whether he could sustain a column on leather community subjects, Robert wrote three test columns and I wrote back: *"I have run the first three columns. LOVE THEM!!! So whenever you want to send more, go for it!"*

The style of these columns are a good fit for the LeatherPage. I especially loved how Robert would write the things I was thinking. A good example is these two paragraphs from *"The Metaphor of Leather"* (with my particularly favorite parts in bold):
> Is it any wonder that our institutions dry up and blow away? That our clubs wither for lack of members, that we

no longer have our safe gathering places? Is it a surprise that contests cannot find anyone willing to stand for a title? Is it any wonder no one wants to identify as a member of such a narrow, destructive, archaic community? **Of course there is no new blood in our community, no new leaders. Back-door rumors, backstabbing envy and back-turning isolation eliminate them quite efficiently.**

In the "leather press" our history is recorded by liars and fools whose primary talent is the same as the Queen Mother's: they kept breathing long after others had stopped. Shills and well-fed lap dogs. **Their press pass is no more than free admission, free tickets, free drinks or a free buffet. Dish sells papers, so instead of professionalism in our community journalism, we get dealers in pain, gossip, vicious filth, hurt and bitterness** *who heroically keep their work beyond any taint of either accuracy or fairness.*

Although I really liked the late Queen Mum (and thought she made herself useful far beyond some leather writers), as time has gone on I have come to enjoy Robert's columns more than ever. I consistently find that I made the right decision in asking him to write for LeatherPage.com. He brings to the site a voice that was missing. A regular insight in to a leatherman's feelings and beliefs. And that is what I wanted LeatherPage.com to promote.

The Metaphor Of Leather

Another Folsom/Castro Fair weekend in San Francisco. If I wear leather down to the bar, I get stopped by tourists who want me to pose for pictures like the guy in the Mickey Mouse suit at Disneyland. All these folks in town for High Holy Days— hope they aren't disappointed. They get so pissy when they're disappointed.

I once was one of those who believed that giants walked the earth. I read all the name-brand works and believed in magic places such as the Castro, the Village or Folsom and in immortals such as John Preston, Dave Rhodes, Robert Payne, Larry Townsend or Marcus the Merciless. To just walk among such Kings. . .

Now I read of a missing darkness, a lost passion in our leather community. I get so pissy when I'm disappointed.

The Re-examined Leather Life

Call it a crisis of faith. Call it guilt. Perhaps it's just what happens when you try to combine the social and sexual part of your being with how you earn your living. We market our community, icons and images to people who have no interest in the value of things, merely their price. We give up our sacred and secret traditions to people who consider them fashion, instead of passion. We distrust those whom we should embrace and embrace those whom we should distrust. People are no longer people but either allies or enemies. A stranger catches your eye, smiles, makes friendly conversation— what do they want?

In the name of nostalgia, of some artificial "authenticity," a "dress code" is slapped in the hands of some doorman. He wasn't even born 25 or 30 years ago when the bars were being raided and an underground language was born, and when dress codes were designed to protect bars from prudes, NIS agents, MPs and the

cops. He doesn't understand why boots and chaps are required, but he knows he is supposed to turn away anyone who doesn't have whatever is required by the soulless, unyielding, one-dimensional list of acceptable and unacceptable accessories he has memorized.

Inside, a herd of flesh-eating dinosaurs rips to shreds any sign of nonconformity or originality. So insecure— instead of reaching out to teach a new generation who might be shy, inexperienced, unsure or under-accessorized— they would rather eat the young than teach them. These we call "mentors' and if allowed to feed unrestrained they will destroy any chance for a future.

Doesn't matter. Bars are dead— "I don't drink or smoke anymore so why should I want to go to a smoky alcohol dispensary? I only go to properly pan-sexual, politically correct, hermetically hypo-allergenic, well-lighted, competently controlled play spaces that exactly conform to my exquisite tastes. Oh, and they must be free and open to all and, of course, with action ready to begin precisely when I arrive."

Is it any wonder that our institutions dry up and blow away? That our clubs wither for lack of members, that we no longer have our safe gathering places? Is it a surprise that contests cannot find anyone willing to stand for a title? Is it any wonder no one wants to identify as a member of such a narrow, destructive, archaic community? Of course there is no new blood in our community, no new leaders. Back-door rumors, back-stabbing envy and back-turning isolation eliminate them quite efficiently.

In the "leather press" our history is recorded by liars and fools whose primary talent was the same as the Queen Mother's: They kept breathing long after others had stopped. Shills and well-fed lap dogs. Their press pass is no more than free admission, free tickets, free drinks or a free buffet. Dish sells papers, so instead of professionalism in our community journalism, we get dealers in pain, gossip, vicious filth, hurt and bitterness who heroically keep

their work beyond any taint of either accuracy or fairness.

It is difficult to remember now where I used to see a little hope, a little light in what seems to be all too much darkness. Maybe it was in a smaller place, simple ideas, leather families and tight circles where people don't realize what quiet, noble giants walk among them everyday. Maybe it was in places without a Golden Age to live up to.

My fear is that we have allowed so much distance to creep in. Techniques and safety are taught in classrooms, rather than by one leatherman to the next. Why explore your own leather journey, when it's all in anthologies and back issues of Drummer for $6.95 each, plus postage? Don't ask me about my passion or my experience, just make sure I have read the latest scholarly dissection by a titled member of the leatherati. We don't need to really touch each other, there is the internet for that. We need not create leaders, feed our hungry, look in on those who are sick or lonely. There are fine organizations and funds for that and they are welcome to my check as long as nothing else of me is required to come along.

A Light In The Middle Of The Tunnel

Still, there are lights we cannot extinguish no matter how we try. In everyone who looks inside themselves for an answer, there is one. Inside groups, families, tribes, cadres that cling to and nurture each other there is a community. If there is a chance that the sexual freedom we have won will actually survive, it is not in our titleholders or any cult of personality, in some major city, in a philosophy signed by the famous, not in a manual by revered leather elders, or in a relic dredged up from some antediluvian golden age, or in the hollow, robotic forms of the past— it is in a lot of smaller, less grand things. We can't simply rely on a leather museum or on some name on a magazine masthead to pass on the tradition, the ritual, the history, the best of what we know our alternate culture to be— that is up to each of us. Each generation gets to twist it as they see fit.

Therein lies the metaphor of leather: Leather ain't nothin' sittin by itself on a shelf or hanging empty for display. It does not live unless it is worn, used, scuffed, scraped, damaged and tested. It must be lived in, sweated in, fucked in, passed on. With age and use, leather gets softer, conforms itself to the wearer and gains authenticity. The "leather tradition" is nothing until each individual makes it their own.

I. Painfully Obvious *Some Basics of Leather*

Passing The Bar A Guide To Painfully Correct Leather Bar Behavior

There is no place in leatherdom as important to see and be seen as the neighborhood leather bar. It is community center, political forum, hunting ground, marketplace, stage, test track, sanctuary, communications hub, pharmacy and communal living room.

Here you can watch the animals gather around the watering hole in their natural habitat, observe their mating rituals, covet their pelts and perhaps eventually get them eating out of your hand. You can also write stories on the back of a cocktail napkin and call it work. It was said of some titans of literature— and is certainly true among some titans of leather— that no two of them has ever seen each other in daylight or when both were completely sober.

I make no excuses for the time I have spent in bars. Agatha Christie used to spend hours in train stations, eavesdropping on conversations to learn about characters and dialog. I have learned amazing things in bars, taverns, saloons, pubs, lounges and beerhalls. I even remember a few of the more impressive discoveries.

Booze, Sex and Sundays

Surprising as it is to someone so comfortable in such dens of sin, there are people actually intimidated by walking into a leather bar for the first time. Once upon a time there were strict rules in leather saloons that were enforced with vigor. If you walked into a leather bar wearing underwear, you would be unceremoniously debriefed. If you came in with a tie, it was sliced off. If you came in with perceptible cologne, it would be hosed off you. . .and not with the soda gun.

While this is a more or less general overview that could apply to cowhide clubs nearly anywhere, in addition there are all sorts of quirky regional traditions and rituals can emerge through a slew of different reasons and origins. In one city it was strictly forbidden for anyone to dance in the bar. Even swaying in time to the music was met with a sharp reprimand. A case of the "leathermen don't dance" myth? Turns out it was solid Baptist city fathers who restricted the sinful combination of dance and cocktails to specifically licensed dancehalls-- and could get absolutely apoplectic over the idea of same sex dancing. To keep open, the proprietors could flaunt nearly any civic sensitivity— with the exception of rhythmic male gyrations. One boppin' boy and the law would swoop down to protect public morality.

Nothing more regulated in this country than booze, sex and Sundays.

Front Doors, Black Walls

Beyond that, many vestiges of older and less enlightened times remain in bits and parts of leather bar tradition. Dress codes and door security served very pragmatic purposes: to protect patrons and management from puritanical authorities and the pruriently curious. Leftover from days when being seen in a leather bar could cost you your job, many bars still have restrictions about taking photos. Discretion was a very big part of early bar culture. What went on inside, stayed inside.

At a time when gay bars had a harder time with permits, licenses, inspections and harassment than straight bars, a leather bar had an even more difficult time. In many places, that hierarchy hasn't changed. Understand then that often opening a leather bar and keeping it open is rarely the easiest way to make a living.

Leather bars, where they survive, have become much more genteel. The rules are subtle and much less obvious. To begin with, some

leather bars reflect their underground past by having unmarked or back alley entrances. They might be just a tad hard to find— by design. Once you find the door, there may be a doorman who will want to evaluate your manner or dress, just to see if you will be trouble. Once upon a time, you would only be let in if you looked like you *were* going to be trouble, but today they might let in the most ordinary of sorts.

Once inside, you can tell you are in a leather bar. There are strict interior decor standards whether you are in Columbus or the Castro, Amsterdam or Atlanta: All walls are the same shade of Leather Bar Universal Black #43 hung with posters from other leather bars, contests, runs and events and chains. Optional equipment can include club colors, random auto parts, softball trophies and panels of chainlink fencing. No ferns, no pastels.

Laws Of The Jungle

In our modern and enlightened world, there are few remaining examples of absolute power. A captain at sea, a master in his own dungeon and a bartender behind his bar have nearly unlimited authority and responsibility. Their word is law and not subject to review or appeal.

To assist the uninitiated and as a refresher for the regulars, this constantly updated code has been contributed, revised, edited and approved over the past 25 years by a motley panel of my favorite mixologists, who offer the following Guide To Painfully Correct Leather Bar Behavior:

1) Respect the dress code. A bar with a dress code is trying to create a specific atmosphere. If that atmosphere excites you, cooperate by dressing the part. If not, there are over 6.7 million drinking establishments in the United States alone. Go somewhere else without a fuss.

2) No cologne. No aftershave. If you must wear some sort of scent, either WD-40 or a #3 diesel fuel has a nice bouquet and does wonders for dry skin.

3) A bar is a place of business, not a public drop-in center. It is bad form to just take up space and not generate commerce.

4) When ordering, know what you want and have your money ready. If you are thinking of ordering anything with a cutsie, clever name, that requires a blender or a little paper umbrella— think again.

5) Don't ask the bartender to mix you a strong drink. Ask for a double and pay for it.

6) If you drive, don't drink alcohol. The bartender doesn't care what you drink...have a non-alcoholic beer, a soft drink or some juice.

7) There are few things as embarrassing as being cut off at your favorite leatherpig trough. When you feel you've had enough, cut yourself off before you get stupid.

8) The customer is always right. Keep in mind, however, that it is the bartender who determines who is still a customer.

9) Do not snap your fingers or whistle unless the bartender happens to be a cocker spaniel.

10) About tipping: If you can't afford to tip, you can't afford to drink. Stay home and watch cable. According to my favorite innkeepers, if you can hear the tip hit the bar, you are being too cheap. Someone is bound to think you are straight.

11) As a general rule, don't fuck with the guy that signs your paycheck, cuts your hair or mixes your drinks. The results are guaranteed to be anything but pleasant.

12) Don't get pissy when asked for I.D. or when asked to leave at closing. The bar doesn't make the laws, but it does have to enforce the law or risk its license. At my age, getting carded is rare and shameless flattery and generally I try to exit gracefully before the lights go up.

13) The same goes for sex, nakedness and that spontaneous flogging demonstration you think you do so tastefully. If the bar staff tells you to cease and desist, don't hassle them. Instead run for public office and modify the alcohol and morals ordinances.

14) And drugs. Why is it the least coordinated want to try and walk and chew gum at the same time?-- most of you can't handle one impairment without incident. Don't involve the bar with your other chemicals. Doing drugs (yes, even that reefer you have a prescription for) in a bar ceases to be a private activity and imperils the business, its staff and patrons and the community. Just don't— and if you must, take it somewhere without a liquor license.

15) Keep in mind that there is a difference between "drinking " and merely "getting drunk". One you can do by yourself out of a paper bag for less than a couple bucks. The other requires a bit more social skills, grace, discipline, attitude and aplomb. For your enjoyment, reputation and the safety of others—don't confuse the two.

16) If you insist on making an ass of yourself when you drink, drink only on New Year's Eve and St. Patrick's Day (or regionally, Mardi Gras in New Orleans and Halloween in San Francisco). These are amateur nights and you will have lots of company to blend with. Cheers.

What Should I Wear?

"What are you rebelling against?"
"What have you got?" -Marlon Brando to the town cop in *The Wild Ones,* 1954

It seems that anymore some of SM/leather culture tends to be simply etiquette taken to the level of sexual fetish. Over many, many years, the questions that come up most often go over and over rules governing how to behave and what to wear. No one wants to appear disrespectful (or worse, foolish) so they are frequently asking for the one, final, definitive, authoritative book of leather do's and don'ts.

Emily Whipping Post? Mistress Manners? A Boy Scout Manual for Leather? It doesn't exist. You find that book, you let me know. All you will find are more opinions and extrapolations from military etiquette, uniform manuals, service training or the social forms governing formal attire. We are a pretty acquisitive subculture and what we have has been swiped from elsewhere, reconfigured and recombined over the years. The best of which are (hopefully) tempered by common sense and good taste.

A new titleholder recently asked if they should wear the title sash, vest, medallion and pin all at once. "What?" I asked, "No tiara?" Of course, each title should specify how they wish their own title to be presented, just like most leather clubs establish how and when colors are worn— and that should be that. One does not interrupt another's flogging scene and one does not render etiquette judgements for strangers unless requested (or paid by the word). Much more gauche than any protocol or etiquette gaffe would be free-lance meddling in other people's fantasies. If you see some egregious violation you just can't help but react to, do what most polite leather society does and just talk about that person behind their back.

Pretty much any universal, all-inclusive, absolute, worldwide and eternal rules on what to wear and how to wear it should be viewed with deep suspicion. Anyone deciding to write some of those

down should please present these ideas as "serving suggestions" or "options" rather than "rules," lest we empower a priggish new Leather Taliban. Come to think of it, one of the oldest leather traditions I can remember was to find imaginative ways to piss on any "rule" just as quickly as it was carved into stone. I also don't remember being so concerned about what I was wearing— more likely concentrating on how to remove clothing wherever and whenever possible.

So be warned this advice is coming from someone who greeted guests— who were just too damned early to a party in his IML suite— in his leather vest thrown over a fluffy white hotel robe. For those who face the paralyzing dilemma every time they open a closet full of leather (ever consider that "too much crap to choose from" might be your problem?), here are a few quick guidelines:

11 Purely Subjective Rules On What To Wear And What Not To Wear

1) If I earned it, was given it or bought it (assuming the check cleared, it hasn't been revoked or repossessed)—basically, I'll wear anything I damned well please. I'm a leatherman . . . nobody tells me what to wear or not wear.

2) That being said, if I go out in public looking like a fool, something out Gilbert & Sullivan or an over-decorated Christmas tree, then it's my own fault— not the rule book's. A rebel at least gets to own his own lousy taste.

3) As in other areas of life, even after following the strictest formula there is always the chance it all might blow up in your face. You can follow all the rules in the world; that is no guarantee of avoiding disaster. But the only way to truly look ridiculous is when everyone else thinks you look silly and you don't, so rather than agonize over harnesses, belts or hats, keep a healthy perspective and a healthy sense of humor.

4) Less is more. If in doubt whether to add another bauble to your outfit, don't. Wear your smile and dazzling personality instead. (Some folks do their best work wearing little more than a smile). They should remember you, not your plumage.

5) Ask yourself, "Is it appropriate to wear?" It goes without saying that one does not wear colors, insignia, rank and awards one has no claim to wear— but also think about why you feel the need to communicate your entire leather resume, every pin and patch, each time you sally forth. Simplify. Consider retiring titles and glitter you no longer have any function with.

6) Is it believable? A purely personal opinion, but full motorcycle leathers that look like they have never seen the open road come off as a bit contrived. Tom of Finland cartoons notwithstanding, stiff, shiny, new leather that is not yet broken in screams "NEUWBEEEE!!" Likewise: Full cowboy leather on an obvious "city slicker" and a uniform on some unmistakable civilian sporting a goatee.

7) Practicality and common sense must occasionally intrude. Yes, the really tight chaps look great on you but are you sure you will not be required to move, breathe or circulate blood through your legs anytime throughout the evening? And if you are cold, wear a fucking jacket, dummy.

8) If there is some tradition established by your daddy, your club or your title for the wearing of their emblems, you follow those traditions out of respect. If there are no standing traditions, perhaps it's high time you started your own.

7) Like all leather traditions, what is proper to wear may vary from region to region, culture to culture, generation to generation, situation to situation. When in doubt, ask what is expected of you.

10) Your leather "uniform" is a form of communication. Be aware of

what you are saying. If your language is offensive, crass, shrill, bold, contradictory, insensitive, pompous or mumbled you will probably find the need to clarify yourself later. Wear what you want but be prepared for the rest of that conversation.

11) There are many more serious offenses and weighty problems in this world than violations of the dress code. Some even argue that humans have a divine-given right to occasionally be tacky, but at worst it is a social faux pas, not criminal behavior. You may not get into the party, you may not get invited back, someone might chuckle, feathers may be ruffled and noses out of joint but— and trust me here— the actual end of the world will look very different.

Leather On The Cheap A Miser's Guide To Frugal Living In Leather

It is not true what you have heard: "There are no stupid questions." Of course there are. We hear them time and time again. Chief among them is the ones that are asked again and again and the questioner seems impervious to the simple answer he is given.

One such question is, "I would love to explore leather but it is too expensive. How do you afford all of that?" Over the years I have patiently answered this, ranted an answer to it, shouted, pleaded, persuaded and growled. From now on, I am just going to send people a copy of this column.

C'mon. This is just like any other purchasing decision: It all comes down to options. Where you buy stuff (or even the stuff itself) is not so important. Results are. The key is to consider the full range of options, including those for folks who can't afford or don't want to pay certain prices, live in isolated areas, who need assistance, product support, technical support, privacy or reassurance (or don't), who want to support community businesses (or don't). Then you assemble your best decision to get closest to the result you wanted.

Sometimes leathermen talk more enthusiastically about the purchases they've scored than their sexual conquests. The crowd seems to polarize, however, to one half (which brags at how much they paid for their leather) and the other half (which brags about how little). When and if there is bragging to be done, I can be found firmly in the second half.

Basic Issue

The Drummer magazine office where I worked in San Francisco was located above the infamous Leather Zone shop which got a lot of traffic the weeks prior to the Folsom and Castro Street Fairs. On my breaks, just for a little human contact, I would go down and help out with the vanilla-looking boys who would come in with endless

questions about "What's this for?" and "How do you use this?" Among them would always be these guys who looked like escaped models from an International Male catalog and showed no interest in the clothes or equipment, what it was for, what it meant or even what it cost:

"I'm going to Folsom this weekend. What do I need?"

"Well, what do you want? Do you see anything that excites you?"

"Look, I just want the basics. What do I need?"

"What do you like to do? What do you have in mind?"

"Whatever. I have VISA. Platinum."

Would you like to buy a magazine? Would you like the publishing company that goes with it?

So what is the basic, standard issue, approved and certified uniform for a leatherman? Most people don't need to involve a salesperson, they get all the knowledge they need from a Billy Doll: Chaps, harness, vest, hat, boots, armband, cockring (optional), hair (optional), big dick (optimal). I think that there are still some places that one is allowed to go and call oneself a leatherman without the requisite shaved head and goatee. Some, but few.

Support Your Local Merchant

Sometimes it's good to shop among friends. Your friendly neighborhood community leather shop should not only have what you want, but know why you want it and can advise you about how to get the most pleasure from it. It's not just the knowledgeable sales staff, but also the understanding, safe, discreet, judgement-free atmosphere. It also feels good to support your local community businesses.

Like any specialty store, you pay for the amenities. Just as the corner Mom & Pop store has to sell something at $2.50 an ounce that the chain store sells for $1.99 and the discount club sells for $1.09. It is merely a matter of economics and options. That is why Mom & Pop

(or Pop & Pop) stores, chain stores and discount clubs all exist.

But even though that $125 spiked dog collar at the local S&M emporium is only $50 at the local pet store, there might be other factors to consider. Some guys are just not comfortable walking into their local pet shop and asking for a dog collar with a "16 1/2 neck".

"What kind of dog is that for?"

"An Aggie. Class of '92"

"But sir, our merchandise is for real animals!"

"You haven't seen him on a Saturday night."

Beyond The Leather

There are a few other aspects of the leather life that get a little pricey: travel, entertainment, events, etc. Always book early. Use the internet to compare prices. Swap information with your friends. The leather community presents a wide network for underground sexuality, but also for underground frugality.

Going out to the local leather bar can get expensive on a regular basis. Beware of false economies, however: Don't skip the cab (or a hotel room) and try to drive home if you've had too much. That can get very expensive. Plan ahead. Meet your friends during happy hour or work the drink specials. If bar-hopping is too expensive, think about using one night out once in a while to meet and construct a group that gets together at someone's house to socialize or sexualize.

Levi/Leather clubs have always been a great way to get together with other leatherfolk economically. Check out the organizations in your area. Plan a group trip to get the best rates. Contact clubs where you want to travel and see if someone will be your native guide to the local wildlife. Return the favor when they come to your neck of the woods.

Some Ideas

-What you "have to have". Your participation in the leather community does not depend on having just the right $750 leather jacket. Your participation in the leather community does not depend on having just the right $150 leather jacket. It doesn't depend on you having a leather jacket at all and don't let anyone tell you otherwise. You choose what you want and can afford.

-Volunteer At Events. You can get into many events or contests by becoming part of the staff. Even if you have physical limitations, there might be desk jobs taking tickets or answering phones in exchange for admission. Ask early and be prepared to give a fair value of labor for your ticket.

-Use Your Imagination. Look for things that can be made to work, that can be altered. Look for alternate materials and alternative uses. Keep your mind open in the hardware store, farm & feed store or local restaurant supply house. You'll be surprised how many things can be adapted to dungeon use (and how many things are purchased for your local SM emporium just this way) and the sales clerks will be surprised as you pop a woodie in the middle of their Home Depot. A nylon cargo net can make a nifty sling. Small Vise-Grip pliers for the nipples. Best piece of dungeon equipment I ever bought was a 1987 Jeep Wrangler, with winch and rollcage.

-Look for the uncommon source. My first leather pants were bought from the Sears-Roebuck motorcycle shop by mail order. $99. They served reasonably well for over 15 years (including saving my ass during a couple of spills from the bike). The JC Whitney auto supply catalog used to have chaps, vests, hats, gloves and jackets in their motorcycle section. The leather was thick, the hardware was heavy duty, the fit needed work. The price was amazing. Look outside the usual range of sources. Is there a local biker culture in your town? Where do they get their stuff? Where do the police get their motorcycle gear? Don't overlook Army/Navy surplus

31

stores—particularly the ones that get in bulk shipments from foreign suppliers.

A few years back, I got a great pair of Soviet Officer's dress boots for just $50 through a surplus catalog. The yard sale prices are unbelievable when an entire country goes out of business.

-Look for the original source. Where does the dandy new leather, item or BDSM device at your local leather store come from? Is it sourced from a wholesaler? A manufacturer? A supplier? Will they sell to you? Can you buy in volume? Your local SM shop doesn't buy nipple clamps for $14.95 a dozen or J-Lube at $9.95 a packet. The rubber-tipped clothes pins come from a wholesaler by the gross and the J-Lube come from a veterinary supply company in gallon jars. You can buy a regulation straitjacket directly from a hospital supply catalog for a fraction of what it might be in a retail store, if you have the balls to order it.

-Travel. Plan your purchases around your travel. A pair of spurs can sell for $150 at an urban leather/SM specialty shop but at a working tack store out in rural cattle country, you can get a professional grade pair for half that. What costs $100 in St. Louis because you can only get it one place, may be the same item at $85 in San Francisco because there are 20 places selling the exact same thing. And don't just hit the tourist spots. Do your source research as suggested above and find out where the bargains are.

-Timing. Many people wait until IML to purchase their acquisitions for the year. Some wait until the very last day of IML's famous Leather Market to buy hoping that deep discounts are preferable to an exhausted merchant rather than packing and schlepping the stuff back home. Be patient. Instant gratification is expensive. Timing is everything. Be patient. Most people do not acquire all their toys overnight (and too do so is considered a bad sign, anyhow) so build slowly and deliberately. Once again, be patient.

-Trade. If you just must have the top of the line custom leather, you may have to work for it. Evaluate what skills and talent you have and offer to exchange them for what you need. If you are an accountant, offer to do the books for the local leather store in exchange for credit. Offer to sell ads in your local gay publication in exchange for advertising your event. Trade ad space in your event program for ad space in their publication.

-Used Leather. Leather has a life of its own. Good leather will outlast tastes, waists or sometimes the wearer himself. I treasure the leather passed down to me from someone I knew and admired, but there is also many excellent pieces I have picked up from garage sales, estate sales and used clothing stores. They are already broken in and already have half a life already. Add your energy to a piece of leather and pass it along.

-Leather Swap Meets. Many clubs and organizations have used leather swap where folks can trade pieces they have outgrown or no longer use for something else. If there isn't something like that in your area, maybe you could organize it.

-Earned Leather. I had to slip this in because I know someone will harrumph: "But leather should be EARNED not just bought!" To which I say: That's nice. But leather vests, hats and jackets do not just descend like manna from heaven— someone still has to buy it in the first place.

Yes, in an ideal world there is a network in which every interested novice has access to a mentor who cares enough to mark each milestone in his training with a piece of leather. In an ideal world, these gifts mean as much to the recipient as to the giver. I have given three leather jackets to three boys: the first eventually passed his along to his boy, the second was buried in his, the third I still occasionally see in Chicago. Lives are enriched by both giving and receiving, but unless we're using your MasterCard, stop yapping about it.

-Pick And Choose. You can't do or have everything. Sorry to break it to you, but even Barbie has to make difficult choices about how many accessories are reasonable. If you like uniforms, pick one and slowly complete it rather than collecting dozens of unrelated items. Rather than scrimping on twenty events, trips and runs each year, take that money and do the three or four you really like.

-Leather Craftsmen. In addition to big storefronts, many communities have a host of individual talent, working out of their homes, tailor shops or dry cleaners. I had some leather manufactured once by this brilliant artist who also sewed costumes for the circus company that would summer near my home. Prices vary, but I was able to trade some antiques, some yardwork and very little cash for some exquisite pieces of custom craftsmanship of my own design.

-Teach Yourself. The local Tandy Leather store used to offer kits and courses to learn leatherworking. Many community colleges, hobby stores and community centers have evening workshops. Maybe you won't end up as a world-renowned leather couturier, but at least you and your friends won't be paying for day-to-day repairs and alterations.

Travel in Trying Times How To Get Toys Past Airport Security

The well known SM educator and fetish diva returns from a presentation on another coast to find that her luggage has been opened and several expensive pieces of equipment are missing. An SM writer traveling with samples of his work watches as barely post-adolescent federal inspectors pass his magazines around for a laugh and a fag joke. A leatherman returns from judging a national leather contest to find his bags have been rifled, his leather has been damaged and a polite note from the government has been added.

It's not just us that have had trouble with the new security. Recently a former governor of Arizona, general and war hero had his Congressional Medal of Honor (the highest military decoration in the country) confiscated as a dangerous weapon by suspicious airport security. Recent world tensions have all of us understandably concerned, but as often happens in a crisis, some folks have gone nuts and some of those nuts are in charge.

So under the new realities, how do you travel with rope, toys, paddles, whips and chains? How do you protect hundreds of dollars worth of custom leather if you are not allowed to lock it? Who is responsible if something turns up missing?

Homeland Security

As of 1 January 2003, all checked luggage on U.S. aircraft must be screened for explosives and prohibited items. In most of the nation's 429 commercial airports, this security is the responsibility of a division of the new Homeland Security Department (HSD), the Transportation Security Administration (TSA), in unwieldy cooperation with local police, airport security and the airlines.

What does the TSA advise passengers about their own rules, procedures and policies? The real answer seems to be that this is all pretty new for them, too. The TSA is itself in transition, having

35

started out in the Department of Transportation (DOT) and now becoming part of the HSD.

This is from the TSA's website http://www.tsa.dot.gov (the site also has a downloadable list of prohibited or restricted items.): "Think carefully about the personal items you place in your carry-on baggage. The screeners may have to open your bag and examine its contents."

You might think of clearly labeling your anal beads. That might cut the inspection a bit shorter.

And this from their FAQ section: "What happens if my belongings are missing from my bag when I arrive at my destination?" Obviously the question is not asked in case a $4 chrome cockring accidentally rolls off the inspection table and falls behind the computer display. The more realistic concern is the security of unique and expensive items that might catch the attention of the enterprising or the acquisitive.

Their answer: "TSA screeners exercise great care during the screening process to ensure that your contents are returned to your bag every time a bag needs to be opened. TSA will assess any claims made to TSA on an individual basis."

This would seem to indicate a high degree of risk and no degree of accountability. Indeed, so far there are few reports of successful claims against the TSA, let alone even satisfactory response. People who are primarily used to traveling around the United States in the past will find this a new and disconcerting situation, but in many parts of the world luggage is subject to nearly constant danger of rifling or theft—and often from custom or security authorities.

It will take some time for this new way of traveling to work itself out. Some of the new regulations can be confusing, if not contradictory. Security instructions suggest (some insist) that you not lock your

luggage, yet there is no accountability against theft (or someone actually adding something dangerous to your bags). Packing for security rather than maximum capacity may mean additional bags, but airlines have begun to crack down on overweight and extra bags. Food items are not recommended in either carry-on or checked bags (because they can read on x-rays as explosive material), yet many airlines have stopped or reduced food service.

To Lock Or Not To Lock

This simple question—whether bags should be locked or unlocked—is symbolic of the whole mess. It seems like a basic, straightforward, yes-or-no question, but after several calls to many different sources and authorities, this question is still unanswered.

Although most airlines advise passengers to leave their bags unlocked, you need to read the fine print. There doesn't seem to be wholesale agreement and policies seem to vary from airport to airport, airline to airline and are subject to change. Some airlines are still recommending locking or sealing your bag to prevent tampering.

I decided to try and get a definitive answer from the airline I usually fly. After several calls to the airline headquarters, the local airline baggage counter and the TSA desk at the local airport, it seems to come down to this: They don't know. I was referred to the official "Contract of Carriage" which specifies that all bags must be locked for the airline to be even minimally responsible. The airline's website says to lock your bags, the 1-800 desk says that a locked bag will not be accepted for check-in (but check with the individual airport counter). The airline counterperson says it is up to airport security (TSA) and the TSA says it is up to the airline. The TSA website indicates that it would be possible to pre-hand inspect a bag, but you would have to arrive at the airport several hours early and they wanted to know if there was a "religious or cultural special consideration." The airline reps said that they had

never heard of pre-inspecting bags but she has accepted locked bags (advising travelers that the lock will be cut if the bag needs to be hand searched). In the background, her colleague was saying that she always has the passenger remove the lock.

So, what to do? You would think that one could go ahead and just use a inexpensive lock, so worst case, you lose a cheap lock but your luggage is still secure for some percentage of the trip. But no, there have been documented instances of airlines holding up a planeload of passengers to locate one person, take him off the plane and have him remove his lock from his bag. The rational solution is pair of bolt cutters and two seconds—the lock is cut, people are on their way. Once again, just one or two irrational human beings in the right place at the right time can the whole fragile system to a halt.

Carry On Luggage

Rules for carry-on luggage have not changed drastically, although what you can or can't check effects what you need to schlep with you through the security check.

1) For both the walk-through metal detectors and the x-ray machines for carry-on bags, different airports and different machines are set to different tolerances. My power bars caused some excitement in a carry-on last May (they showed up as a dense spot when it went through the machine) but chocolate (a particularly dense material), have flown through fine at other airports. Some times I can walk though with change in my pocket, watch on my arm and ring in my nipple; sometimes I'm taking off my belt, shoes and justifying the fillings in my teeth.

2) If possible, take only a carry-on bag (I do know leatherfolk who manage to travel this way) and a "personal item" which can be a briefcase, camera bag or gym bag. Try to avoid checked luggage altogether.

3) Pack food and gifts (unwrapped) in carry-on. Ditto wine and liquor (but some airlines prohibit alcohol in carry-on bags).

4) If you travel frequently and are worried about film, videocassettes

or disks being damaged by x-rays, there are lead-lined pouches that can be purchased (this will, of course, prompt a hand inspection). Such items should always be carried in carry-on bags.

5) Keep your most valuable and personal items with you, in your carry-on bag. At least these are inspected at the public checkpoint, in your presence.

6) Rethink traveling with irreplaceable gear. Is this really necessary? The pins you can never replace can get knocked off your vest, the authentic 18th century shackles might disappear, the delicate, one-of-a-kind leather outfit might get damaged during inspection. Perhaps, for a while, it's best to travel with more simple and with more hearty accessories.

Checked Luggage

Until such time as our new reality becomes normalcy, here are the latest suggestions from travel/consumer websites about checked luggage:

1) Make a detailed packing list of all items in the bag. Keep the original and pack a photocopy of that list inside your bag on the top or where it will be obvious if the bag is opened. One site even suggested taking a digital photo of your stuff laid out before it is packed and printing the photo right on the packing list.

2) Ship your luggage ahead overnight via FedEx or UPS. (This does not work well when traveling over holidays such as the upcoming Memorial Day, Labor Day or MLK weekend,).

3) Make sure everything is labeled (remember Mom sewing labels in your shorts before summer camp?) as much as is reasonably possible. Tags on all bags, even carry-ons and bags packed in other bags.

4) If you carry your passport, keep it in a passport cover to protect your privacy and nationality.

5) Anything you might not want inspectors handling (not just your toys and personal hygiene items, but gifts, easily pilfered, sensitive or confidential materials), place in sealed, clear plastic bags. Gallon-sized Zip-Locs are very useful.

6) A friend of mine who is a screener at SFO confirms that only about 10% of all luggage is actually opened for hand inspection—any bag that shows something suspicious on the x-ray screen and a certain number of random bags. Not all bags. The confusion seems to be in the wording: "100% of all bags" are screened, but screening can be done by x-ray, chemical swab or by hand inspection.

7) Our chances of having our luggage searched, however, increase dramatically. Any dense concentration of material will prompt a hand inspection: A neatly folded pair of rubber or leather chaps or pants, a coiled rope, a bundle of papers or books.

10) Boots and shoes are a particular fetish. They seem of specific interest to the inspectors. They recommend that footwear be packed on top of other items and left empty (rather than filled with socks, t-shirts and small items) for easier examination.

11) Often you can accompany your luggage from check-in to the TSA screening area. Some even have quasi-"viewing areas." If you are not in a desperate hurry to get to your gate, I would stand by during the inspection process and be available to answer any questions. ("Yes, officer that is an electric butt plug. It works like this…")

12) Since the airlines are reluctant to take responsibility or offer insurance, time to think once again about homeowner's or renter's insurance that will cover your luggage and personal items when traveling.

Personal Experience

How we are treated, it seems, will depend on the professionalism and tolerance (and the mood swings) of each individual we encounter in the system. In the absence of solid, standardized rules and procedure, that makes travel an experience that will vary widely from person to person and trip to trip. Sharing experiences and comparing notes among ourselves will be very important for some time. These are notes from recent trips:

SFO

San Francisco International Airport is supposed to have some of the most sophisticated and sensitive security equipment in the world. The one checked bag went directly to the TSA inspection unit. I had attached a colored plastic tie instead of a lock. I carefully packed my empty boots on top and put a detailed "packing list" on top of everything. When I got to my destination, there were two white TSA seals along with my original colored one and the bag had obviously been rifled. My packing list was neatly folded with a printed notice from the TSA. Slight damage/missing emblems from a uniform (probably knocked off while repacking). Flew through the carry-on security checkpoint with no problem, but then again, it was close to midnight and there was little traffic. I did have to remove my belt, ring and even my wallet to get through the metal detectors.

Going through SFO a second time, I accompanied my bag to the screening area and watched it being searched. I had a dozen or so copies of *Bound & Gagged* magazine—samples of my work— wrapped in a clear plastic bag. As I was standing right there watching the inspection, the young screeners passed the package of magazine back and forth, sharing a giggle. What was the purpose of this inspection by committee? What did they expect—after all, this is San Francisco? Why was the package even removed from my luggage when it was obvious that the contents were not dangerous— or at least not dangerous to anything except the libidos of teen-aged male inspectors?

DCA (Reagan-National)

One would expect that National Airport, with flight paths so close to capital buildings and monuments, would be the most locked-down and secure airport in America. No special packing this time. I packed the same way I have for years: Boots on the bottom crammed full of smaller items. I asked to watch as my checked bag went through the x-ray and checked what they were looking for on the screen. Based on the screen image, my bag was picked for hand inspection which I could watch through a frosted glass screen. First the handles were

swabbed and tested for residue, then, using the x-ray image as a guide, the inspector unpacked the bag down to where the blob on the xray had been (it turned out to be soap). I then interviewed the two TSA inspectors about how the bag was packed and what suggestions they would make. They were uncooperative at first, saying, "ask your airline for a list of what you can't take on an aircraft." I then pulled the printed list from the TSA website out of my briefcase and asked what items he meant. He specifically mentioned my paddle and my leather hat. His colleague chimed in that I had two pair of boots and, if I could, I should pack only clothing.

Neither boots, caps nor paddle were on the forbidden list for checked baggage. Clearly, these inspectors are making judgments about what you should or should not pack, not what will or will not explode. The number of boots, what I use the paddle for and my choice in headgear is irrelevant. Bottom line is still that this is all quite new, both for inspectors and travelers. Because of what we tend to pack and how we move about the world, the traveling SMer will probably continue to be subject to a higher level of scrutiny.

The TSA's consumer response line (886-289-9673) promises to "return your call as soon as possible," but after seven months no response had been received to several phone calls and left messages. We can't rely on the airlines or the TSA, so we need to keep exchanging new ideas on how to make sure inspectors can do their duty, while closing the door to theft and discrimination based what we travel with. In the mean time, it seems inevitable that we will be judged—not by the content of our character—but by the content of our Samsonites

IML: Four Nights For Under $1,300

Everyone has their opinion about the annual International Mr. Leather (IML) weekend held in Chicago every Memorial Day Weekend. Some enjoy the contest itself and actually care who will be crowned King of the May. Some enjoy renewing old acquaintances and making new ones. Some move among the private party circuits or hook up with various masters or slaves from around the world. Some enjoy the oh-so-gay combination of sex and shopping offered by the Leather Market. Some thrive on the glitzy circuit parties and seeing some of their favorite porn stars in the flesh.

I love IML and I love Chicago. Don't expect me to apologize for either affection. I can sit in the lobby of the host hotel and take up with friends that I only see only once a year. We start right back in where we left off last time, with the next chapter in the same conversation we have been enjoying for 18 years. It is a family reunion with family that I might actually like.

With time and experience, you learn to manage both your travel budget and your expectations and get the weekend pretty much down to a science. Right around this time of year, folks ask my advice as to where to go and what to do during IML. Of course, tastes vary. You may not like what I like. I'm not big on massive circuit parties...but you may be. You might not blink at spending two or three grand on a typical vacation...but that's a little beyond my means. What follows is a modestly frugal, but thoroughly enjoyable IML weekend for one starting out with $1,300:

Thursday- $1,300

Round Trip Air Fare: $209

This can vary wildly depending on where you are coming from (in my case, San Francisco), your frequent flyer status and your level of tolerance for inconvenience. I have flown the same airline for years because I prefer a direct flight to Chicago's Midway Airport (which

is just 7 miles south of the Loop) rather than O'Hare International (which is nearly 30 miles west.)

Airport To Hotel: $1.80

The other advantage to Midway is that it is easier to take advantage of Chicago's famous public transportation. For $1.80, follow the directions to the CTA (Chicago Transit Authority) bus stop, hop the 55N bus to the Midway Trainstation and transfer to the Orange Line (Clockwise) to Monroe/Wabash. The station is right around the corner from the year's host hotel, the venerable Palmer House.

Four Nights, Host Hotel (+tax): $712

The one indulgence I recommend is staying in the host hotel. Aim for staying better, but shorter by paring down your stay to just four nights. In the past, I have shaved it down even closer (arriving on Saturday morning and leaving on a Sunday red-eye) but that borders on madness.

Once upon a time, one could arrive on Friday but not anymore. Thursday is pretty much de rigueur. I recommend leaving town on Monday just after catching all the best last-minute bargains at the Leather Market and just before the returning Memorial Day crowds mob the airports. If you feel the weekend is a little rushed, consider adding a day to the front of your trip rather than staying after IML. Better to get into Chicago early—while everyone is fresh and enthusiastic —rather than leave a day or so later. Quite frankly, by Monday evening most of the town and its visitors look a bit like a $15 hooker after a Shriners convention.

Stocking The Room: $45

Experienced travelers know not to touch the mini-bar unless they really like paying $9.50 for a Diet Coke. Best idea is to shop at your local warehouse store for cheap eats before you leave home, but if you didn't, go down the street to Walgreen's and get a bottle of liquor, soft drinks and some shelf-stable snacks: Power bars, cheese,

crackers, fruit or trail mix. Plan on eating just one meal out each day and grazing your room stash for the rest of your nutritional needs.

Barhopping: $80

This is where you have options, depending on what you have planned for the weekend. Your main question: Do I buy a weekend package for $140 or not? The package includes admission to all official IML events, the free Shuttle Bus service, the Official IML t-shirt and poster.

If you plan to make full use of it, the weekend package is worth it. Just the event tickets add up to $150. Skip even one event and the value quickly begins to slide. And if you are like me, you have enough posters and t-shirts.

The tricky part is the shuttle bus. A taxi from the hotel north to where the bars are can cost you the better part of a Jackson—each way. Four round-trips during the weekend and you have easily paid for the package. Car rental? Forget it, you'll pay as much to park it as to rent it. But if you don't intend to leave the hotel much or if you haven't the patience to wait for busses, the bus pass is a waste as well.

For first timers, I would definitely recommend the package. After a while, every contest, introduction and victory party looks pretty much the same, so the more experienced might prefer to go ala carte. On Thursday night, I make the rounds of the bars while they are still the least crowded. Start at the Cell Block on Halstead, then work your way north to the Eagle and Touché. When finished, find someone else heading back to the hotel and if you are lucky, you can develop more in common than just splitting cab fare.

Get barhopping out of your system on Thursday. Friday or Saturday nights you will spend most of your time waiting in line to get in the bar—a waste of time and cab fare.

Friday: $252 remaining

Breakfast (+ tip): $7

Remember, it's one meal a day and the best food value, pound for pound, in most restaurants is breakfast. Take advantage of inexpensive cafes catering to downtown working stiffs which are open today—they'll be closed the rest of the weekend, leaving you with the more expensive tourist spots.

The Leather Market: $0

The Leather Market is so huge anymore that you need maps, a GPS navigational system, sherpa guides and a tactical plan to just get though it. Do not—I repeat—DO NOT buy anything your first time through. This is a reconnaissance patrol only. Handcuffs may be necessary. Spend a few hours, get all the way through, making notes about which booths you want to revisit. Then take a break. Do something else. Come back tomorrow.

These days the IML Leather Market can serve as a great place to get ideas. Someone always has a new and unique accessory or toy. Soak it in, then sleep on it. Look for the bargains and any supplies you might need for the weekend. Keep an eye out for one-of-a-kind pieces that you won't find back home. Remember, if it isn't something you absolutely need this weekend, you can usually mail order it later.

Pecs & Personality: $25

If you HAVE to go to one of the official events, this is the one. You don't have to leave the comfort of the hotel. You get to see all of the contestants, all the time (not just the top 20) and they are dressed in next to nothing. The atmosphere is much more social, more casual, less regimented.

Lobby Lounging: $12

After a short disco nap, let the other schmucks wait in lines outside the bars up north. You know that the most happening leather bar in the city will be the lobby of the host hotel.

Be a mensch and buy the first drink from the hotel, but then refill your glass from your room stash. I know that sounds awful, but the lobby bars are usually so overwhelmed that I don't think they'll miss you. Don't be obvious and if the staff seems to frown on you running your own rum, slip them a tip to show it's nothing personal.

Saturday- $208 remaining

Breakfast (+ tip): $10

Buddies at 3301 N. Clark or Ann Sather's around the corner on Belmont are two choices for hearty food and gay atmosphere. If you want to save the transportation costs to Boy's Town, however, there are several quick choices near the hotel for a filling, Midwest breakfast. Since most of downtown is leather-friendly this weekend, walk to a corner diner for just under a ten-spot. Bonus points for successfully working the all-you-can-eat buffets.

Workshops & Receptions: $0

Several workshops, receptions and gatherings happen during the IML weekend at no charge. Subjects and interests range from health, leather leadership, boys, cigar fetishes, psychology, leather history and MAsT (Masters And Slaves Together).

Leather Market: $47

Today's mission in the Leather Market: Supplies for the immediate weekend. Cigars from the Hot Ash Booth (a bargain at $6 each), a great set of Army surplus coveralls for $19.99 and some seduction supplies for later tonight ($15 a bottle).

Lobby Lounging: $12

Another lovely night to stay in. You may need that nap after your day at the leather mart. You may also be lucky enough to take advantage of the many private parties on Saturday night.

This is also where advance work pays off. You have been working for weeks contacting individuals, lists, working chat rooms and introducing yourself to clubs and organizations. By now you could have a pretty full dance card with parties and private meetings already—but follow the rules of debauchery etiquette: **1)** If invited to a party, be a good guest. Respect the scene. **2)** If you make a date, follow through. **3)** If the date does not work out, be honest. It's very awkward when you tell him you are going to bed and then meet up with the same fellow minutes later cruising the same hallway. **4)** Be safe. Let someone know who you are playing with and watch what you ingest.

Sunday- $139 remaining

Brunch (+ tip): $16

Sunday brunch is to gay men like Sunday mass is to churchgoers. Leathermen are no exception. The hotel usually has a brunch buffet on Sunday. Advantages: All you can eat, you don't have to leave the premises and it is likely to be a solidly packed, friendly, leather crowd.

Sunday Paper & Coffee: $3

It is my habit to spend Sunday morning meandering slowly through the Sunday paper with a cup of coffee and I see no reason to interrupt my habits merely for IML. Except that the paper is the Chicago Trib instead of the SF Chronicle and instead of my living room, I am encamped in the hotel lobby greeting dozens of men in various stages of undress and restraint (which only rarely happens in my living room).

Private Victory Party: $0

Forget the official victory party. Over 50 men are expected to compete for this year's IML. Only one will win. That's a lot of crushed, frustrated, mostly naked men to console. Hang around the host hotel lobby where the party will be continues until dawn...or until you move it up to your room. If planned correctly, your weekend and your room supplies should run out at roughly the same time, leaving no waste and no half-empty bottles to pack back home.

Monday- $120 remaining

Breakfast (+ tip): $10

It's a federal holiday, so selection near the hotel might be slim. Still, you should be able to get a continental breakfast and coffee before you pack and check out.

Tip for Hotel Staff: $20

Being frugal is not the same as being cheap. The maids have been conscientious and courteous no matter what they found hanging from your ceiling. $5 a day is a minimal tip for their efforts.

Leather Mart: $60

Take one, last, quick cruise through to see what bargains are available. Has that $120 leather shirt come down any? Sometimes it's worth it to an exhausted merchant to save on shipping the stuff back home and sell to you for a discount. I usually find at least one very basic piece of leather at a bargain, last time a $180 leather hat that was reduced to $60.

If the piece of cowhide you had your eye on is sold out or is still out of your budget, don't despair. Collect business cards from all the merchants you are interested in doing business with and mail order it in time for next IML.

Taxi To Airport (+tip): $17

You have been a very, very good boy. Since Midway is within the taxi's flat-price zone, you can afford to reward yourself with a taxi instead of the train. Pat yourself on the back: If you flew into O'Hare, this cab ride will cost $40(+ tip), one-way.

$13 remaining

You could take your thirteen bucks and put it a savings account for next year, but with today's interest rates you'd earn about six cents in twelve months. Better to have a double martini and rent headphones on the plane home. Considering the many things one could return home from IML with (or without), if you come back with money in your pocket, mark it a resounding success.

II. You Only Hurt The Ones You Loathe *Notes on Relationships*

Advice For The Ambitious Single Slave A Basic Primer In The Pursuit of A Collar

Assuming you have already done all the preliminary soul-searching, experimentation and perhaps some basic training, you finally decide you want to seek a "24/7" (that's 24 hours a day, 7 days a week) slave position.

You are really serious about this. It isn't just a temporary fantasy. You are ready to make the commitment. You have the experience, the desire. You want to move beyond one-night and weekend scenes. You know just why and what you want out of a life of servitude. You have the attitude. What is missing? The Master.

Just One Question

The most common question that was asked when I began to write this was: "Why write about 'Searching for a Master?' why not 'How To Find A Slave?'" Well, it's like this. One of my favorite bottoms and an expert at statistics (and a boy who knows better than supply me with bad information) ran a very unscientific survey of the San Francisco leather community. He estimated that out of 100 leathermen here, only 4 are likely to be 80% top or more. Allowing for the psychos and the already married, in pure marketing terms, the ratio of slaves to potential Masters are several hundred to one. Sirs, we do not need ways to search for more slaves, we need appointment secretaries.

For the purists, please note, I serve a very demanding master: The English Language. That is why you will not generally see "Master" with a capital "M" (unless it refers to a proper noun), and just as it unnerves me to use lower case to refer to submissives, as is community custom. This article is the one exception that seemed appropriate and was covered under a special extension of my artistic license.

Sprucing Up The Property

Dating and jobseeking workshops both agree: Sell yourself! How much more true are these words for a slave putting himself on the market. It's a tough market out there, so how does potential chattel go about creating an attractive and competitive product?

This goes beyond a little gym time and a fresh hair crop. Are you prepared for service? One of the very first screening questions I ask is, "What is the primary duty of the slave?"

Correct answer: To protect the property of the Master.

It is your first duty to look after the property (you) for either your current or potential Master. To maintain it and improve it to the extent you are able. How can you serve if you are not at full capacity? How do you expect a busy Master to want to take possession of property that you yourself do not respect or value? So, what does the property need? A couple of night courses? A little additional self-esteem? The removal of some excess baggage? Before putting the property on the market, enhance the value with a little "home improvement."

The Top Species

As a general profile, a Master has had to have some time to work through issues of identity, coming out in leather and gaining the experience necessary to direct the lives and libidos of other men. Considering there is, in most gay communities a "missing generation" of sorts, this means most seasoned Masters will be in their late 30s (at the very least) and older (say mid- to late-40's).

The exceptions: I have seen a few men who shortcut all of that and become Masters of some repute by their mid 20's. In spite of fantasies of randy, strapping, young Masters, this is actually very rare. Even after one comes to the self-realization of tophood, it is only responsible to spend some amount of time learning the methods, techniques and precautions involved in controlling other men.

There are also slaves who would rather have an inexperienced Master to break him in right. How did you think Masters got trained? Other Masters?

Their Natural Habitat

Where do the Masters hang out? What are their habits? Where do they graze and hunt?

Logically speaking, a 22-year-old slave seeking a 45-year-old Master will find that their interests, habits and stomping grounds may be a bit different from his peers. You may have to do a little research.

More importantly: What qualities do you value in a master? Intellectual? Physical? Makes a difference whether you start looking in a gym or a SM literature group.

Some Sweeping Generalizations

There are some of us dinosaurs who still put in time at leather bars. Urban areas offer the environment and opportunities that breed accomplished Masters. Personal connections among networks of friends are still the most effective and reliable introductions.

There are gatherings such as International Mr. Leather (IML). The International Masters and Slaves contest would be another logical choice. Involvement in a local club, organization or leather group may not find you an owner immediately, but might just introduce you to someone who might introduce you to likely candidates. Don't forget community service as a way to meet potential tops, daddies, etc.

Internet

One thing that has leveled the playing field, particularly for players in isolated or rural areas has been the internet. Chat rooms, discussion lists, internet personals and cruising web pages can introduce Master to slave without the inconvenience of leaving your apartment.

Unless this is to be merely a cyber relationship, however, it remains fairly theoretical until that all important first meeting. Like classified ads and those familiar warnings about meeting men in bars, the facelessness of the internet requires that you carefully check out the object of your cyber affection. Is he known in his community? Do his former slaves speak well of him? Does his "mastery" exist in the real world or is it merely cyber hype? Is he who he says he is? Be smart, be careful.

Don't. Just Don't.

In seeking a Master, there are some things you just do not want to do. Among them, do not:

-Act like a pushy bottom. You can be a pushy bottom. As a matter of fact, lots of tops like a boy who knows what he wants and can make that known. Just don't act like a pushy bottom. Learn the art of convincing the top that what you want was his idea all along.

-Worry about offending him by checking a few facts. Any worthwhile potential Master expects that a slave will confirm he is who he says he is. It shows you are serious. The full credit and DMV check might be a bit much, though.

-Become a piece of furniture. No matter how well upholstered, you can't just spend all night quietly decorating the bar, expecting the perfect sir to come up and drag you back to his cave by your hair (which explains why long-haired boys are so appealing to neanderthals like me). You might actually have to take an active role and politely introduce yourself.

-Expect to custom order. Finding a Master is not like buying a new car: You pretty much have to buy off the lot. Other than the standard leather exterior, your choice of color, year, horsepower and accessories may not be available. Limiting your search to the Master you saw in the Tom of Finland drawing might preclude some of masterdom's best talent. Try to expand your tastes.

-Assume that your definition of slavery is universal or eternal.
Even once you have hammered out a mutual definition, don't
assume that it will stay the same. It will not start out identical, and it
will evolve from there. Keep talking. Keep comparing notes. Grow
together.

-Be too rigid. Learning to be a good slave is very similar to learning
how to surf: Don't lock your knees, stay flexible, keep adjusting to
changing conditions. Try to avoid ending up with your head buried
in the sand and the board up your ass. If you wipe out, paddle out
and try it again.

Don't get locked into "Well, a Master doesn't do THAT!" or "That's
not what a slave is supposed to do!" Stay tuned to what might be an
imaginative, new variation on an old theme. Learning to manage
your pain is only part of SM training— learning to manage your
expectations is much harder.

-Wear a locked collar around your neck. We've all seen this one.
The guy that wears his own collar, hoping to find the right man
to give the key to. Roughly the equivalent of keeping a wedding/
engagement set at the ready in your pocket and a wedding dress
in the car…just in case. If you're serious, wait for someone else to
collar you.

- Say that you "have no limits". This will annoy and exasperate a
top because it's just a silly thing to say. Of course you have limits. If
nothing else, the limits of how long you can exist without air. Know
your borders and express them in a way that is not whiney and keeps
the top where you want him: Interested and on top.

-Expect too much. Underneath it all, this is a relationship between
two human beings. Some of the dynamics will be the same as any
other domestic arrangement, but also don't…

-Expect too little. The intensity of a Dominant/submissive

relationship can unleash demons and angels other arrangements may not. Be prepared for revelations, not only about your Master as time goes on, but about yourself as well.

Leather Relationships, Part 1

"Every individual is a universe. Distinct in their own culture, evolution, philosophy, language and perspective. Life is a fascinating voyage of discovery among these innumerable worlds."

When Worlds Collide

When, however, two or more of these separately evolved universes decide to merge and share a two-room, one-bath flat with a dungeon and a garage, it can test the resolve, love, diplomacy and resilience of all concerned. The dynamics of any unconventional relationship— gay, leather, SM or one that simply defies the skyrocketing divorce rate— is a tightrope between practicality and fantasy, imagination and reality, discipline and compromise. The trick is often knowing where to draw the lines between all of these, and more often, when to ignore those lines.

In a column written during his year as International Mr. Leather 2000, Mike Taylor posed the question, "Can two leathermen also share love?" Well, if any one could, leathermen ought to. One would think that we could approach human relationships with more imagination, discipline and tolerance than anyone else.

There is a level at which running a household is pretty basic no matter who ties who up or who wears the flogger in the family (and on which side). The dog has to be walked, the garbage needs to be taken out, the bills need to get paid. Beyond the basics, these are just some of the observations drawn from years of watching the endless variety of relationships between leathermen. By no means a comprehensive and exhaustive study, hopefully this brief overview will be helpful.

There are, of course, too many choices and nuances to the millions of possible pairings to cover every permutation, so before I get a box full of mail saying "My relationship's not like THAT!" just let me say: "Someone's is." My other assumption is that one goal in

forming a "relationship", and one measure of success, is endurance. Oh, and love. . . I suppose. Wild weekends, temporary training, one night stands and other excitement aside, what creates a relationship that lasts?

Master and Slave

To begin a discussion about the rules and guidelines of a master/ slave relationship, you must first understand that there are no rules and guidelines for a master/slave relationship. The historical models stretch the entire length of the human experience, from ancient slaves in the Egyptian and Roman Empires to modern indentured workers. In the ancient world alone, the models range from gallery slaves that were mere propulsion to the major domo, a skilled and trusted administrator who ran the Roman household so the patrician was free to write poetry, plot against Caesar and throw up at the orgy. Some slaves had slaves of their own. What kind of slave and what kind of master did you have in mind? The American experience in slavery alone covered over two centuries and included, field hands, house servants, skilled artisans and overseers who were themselves slaves. Which model do you favor and which did your potential owner/property have in mind?

Did you think this would be easy? Some sort of set, standard, off-the-shelf rules that didn't require debate or decision, just blind obedience? Nope, sorry. Chains (and imagination) required past this point.

As it exists in our modern, SM community, a master/slave relationship is an artificial construct. Let's face it, slavery is illegal so any form that exists is a voluntary agreement between two parties. Many people sign contracts to outline their participation in the relationship. Such an agreement is glossary, a settlement of terms, but not primarily a binding oath. Since a slavery contract would be ultimately unenforceable (and unlawful) these two people are still only bound by the same thing all human relationships are

bound by: Trust and mutual needs for sex, intimacy, a sense of place and companionship.

Threatening to publicly label someone a "bad slave" if he breaks a contract is no help because: 1) The leather/SM community is notorious for not believing or accepting someone telling us what to believe, 2) the community has a famously short memory, and 3) many tend to see "bad slave" or "bad master" as a recommendation rather than a warning. You can't rely on the law or the community, so you had better arrive at an agreement that is enforceable because it meets the needs of all concerned and it works.

Clearly defined and immutable roles such as the sharply focused master/slave have certain advantages. In a relationship in which roles "switch" on occasion, it may be difficult to accept the powerful sadistic top one weekend as the groveling, abject pigslave the next as the same person. This is particularly important in couples who can't keep sexuality and domesticity separate at inconvenient moments like an argument over overdrawn house accounts.

On the other hand, a partner who wishes to explore another side of his personality (say, a master who wants to be dominated every once in a while) is usually forced to go outside the relationship or leave that desire repressed. There are those who argue that that is how it should be: "A chair is a chair and a chair should never try to be a table," one very certain elderly master once told me. "Just like a master doesn't try to be a slave and a slave doesn't try to be master." Appealing as that is to one's sense of order, its narrowness and ultimate impracticality bothers me and I find that leatherfolk tend to be more complex, curious and greedy for exploration. Still, I would never argue with what works for a man and his furniture.

The Slave

What are the characteristics of a good slave? Guy Baldwin once made the example of the perfect submissive as someone to whom

you would say: "Here is a budget. I want to take 4 weeks in August to visit 7 European capitals, see the finest museums, and learn all I can about Renaissance art. You will make the arrangements, tickets, take some courses and be able to answer all my questions. And I have every confidence that the hotels, transportation and information will be taken care of to my satisfaction completely, competently and without complaint or excuse."

Slave, boy or puppy— a submissive's capability, strength, intellect and wits are submitted to a master to make the master stronger and more capable. Submissive, therefore, does not mean inferior. Considering that a slave reflects his training (and therefore his owner) to the rest of the community, he is also a walking billboard displaying the triumphs or failure of the master. The idea that a slave is a worthless piece of trash does not reflect well on any master that would own such an object.

Some, but not all, slaves are masochists. Service may be the pushbutton, not pain.

A slave serves his master at his master's whim, not generally out of his need. Those who actually need slaves tend to hire minimum wage employees which is much less trouble and cheaper in the long run. Far from being a labor-saving device, slavery is a lot of work— for the master.

The Master

So, what is a master? Start by remembering that traditionally, "master" can also refer to a boy not yet mature enough to be called "mister." The more ambitious the goal, the more humble the beginning.

Many people decry "self-proclaimed" masters. In reality, there is no other kind. There is no certification, no SM review board that administers a standardized test for SMBD mastery. Only the Coast

Guard hands out Masters licenses (to captain a vessel). I have my own personal standards that you are free to dispute or accept:

A master should have mastered something. Men, a skill or subject, land, a vessel or at the very least his own demons and fears. A master commands by authority, he speaks clearly and decisively with no need to raise his voice, to be shrill, demanding or rude. The weight of his words and the fear of his displeasure are enough. A master is not rash. His skills and experience speak for themselves with no need for puffery, bragging or broadcasting. He is confident without being arrogant. He knows the difference between brutality and strength. He recognizes that ownership carries obligations and he takes responsibility for the consequences of his actions and commands without question or excuse.

A master can be a sadist, or not. Although his slave may not judge him, the rest of the world is not so constrained. And he will be judged, not only by his own life but also by all the lives that have ever been under his command. The master who attempts to treat the world beyond his jurisdiction (equals, superiors, community, potential future slaves) like he does his slave is heading for an abrupt and humiliating lesson. Ultimately, everyone is submissive to someone.

If a slave is defined by his obedience, a master is defined by how he uses and directs that obedience.

Stables (Harems)

I am always a bit skeptical when I hear someone say casually, "Oh, I'm currently training three slaves," and they don't look in the least exhausted.

Of course, I smile politely and say, "Isn't that nice for you?" but in the back of my mind it calls into question the master, the quality of the training and the mental acuity of the slaves involved. It seems

one could "handle" three slaves, "enjoy" three slaves, possibly "own" three slaves but not be "training" three slaves simultaneously in any manner that does justice to the term or the men. Not without at least breaking a sweat.

We have all read the improbable jack-off stories about secret "slave stables" where men are kept in servitude by rich and powerful tops, but that is not to say that slave stables do not exist. Just probably not as fiction portrays them. We have all known forceful personalities who thrive at the center of a circle group of sycophants, the one who holds court at a party while admirers pay tribute. In leatherdom, some dominants gather a stable of occasional, off-and-on, weekend or semi-consistent submissives that are drawn by sheer force of personality and sexual charisma.

The dynamic tends to encourage all the intrigues and plots of Byzantine courtiers competing for the attentions of the Emperor. As opposed to leather families, there is usually less equality and more rivalry in a stable with everyone vying to be anointed as "the favorite". The submissives revolve around one person, like planets around a sun, and have little to do with one another unless eclipsed.

Any cult of personality takes the right personality. The status of "stablemaster" is one of the most envied and often imitated, but it takes a unique personality (not to mention extraordinary stamina and independent wealth) to keep all participants satisfied enough to keep involved or else a steady supply of new "trainee studs" ready to take the place of those who move on. More often than not, I've found that stories of one's "stable of willing slave boys" are actually myth, wishful thinking, empty braggadocio or a just loose confederation of fuck-buddies.

Bringing fantasy into the everyday world is never easy and neither is preserving the purity of your fantasy in the face of harsh realities. It is perfectly understandable when some people simply enjoy fantasy as fantasy and therefore avoid the risk of shattering a beautiful and

delicate illusion by dragging it into a hostile world. For the rest of us, the key is to be dumb enough to keep trying and smart enough to recognize and enjoy the delights we find along the way— regardless of our overall success of converting fantasy to reality.

Leather Relationships, Pt. 2

It is no myth. There are some folks who can live a "leather lifestyle" every hour of every day. Maybe they work for a business within the leather community or have a very liberal employer. Maybe they don't need to work at all. Maybe they need no commerce whatsoever with the outside world and no reason whatsoever to step out of their dungeons or out of their hides. They have found a way to do what they want to do, how they want to do it. They are lucky people.

365/24/7

If you, however, have to climb off the bike every once in a while, maybe put on a jacket and tie, earn a little mortgage money, that's OK too. If you don't have time to keep 5 slaves in holding cells (not to mention affording that much Purina BoyChow) that's all right. Put down the tattered copy of *Mr. Benson*. You can be just as authentic, just as important a member of this community. Your possibility of finding a partner is just as great— possibly even greater— because most of us are just poor schmucks who love men and kink but still have to keep up our VISA payments, go to union meetings or shop at Wal-mart just like everybody else. Our leather hearts still beat under tweed or pressed cotton, we just have a certain balance to find and maintain between one world and the other.

We have discussed masters, slaves and stables, but what other alternatives are there in leather relationships?

Leather Families

For many of us, the first casualty in our voyage of discovery was any close relationship with our biological families. For us, the formation of "leather families" has been a godsend.

63

A common structure is a "triad" in which two tops are in a relationship with a submissive. It is not as common with two bottoms with a top, but I have seen it work. There may be an extended family beyond the core. The participants may share a house or live apart.

Like the stable, a leather family may grow up around one or two very strong individuals, but unlike the stable, the leather family is a network among individual members not just an entourage. They might be organized and carefully built or just accidental groups thrown together by circumstance. The close relationships between family members may not be sexual, but may grow and wane the way real families do. In the past 20 years my leather brothers and sisters have been there through death, divorce, triumph and tragedy.

Closeness does not equal happiness. Frankly, the closer we are to one another the more damage we can do which is why some people tend to distance themselves from other people out of fear. But if no one is close enough to hurt you, no one is close enough to love you, either. Experienced leatherfolk understand vulnerability, trust and pain in a way most other people can't. That is why leather families, with regular maintenance, patience and understanding, have enduring power to repair any damage.

Daddy and Boy

Daddies and boys tends to be the term used to describe much more nurturing, mentoring relationship between a dominant and a submissive. One should not assume that the "daddy" in a relationship necessarily has to be chronologically older than his "boy". One should not assume that the "daddy" is always on top sexually or even dominant in many other areas. I have seen some very fatherly younger men who take on some very boyish guys many years their senior.

So what really constitutes a Daddy/Boy relationship? Everyone seems to fill in their own details, but these might help you paint the broad strokes:

Daddies

Once upon a time, "daddy" was Ward Cleaver, Dr. Stone (Donna Reed's husband) and Ozzie Nelson. A man was the undisputed head of the household, the king of his own castle. Wife and children were both obedient and safe within his protection. The 1960's and 1970's shattered that idyllic, well-ordered world and presented new family images of equality and consensus rather than the divine right of a patriarch. The family had evolved.

In its most basic form, a dominant/submissive relationship assumes that one party brings more weight to the relationship than the other. There is a "senior" and a "junior" partner. This runs contrary to all the post-1970's "equal partnership" and "shared responsibility" in relationships but it recognizes one basic reality: We are not all equal. Individuality brings to the table unequal skills, talents, assets, income and capacities. The Daddy/boy relationship not only recognizes that inequality, but celebrates it.

A daddy might be a top or a master. He might be someone who has superior organizational skills, more wisdom in dealing with people, more talent with money, a more forceful personality. He might be the one who owns the house. For whatever reason, he has the position of senior partner. He assumes the greater authority, along with the greater responsibility.

Boys

Some one asked me recently, "Do you think I am a good boy?" He was very offended when (quite diplomatically, I thought) I answered that he seems to have very much his own definition of the concept of "boy" and I imagined an equally personal vision of what is "good"— so chasing after someone else's version or worrying what I thought was a waste of time.

"What the hell was that supposed to mean?" he asked.

If mine was the wrong answer, his was the wrong question. What the hell do you mean by "boy"? Many men prefer their boys to be a little on the "bad" side, so a "good" boy might not be a ringing endorsement. Once again, part of reaching an understanding is reaching a common definition— and everyone seems to have their own little twist about what a "boy" should be.

"Good boys" don't ask irritating and unanswerable questions.

I would hope that someone identifies as a boy because they are submissive and/or wish to be known as a student. Both service and learning have a nobility to be proud of. I would hope that they have not declared themselves a perpetual adolescent that will hide from personal responsibility and consequences behind the label. That's liable to just piss folks off.

Of course it only complicates things when people start cobbling together their own words and assigning them subcultural significance, like "boi" or "boyz" or "daddi". Please, it's tough enough to understand each other as it is.

For myself, I don't believe a boy is to be "seen and not heard". That is a waste of training and not a good reflection on any daddy that has been involved in his education and development. I expect him to be respectful and exercise good judgment-- but I expect that of daddies as well. Come to think of it, most of my irritation with boys has never been about their behavior as boys, but rather their conduct as men. Part of respecting someone is expecting the very best of them.

Partnerships of Equals

When I first came out, a popular question to ask gay couples was "So, which one is the man and which one is the woman?"

Recently I overheard a couple in the leather community being asked, "So, which one of you is the daddy and which is the boy?"

When asked out of idle curiosity, this question strikes me as equally intrusive and impertinent. If asked as part of application to join in a three-way, it should be asked in a way that will not be overheard.

Some successful relationships are just a happy joining of two lives with mutual interest and affections. Perhaps these two people do not pursue their fantasies together; perhaps they do but have simply not fallen into ironclad roles. Perhaps they do not pursue those roles as a couple— perhaps they just don't care to tell you. An alternative community should be the LAST place anyone need worry about criticism of an arrangement that works, one that brings happiness and contentment and which makes a contribution to society. That would include the choice to remain single.

Cultural Legacy

It may be considered heretical in some circles, but I have never been a completely enthusiastic supporter of gay marriage. I know all the social, political and economic arguments, but they do not answer the moral question of why gay families would want to buy into an archaic, bankrupt institution that seems to work for straight folks less than half the time. The essence, traditions, ceremonies even the language of marriage is that of a transfer of property— the bride— from father to groom. Some prize.

When two men or two women enter into a relationship, they must do so without the baggage of 5,000 years of roles and ritual. They are forced to define for themselves who shall fulfill each role, exactly how they will relate and how they will conduct their lives. Negotiation, reason, fantasy, practicalities, temperance, and love come together to create what tradition, religion and the law refuse to define. And I suggest, my friends, that they do it much better.

Perhaps the historical legacy of the modern gay movement lies beyond merely laying claim to the ruins of an institution whose time is past, but the ushering in of a new era in human relationships. In

this way, the variety and diversity of SMBD relationships make a powerful statement to the world. Our contribution to humanity— straight, monogamists, polygamists, gay, bisexual, pansexual, transgendered or questioning— is to forever redefine and expand the concept of family, who can form a human union and how much power church and state should have in those very personal decisions.

To Sir, With Ambiguity What The Hell Do I Call You?

We in the leather community love our titles. Not just "Mr. Topanga Canyon Leather 1989" and "Mr. Community-Unity 1997" but our "daddies", "mistresses", "masters", "slaves", "boys", "puppies" and "sirs". Almost the equivalent of strange dogs sniffing each other, two leathermen meet and watch for clues in titles and how they are used. Friend or foe? Poser or player? Rival or prey?

It's one of the first things you have to worry about as you begin to socialize in the leather community: What the hell do I call you? The answer— for an anarchy that can't decide if we are a kink nation, fetish tribe, leather family or SMBD practitioners— is not simple. Everyone seems to have an opinion about what they should be called and opinions multiply exponentially in regards to what others should be called. Someone I did not know once insisted I introduce him at a public function as "master." I replied that I would be happy to if he could prove he had an advanced degree or was certified by the Coast Guard to captain a vessel. Otherwise, no.

What you decide to print on your trick cards is one thing. What you want me to endorse into a microphone is something else. But what is the etiquette? What does tradition say?

When exploring custom, do not ignore the less-than-cordial origins of some of our modern politeness. Both the handshake and the military salute are done with the right hand because that was more often a warrior's weapon hand. The purpose was to check if the person you were greeting was armed— a useful activity which has parallels for anyone attending a Leather Leadership Conference. The purpose of clinking glasses after a toast was to mingle the wine in case one glass was poisoned. Also very practical, depending on the sort of folks you hang out with.

Confusing Good Breeding With Affection

So, we see that good manners are not always necessarily "good"—

or even benign. Remember, the Marquis de Sade himself was a cultured, educated, well-mannered nobleman. Social graces and sadism are pretty much intertwined.

A close friend of mine was raised among the old Southern aristocracy of Maryland. He was quite relaxed and informal with his close friends, but you could tell when he was annoyed with outsiders when his demeanor changed to an icy wall of courtesy. Dullards took his "Yes, ma'ams" and No, sirs" and unfailing politeness to be respect. The more irritating, the more polite. Civility can be either a stroke or a slap, a warm embrace or barbed wire.

Always check the wrapping. The sharpest of daggers can be delivered in a velvet-lined box. You can often tell the difference between insincere and idle flattery and true admiration by the package. In the same ways, it becomes almost a rare and exquisite pleasure to be pierced by a cunning rapier wit as opposed to hacked crudely by a meat ax of an insult. At least it shows you care. Alas, the art of being a bitch was much more subtle back in the days when one didn't say "bitch".

Choice Of Weapons

Consider the possibility that there might be many fine words that may be too casually bandied about these days: "diversity", "downsizing", "compassion", "empowerment". . . "sir". One might keep aside some words for special occasions to reserve their strength. Kind of like saving the really good obscenities for when you are really, really mad.

Choosing your words carefully indicates that you take the conversation, and the conversationalist, very seriously. Long considered a lost art, people who develop a capacity for deep conversation are at an advantage because they can express complex thoughts beyond simple up-down, yes-no, top-bottom, your place-mine. Negotiation over a scene, meeting potential partners for the

first time, rubbing leathers with other folks— these are situations where you want the best possible arsenal of language available. Communication, even before knot-tying, is among the first and foremost skills of SM. I say this mostly because I believe it but partially to encourage more young men to seek out charming, irascible, middle-aged writers as sexual icons.

Shaken, Not Sirred

With these things in mind: When you hear someone at a leather function being called "sir" it can mean many, many, many different things. Some men of a certain age insist it is done to make them feel over 50. The speaker simply could have been raised well and has not been in the leather community long enough to erase that civility. The speaker could have been in the military, where using the salutation became a habit enforced by iron discipline. They might be talking to a "sir" but not their "sir". They might be talking to a woman; they might be talking to themselves. At least one function I attended, they might actually be addressing a British knight.

To be absolutely proper, addressing someone as "sir" indicates distance. It can be distance, however, on two opposite ends of the social spectrum. In the first case, it is the proper distance of formality between two men who are not yet familiar. Strangers call each other sir until they get to know each other's position, rank, status— or name. In the second and opposite case, it is the recognition of place among gentlemen who DO know each other. A sign of admiration, of rivalry perhaps, a form of salute but once again, a recognition of respectful distance. In between those extremes, people address each other by last name, title, rank and as they get closer, by given name, an affectionate nickname or prisoner number.

The leather community tends to be a weird mix of over-familiarity and over-formality, by turns hugging and fucking total strangers yet at the same time employing a confusing rigmarole of protocol and hierarchy. Use of the word "sir" is an excellent example. Also

71

understand that some people break the rules because they don't know the rules— but others break them because THAT is a leather tradition much older that any silly rule. And some of us get away with it.

It should also be noted that once upon a time, leathermen adopted handles such as "Master Q" or "Daddy George" or "Boy Billy" or "Sir Mel" to protect their jobs and safety, in less understanding times and places.

On Your Own

As with most things in our long journey, we can only rely on rules, history, tradition, etiquette or other people's opinions up to a point. After that, you are on your own.

If you are unsure, ask someone for a formal introduction. This will get the job done (or allow you to blame someone else) and is certain to give someone nostalgic for the old days of protocol big goosebumps. Ask a few questions. "How do you preferred to be addressed?" Talk. "How is that spelled?" Explain. "I'm sorry, I couldn't possibly call you 'Daddy' until we established that sort of relationship. Please understand that the term means too much to me to be used casually."

You can be called whatever the hell you want to be called. That freedom, however, does not mean some people will not giggle when you introduce yourself. It will not magically clear up questions like "What's that supposed to mean?" or provide criminal penalties when someone says, "No, I won't be calling you Lord Master High Poobah of the Ultimate Sexual Existence. How about 'Poo' for short?" It does not free you from people reacting like people. If you really intend to converse with someone, it is much more important that you find something they can say without either wincing or tittering.

Patiently explain how you wish to be addressed. Patiently spell it

for folks when requested. Avoid getting bent out of shape. Listen to how they wished to be addressed. If we can't get this lesson of tolerance down, friends, there isn't much point looking beyond mere introductions to some of the tougher topics.

Lawyers, Guns And Money A Legal Guide To An Illegal Lifestyle

It happens more often than we want to admit. Public accusations, charges and counter charges, the nasty results of a scene gone wrong. It strikes at the heart of both a top's and a bottom's worst fears: An out -of-control, irresponsible top or a hysterical, litigious, injured bottom. Who is telling what portion of the truth?

Essentially, this is it, boys and girls: What we do is largely considered to be illegal. It comes under most definitions of assault, kidnapping, false imprisonment, sexual misconduct and a couple other dozen headings. Many jurisdictions do not require the "victim" of an assault to press charges in order to prosecute domestic violence. Charges are made in the name of the state or the people. This is good for terrified, battered spouses, but bad because the law often does not make a distinction between domestic violence and consensual SM.

We exist under a very fragile series of social contracts. A contract of trust is exchanged between the top and the bottom that keeps activity consensual, within the bounds of what each party wants or expects and a private matter of no concern to anyone else. I respect your limits, you don't have me arrested.

The kink community provides social and educational support in exchange for reciprocation and a little discretion. In the best of circumstances, the police agree not to become involved unless there is a ruckus. But when things go awry, we see just how fragile these contracts are. A few things to think about, now while the blood is still rushing to the bigger head:

Preventing A Bad Scene

There are many ways to improve your chances so that an encounter does not end up on Judge Judy or worse. Understand that SM is more than just technique and methods. Some folks seem to confuse

74

bondage with macramé, forgetting that there is another soul involved.

Of course it would be ideal if all SM practitioners were skilled and all knew their partners well enough to read them accurately-- but the possibility of heaven between strangers has always been about equal to that of hell between mates. Familiarity is no guarantee of flawless communication or flawless sex.

Don't rush. Approaching every scene as if it's your last chance at nookie increases the chances of your eventually being correct. It's like bridge…don't overplay your hand or that of your partner.

Just because someone begs you to do something to them doesn't mean you do it. Likewise, just because the master-du-jour told you to do something idiotic doesn't relieve you of the consequences. You are responsible for your decisions, not the lust, not the caffeine, not the liquor, not Twinkies, not the abuse you suffered in grade school or summer camp. There is only so much baggage that can fit in a dungeon.

Don't be stupid about chemicals. Know the limits of your own impairment, even if it is lack of skill or low blood sugar, and make your partner responsible and communicative about his.

Dealing With A Bad Scene

Allowing for some amount of "cool-down" time after an intense scene is not just a warm and fuzzy, afterglow, opportunity to cuddle or conduct customer satisfaction surveys. It is a very practical way of protecting yourself from the hazards of releasing a partner out on the streets whose mind has just been through a mix-master.

"Safe words" are not some sort of inauthentic, politically correct, soft-serve idea that breaks the mood. They are a very important method in the inexact science of gauging human reaction. Calling

to check up the afternoon after a scene not only shows you were raised right; it heads off his possible post-encounter bout of guilt or depression before it can explode.

Individual responsibility certainly applies to bottoms as well as tops, but as the active participant, the top is most easily seen as the perpetrator under the law. Many of these comments are targeted at tops (or switches that are working the dominant side of the street) because while bottoms might be physically at their mercy, tops are the most vulnerable before the law. The price of power.

The forces we deal with are very powerful both physically and emotionally. Most of us are keenly aware of the basic concepts to prevent sprains, disease transmission, etc. but ignore the importance of cleaning up the emotional aftermath of release. Would you walk off and leave a bottom still half-suspended? Examine his emotional state the same way you would check him over for cuts and bruises. Talk it out until you are satisfied that the invisible restraints have been unbuckled as well and follow-up if need be. This is particularly important if something went wrong or there was an emotional catharsis during the scene. It is part of being a responsible top, not to mention that you are the one walking around with your liability exposed.

Dealing With Injury

This is very simple. If you injure a bottom to the point that he requires (or will later seek) medical attention, and unless you have access to your own personal, discreet physician, you better damn well go with him to the emergency room. In this day and age, anyone showing up at a health care provider with injuries indicating assault, particularly domestic assault, will automatically result in police involvement. It is mandated by either domestic violence laws or the hospital's legal department.

If both parties are there to explain to the officer that the injuries were

the accidental result of consensual activity, you might get away with just a lecture. If an injured bottom shows up alone or if stories don't match, it is almost a guarantee of trouble. If there is any question whatsoever, insist on him seeking medical attention and take him yourself— for your own protection.

And just for the record, sending a bottom to the hospital should be a clue that something went wrong.

Dealing With The Authorities

Under normal circumstances, the authorities get involved with an SM in only a few ways. If there is injury, if there has been a complaint (noise, public lewdness, alcohol license violations) or if they really, really want to.

Even under the best of planning and the most discreet of activity, uninvited uniformed guests may crash your party. That is why, years before AIDS fundraisers, the leather community did regular benefits for legal defense funds. Is it an election year? Police commissioner under pressure to clean up vice? Over-eager rookie? Sometimes these things just happen and good people get enmeshed in the creaking machinery of the system. This is also the point where a united community can help.

It may be tough to believe, but we are much better off than just 20 or 30 years ago when the cops almost everywhere would raid gay establishments indiscriminately and recreationally. As Club X in San Diego has shown, a responsible approach to SM events goes a long ways towards thwarting even the most zealous guardians of public morality. Because San Diego seems to be ruled by a Southern California chapter of the Taliban, Club X has revised their already unassailable dungeon rules, policies and release forms, thoroughly checking them with a lawyer.

This raises a good point: If you had a chronic medical condition,

wouldn't you seek out specialists who would be in place and ready to assist if the condition worsened? If this concerns you, you are addicted to risk or you live in a particularly intolerant jurisdiction, you might consider seeking the advice of understanding counsel before you actually need it.

Individually, as a couple, in a group or an event— know the law. Even though you will see naked folks during the Folsom Street Fair, it is illegal to take your clothes off on the streets of San Francisco. You risk arrest if you do so, and that must weigh in your decision. What sex toys might not make it through a customs search? What silly indiscretion could lose the local leather pub its liquor license? When there is barely enough sympathy to go around for victims abused by the law, it is not reasonable to expect immunity after you casually annoy the law.

Be a responsible top and be a responsible neighbor. Watch the noise, park carefully, see to your bottom and cover your ass.

Dealing With The Community

As a member of a community, you also have a pact with the tribe. The results of that contract can mean anything from fundraisers for your legal defense fund to a full-blown lynch-mob complete with burning torches.

When lurid headlines hit local and gay newspapers about "SM Slave Rings," "Leather Assault Investigated" and "Sex Dungeons" written by clueless reporters, the entire community scurries for cover. Any unfortunate left in the open is targeted to explain the inexplicable and inexcusable behavior of others. Because they didn't scurry fast enough, because they are identifiable members of the community or because of their position, they always seem to get the honor of cleaning up after others. Don't be surprised if their first priority is damage control and not your delicate sensitivities.

Of course, the surest way to ensure that the community stays out of your business is not to allow it to become community business. Don't be stupid. If you do something stupid, keep it out of the papers.

A little logic: Don't expect an outpouring of unquestioning support when you have carefully crafted a reputation as a tough, sadistic, over-the-top, edge player. Likewise, if you are an abject pig bottom who likes to show off deep, bleeding welts, expect some skepticism when you file assault charges. This is not to say that either party does not deserve recourse to the law or the support of the community— just expect people to react like people.

The late Warren Zevon wrote a song that went *"I was gambling in Havana. Took a little risk. Send lawyers, guns and money. Get me outta this."* Sure, it happens when Republicans are in office, but no one should seriously count on the Marines to rescue them from the results of their own decision to risk odds they already knew.

Dealing With Responsibility

Of course, you can choose to take or ignore whatever precautions you wish. You know the rules. You know the difference between consensual and nonconsensual. You know the line between SM and abuse— and if you don't, don't participate in these sorts of activities until you do.

Scenes go wrong. Be responsible. Maybe you went a little too far, maybe you bit off more than you can chew. Don't ask for more than you can handle, don't inflict more than you are willing to put right. Deal with the consequences- even the ones you didn't foresee. Fix it. Handle it. We don't want to hear about it, read about it or clean it up.

In Leather We Are Family ...Then Again, So Were The Borgias

The Borgias were the original dysfunctional family. A noble Spanish clan, they relocated to the fractured rivalries of late Renaissance Italy. The most celebrated family members were Rodrigo (later Pope Alexander VI), his son Cesare (later Duke of Milan), daughter Lucrezia (later Countess of Pesare, then Duchess of Naples, Lady d'Esta, etc). The Borgias were notorious plotters using incest, arranged marriage, swords, garrotes, small armies or poison to enforce their wishes. Mario Puzo (author of The Godfather) said that he modeled the Corleone family after the Borgias. The Borgia name became synonymous with amorality, corruption, schemes and plots-- and brought a whole new meaning to the concept of "family values".

The poet Pasquino wrote this epitaph for the Borgia Pope:

Sextus Alexander iacet hic: conduntur et unalque coluit: luxus, lis, dolus, arma, neces which translates: *Here lies Alexander VI. With him is buried all that he worshipped: Luxury, discord, deceit, violence and crime.*

Our leather tribe/nation/community/anarchy/whatever is often described as a family, but sometimes we seem to have a talent for spinning intrigues and machinations that are much more Borgia and much less Brady Bunch. Then again, perhaps it's part of being of a generation for which the mention of "family" can just as easily conjure the word "Manson."

In 1541, some 38 years after the death of Pope Alexander VI, Michelangelo completed the *Last Judgement* on the altar wall of the Sistine Chapel as a brilliant, biting commentary on contemporary morality. Along with caricatures of other famous 14th century glitterati headed for either heaven or hell, the artist did not hesitate

to paint himself- among the damned. A word of warning: If you think you find yourself or your fellows among my portrayals of the different twisted branches of our leather family (or even combinations of two or more), great. I hope you find that illustrative, but most often when I am accused of writing about some individual with a poisoned pen, I may actually have in mind my own demons and damnation.

So, let's meet some of the family:

Our Surviving Sibling

Our Surviving Sibling has seen it all: plague, wars, oppression, pestilence, time. They were there on the front lines, marching for our rights, fighting city hall, throwing fundraisers, delivering hot meals and going to many, many funerals. They are understandably tired, tapped out, suspicious and protective.

A younger generation backs away because they see only hostility. They see the shell that is left after the last 20 years have robbed our bothers and sisters of the carefree, happy times they thought were still before them. But look closer: These are our heroes, our heart. They had to interrupt their leather journey to become caregivers, activists, fundraisers and mourners. They kept the family alive.

Those survival skills now, however, can become counterproductive. A "bunker mentality" does not allow new people in, is distrustful of change or new ideas. New additions to the family may be subjected to blistering interrogation, testing, resistance and scrutiny. They mean well, but it makes bringing a new date home seem more like the Inquisition. After years of vigilant and heroic service, it is not easy—and we often just don't have the heart— to convince them it's time to pass guard duty on to someone else and take a well-deserved rest.

Our Darling Daughter

The Darling Daughter (or DeeDee) can get away with anything. She gets every award, she is recognized at every event; she is on every "A" list. The party is simply not complete without DeeDee.

Unfortunately, praise, like blame, often does not need to be deserved to be given. Or given lavishly. People get lazy, and when they think they should appear grateful they do what everyone else is doing and spin off a plaque or two to the same people that the last group honored.

Alas, the spotlight moves on eventually. The community finds someone else to be their darling and poor DeeDee is left on a dark stage wondering what she did to deserve such a fuss then and why is there no applause now? What did she do wrong? She either learns to deal with it and how to do praiseworthy things for rewards other than praise, or else she spends the rest of her days trying to recapture the adoration of her fickle family.

Our Crystal Sister

Let's be honest: We know there are drugs in our community. We are an outlaw subculture, so it is hardly surprising that chemical experimentation has gone hand-in-hand with sexual exploration.

And there is a close association in our family with bars and booze. It's like the family business and 9 times out of 10 it is an unremarkable, uncomplicated relationship. Except for our Crystal Sisters, named for both the popular substance and for their highly breakable nature.

Many of our Crystal Sisters are successful, productive members of society who can function just fine self-medicating for years without much consequence. But then we know that there are those who cannot handle substances, for whom their addictions take over their lives. Now, I don't know what the difference is between someone

who is a functional user and someone who is a dysfunctional addict. I'm not a substance abuse professional. I don't know the physiological or psychological triggers. I just know what it looks like when it gets out of hand.

We need to offer them help but it is not easy. While under the spell of the drugs or alcohol, nothing is more important. The rest of family can't win: If you do nothing, you don't care. If you try to help or intervene, you are the enemy of their personal freedom. And we leatherfolk value our personal freedom. Even after a successful recovery, some Sisters are still wearing the experiences like a cross, reenacting their endless Calvary as if addicted to recovery as much as they were addicted to the addiction.

Our Kinky Cousin

For the Kinkster, nothing is as important as getting his rocks off. It is really that simple. He's all for family and community as long as his efforts eventually result in the sexual scene he has in mind. Others can keep the spotlight, the recognition, the socializing, the altruistic sense of accomplishment as long as he gets to make it with the stagehand, the usher or the bartender.

He is refreshingly uncomplicated. The family is very one-dimensional to the Kink. It merely exists as a vehicle to get laid. Once you understand that he has absolutely no intellectual, social, spiritual or political level to him, he will never disappoint you. It's like dangling meat in front of a dog to ensure his loyalty-- as a matter of fact, it's just like that. Just keep plenty of meat on hand.

Our Second Son

The Second Son has always come in second place in everything. He is constantly overlooked. He seems to be invisible when attention or awards are handed out. He has never been president of the local leather club, just treasurer or recording secretary. He is not the titleholder, but every year he sets up the chairs for the contest. He is

the one most likely to clean up the messes left behind by the other, less tidy family members.

It doesn't matter to him. He is sincerely happy for his older siblings and their accomplishments. He is not looking for rewards or acclaim, he is content to be a part of the family and proud to do his part. He may be either top or bottom, slave or master, but he is truly fulfilled in service. Sometimes he wishes perhaps that someone would recognize the good that he does (even just to affirm that what he does is good), but in reality, he shies from the spotlight. He is comfortable in the background and a personal "thank you" is worth more to him than titles, engraved plaques and certificates. Just because he himself shuns glory, however, does not excuse the family from taking him for granted.

Our Narrow Nephew

This is a serious, very focused young man. He has read all the right books and can quote chapter and verse. He still thinks he has an active subscription to *Drummer* and *International Leatherman*. He takes his news from the *Leather Journal* and his gospel from the *Leatherman's Handbook*. He is quick to tell you what is "not real leather" and what is— whether you asked or not.

He sees nothing beyond the immediate confines of the leather family. He has invested everything in the leather community and is bitterly disappointed at his paltry return. His failed relationships are because "leather relationships don't work". His feelings of unfulfilment and lack of direction are because "something has gone wrong with the leather community". Certainly it has nothing to do with the fact that his models are of another generation. He reads the story of leather blind to the more complete context of history or humanity. He is like the man who recites the words of poetry flawlessly, but the joy of the poet is lost on him.

He measures the world by a *Mr. Benson* yardstick of 30-year-old

fictions and fantasies, not seeing that the world is larger than his dungeon—and it has moved on.

Our Ozone Aunt

How to put this politely? Auntie is a few feathers shy of a duck.

Most of the family is a bit dotty but Auntie is way, way around the bend. Like our Narrow Nephew, she lives in a complete fantasy but unlike her nephew, Auntie is not bitterly divorced from reality. She and reality just took different off-ramps somewhere and she never did find the freeway again. The family can find her frustrating because she does not operate by the normal rules and she considers herself immune from the normal consequences. Auntie trusts a little too much, believes a little too easily which is, sadly, a very dangerous habit in the world the rest of us must deal with. Still, she is a precious soul and it is our job to watch out for her, to rescue her when necessary and to protect her because she cannot conceive of the danger when her world occasionally collides with an unyielding reality. She requires patience, but in a way, we need her as much as she needs us: Her lunacy can help make our reality bearable.

Our Crying Cousin

The family's chief emoter, our Crying Cousin bursts into tears at the drop of a hat. She "LOVES" everyone and is so effusive with praise and affection that her approval is universal even to those who should never be approved of. We all know she has a good heart, but the display of her feelings is so often and so over the top that it rings of insincerity. As she grabs the microphone for yet another endless and maudlin eulogy or toast, eyes roll and silent prayers are lifted for a strategically timed rolling black-out.

She is a Three-Oscar Drama Queen, with a Golden Globe and maybe a People's Choice nomination thrown in.

Her personal life is just as much a roller coaster. She marries and

divorces, changes jobs, apartments and moods faster than most can change their boots and she cannot separate commitments to career or community from her tumultuous personal life. While we were all quite supportive of Cousin's delicate condition(s), her participation in family functions (and life in general) is entirely dependent on where she is in the peaks and troughs of her emotional waves. She abhors calm and tranquility like nature abhors a vacuum, going so far as to borrow a cup of anxiety from others from time to time. She's too busy being busy to be reliable.

Our Uncle Iago

Fans of Shakespeare will remember Iago as the manipulative plotter who had nearly everyone killing off nearly everyone else by the end of *Othello*. The leather family, unfortunately, has its share of back-door schemers, gamesmen and would be puppeteers.

Uncle Iago operates in the guise of your best friend, gaining just enough personal information to use against you. After that, an e-mail here, an innuendo there and he spins a dark cloud over you that you can never quite dispel. He is insidious, convincing and charming. He relies on a flattery, a soft word, the seed of doubt planted and nurtured. When confronted or caught, he is the picture of innocence— and stammers unconvincingly that he is only selflessly doing what is right for the family.

Others may scheme for profit, power, sex or advantage, but Iago plays his dangerous games for the mere sport of it. He destroys, not for gain or to build something else in its place, not even for vengeance, but just because he can destroy. Recreational ruin. He is a sociopath and a danger to the community.

There Really ARE Stupid Questions Less Than Inquiring Minds

During the Spanish Inquisition, prisoners under torture were often told, "Answer well and live." A leather career is often divided in two halves in which the first half is spent asking questions of others and in the second, one is answering the questions of others. Even the most patient, seasoned mentor can, after hours of pointless, ill-conceived questions, scream (if just inside his own head): "Ask well or die!"

Having a background in both leather and journalism, I can tell you absolutely, categorically and unequivocally—there are stupid questions. If, after a couple of leather contests, you still doubt this, watch almost any press conference and remember that these are professionals who are specifically trained and paid to ask questions.

That being said, there is often no sin in asking a stupid question. It is just, well…stupid. In the long run it really makes no difference to the rest of us and it usually makes the guy answering the questions look more brilliant than he actually is. The worst damage is to oneself and one's pride. So, assuming that appearing a little less dim would be a laudable goal for almost anyone, you may want to review what you ask:

1) Questions you have already been told the answer to. The first or second time you ask a question that has already been answered for you, it might be investigated as a hearing or an attention deficit disorder. If you are asking for the fifth or sixth time, your concentration, motivation and intelligence may be questioned. If you ask the same damn thing for the eighth or ninth time, it is going to become obviously rude and whomever you are asking may be justifiably moved to violence.

2) Questions that contradict your own claims of expertise. If you were to ask a question about simple addition or subtraction in your post-graduate mathematics class, that could be legitimately

considered a questionable question. If you claim to be a professional, a teacher or a master at your craft, you are expected to know some of the basic level information for that discipline. It is only understandable that requesting really basic information raises some doubts about your qualifications.

Leather Community Cautionary Note: When you find that the level of your self-proclaimed expertise and the level of your questions are at odds, you cannot automatically assume that it is your question that is stupid. It might be your self-proclamations that need adjusting.

3) Questions that are inappropriate to the situation. Back to our example, let's say you forgot momentarily that 2+2= 4 in the middle of your advanced math class. It happens. But in a public situation like that, mindful of your own reputation and in consideration of your classmates valuable time, perhaps you should ask your remedial question of the professor privately, after class.

A perfectly legitimate question can become stupid when asked of the wrong person at the wrong time or place. Some questions are simply dumb because they were asked in front of an audience. When in doubt, be discreet.

4) Questions asked by the blatantly lazy. The best way to illustrate this is someone who asks how to spell a word while sitting next to a dictionary. There is a fine line between asking for help and asking someone to do your work for you. Don't cross that line too often and if you do, show the appropriate appreciation.

5) Questions asked without sufficient thought. The following are actual questions asked by actual lawyers during actual trials:

"So, you were gone until you returned?"
"How long have you been a French Canadian?"
"And how many times have you committed suicide?"
"Were you acquainted with the deceased before or after he died?"

"So, when your husband woke up the next morning, he was dead?"

Lawyers charge hundreds of dollars an hour in a process for which they cannot absolutely guarantee the specific desired outcome. If the answers are ultimately up to fate or a jury, seems to me folks have at least the right to expect that these guys can ask a question. Someone might be expecting the same of you. Think it through.

6) Questions asked to the wrong person. The person at the help desk, the teacher, the fact checker, the resource manager, the spokesperson or salesperson— it is their job to provide you with answers. It may not be your co-worker's job, your friend's job, your spouse's or the guy you are chatting with online…and it is certainly not the guy in line ahead of you or the one trapped next to you on an airplane. If it is an emergency or if they offer to help, fine—but for the most part, leave these poor people alone. Some people see no limit to how much they are willing to inconvenience others for their own convenience.

7) Questions that are actually speeches. Now, there are many types of questions that are not actually inquiry. Rhetorical questions can be a useful, probing tools but are not meant to receive a substantive response. Philosophical questions can nicely frame an argument or statement even though they have no real answers. But don't overdo it. It is a device that should be used sparingly because it quickly becomes obvious and tiresome.

8) Questions you refuse to accept the answer to. Some people are given eye-witness accounts, signed affidavits, court reports, receipts, 8x10 glossies and surveillance tapes in the course of answering their question and still say, "Nope. It didn't happen that way." If, in the face of overwhelming evidence, you will still choose to believe what you want to anyway, don't bother asking in the first place.

Like I said, stupid questions don't often have fatal or cataclysmic consequences. It's just stupid and, after all, humans will tend to

do stupid things. The trick is not to do them more often than is absolutely necessary— and with questions, the best way is to take the extra time and effort to think it through, consider if you might already have the answer, determine that it is an appropriate time, place and person, limit your question and be fully prepared for the answer.

Finally, remember that there are the times when the questions are important. It is vitally important that we ask and ask well. Some disciplines of philosophy, theology and science are nothing but questions. Sometimes the integrity of the inquiry, the credibility of the process is more important than the outcome or solution. Some questions take courage to ask. Some questions are more important than their answers.

With a well-placed question, a surgeon has the additional information to save his patient's life or avoid a fatal drug interaction. A little more thought put into one or two questions could save the lawyer's client. A clearer question about the intent of a bill before your representatives might prevent a homophobic law from being passed. Asking a few questions about an intense bondage scene is much easier before the ball gag goes in. Asking "Are you positive?" in the right way and at the right time can change your life...or perhaps not.

Rumor If You Can't Say Something Good, Say It Repeatedly

Since nearly the beginning of my leather journey, there have been folks who enjoyed telling tales about me. Some of the best ones, I started myself. Often my reputation was having a helluva lot more fun than I was.

Rumors are a difficult problem in our community. We must make hard decisions when we pass along information about a potentially dangerous top, an unstable or litigious bottom (just for example) or a titleholder who probably should not be invited to judge or speak in public. When safety or integrity is truly threatened, that information must be passed to the people it most effects discreetly and confidentially. It is important as a community that we have that level of communication.

So much of the information we pass along about others, however, is just inappropriate and unnecessary. Much of our loose talk is justified by "Well, people should know!" or "It sets a bad example!" or "Inquiring minds want to know!" Pshaw. We are a community that began in dungeons, bars, alleys and other dark places, who revel in pain, humiliation and sadistic ritual (and that's on a good weekend). When we judge people from outside a situation, we can be as ridiculous as the prudes who judge our behavior "sick" from their narrow perspective. The antithesis of leather honor is this recreational, nattering gossip.

Nonetheless, it seems to be an intractable part of our community. Some of you are just starting out on this journey and are shocked at what people say to you and about you. I would like to tell you that they become easy to laugh off and that after 20 years or so, they won't bother you. From my experience, I'm afraid that I can only tell you that it is part of trying to make a difference in this community and if you ever become completely numb to it, it's time to get out.

91

The Place Where Rumors Die

Of course, the place where rumor dies is where it is passed along to you. You have the option to stop it cold. When you hear talk about others, ask a series of questions—and not just "Is it true?" It is not the truth of the matter that is at issue, but ask yourself (or those who are talking) what business this it of theirs? How does it really concern them? Even if the story has been passed correctly, even if the facts are intact, even you can confirm it first hand, what is to be gained?

A personal example: Some of the talk about me has been about my drinking (one of the few useful skills I left the Navy with). The story is that my intake of alcohol in some way correlates to my output of writing, to which I must confess that 1) I have more often written while naked than while drunk, 2) I might have, once or twice, been guilty of TUI (Typing Under the Influence)—but I always edit sober, and 3) even if I were out cold, I could still out-write the talentless hack who passed the story along. But really, unless you are buying the next round, it's none of your concern.

The difference is, I can talk about myself—even in unflattering terms. That is my right. It is not yours. And if anyone wonders, what I type is generally kinder after an aperitif or two. Where I get in trouble is being too direct after the third cup of coffee and before the fourth.

There are many ways to handle the inevitable situation of rumors being spread about you:

Confrontation

It is tempting to plan a dramatic confrontation with someone spreading stories about you. If you insist on this path to assuage your wounded honor, I would urge caution. Leatherfolk being as they are, at one point the thrill of drama overtakes the pursuit of justice.

We are talking about very subjective feelings and reactions here. Even when confronted with indisputable truth, some people will always harbor a lingering shadow of a grudge.

I simply do not have the time to arrange, meet and reconcile with everyone who thinks they know "the story" about me (or makes one up). I have no time for them or the people who listen to them. I am happy to answer any question people might have about me, but when they ask everyone *except* me— they obviously have no interest in truth.

Protestation

It is natural to want to protest, to issue a rebuttal, to release a "public statement" as if you were the White House Press Room. Unless you *are* the White House Press Room, I recommend not.

At this point, one usually hears the quote from Shakespeare: "Methinks the lady doth protest too much!" I much prefer Emerson: "The louder he spoke of his honor, the faster we counted the spoons." Greater volume, repetition or wider distribution of your defense can often have an opposite result.

Rumor has a life of its own. I've found that making efforts to squelch it merely gives it (and the rumor mongers) credence and by the time you squash it among one circle (even the original source), it lives on somewhere else like crab grass. Incurable gossips are not interested in the truth— particularly if the truth is duller than the story or if it requires they admit that they were wrong.

Better to disprove the rumor by example, by continuing to be the person you are. You might also reevaluate how important it is to you to be "popular" with folks who would gladly believe the worst about you.

Motivation

There is a curiosity to understand why people want to gossip about others. Maybe these people lead such excruciatingly boring lives that *anyone* else's seems preferable to talk about. Maybe it is our natural reaction to knock down heroes and find the "feet of clay" in anyone who dares stand above the crowd. We know that heroes can never live up to our unrealistic expectations, so in this way we can manage our own disappointment. It may also be as simple as hoping that one feels taller after cutting every one else down to size.

Some of it may be proving that we are privileged to have certain information that is not common knowledge to others. Information is power. Your level of information defines rank and status.

There is a fellow I know in our community who delights in showing off the fact that he knows this famous leatherman or that well-known personality. He does this, however, by starting off with "Who? That old queen?" and launches into how each of these community figures is unworthy of your admiration. This has always seemed to me to be counterproductive; if one is living vicariously through the reputation of others, one should be building up their currency—and thus, one's own by association—rather than tearing them down. The obvious question becomes, "If this person is so terrible, why do you brag about knowing them?"

Neutralization

My preferred method for dealing with gossips is to remove any lingering secrets that might be interesting enough to talk about. No secrets, no news.

Another way is, if you know there is a story circulating about you, tell it first before anyone else can. It then loses value faster than 25 shares of WorldCom stock.

And really, what could they say about me? Six years tramping

around the world, 14 years in exile in the Midwest. Published a gay, SM smut magazine, a few more years tramping around the world. I've written about my sex life in dozens of fiction stories, I have made no secret of my likes, dislikes and my opinions— so take your pick. My readers already know the worst of me. Sure, I've knocked around some, made my share of mistakes and there might be one or two things I haven't already mentioned…but it's not like I'm hiding something really awful like a felony conviction or a law degree.

The advantage of leading an openly perverted and honestly dissolute life (known to some as "owning your own shit") is that it makes you pretty well bulletproof from petty gossips.

But my very favorite method of dealing with the vicious rumors that have spread about me over the years: I have outlived most of the gossip and nearly all of the gossips.

III. A Disciplined Anarchy *History and Community*

Advice For The Ambitious Leather Columnist

"The difference between journalism and literature is that journalism is unreadable and literature is not read." -Oscar Wilde

Journalism, politics and prostitution are said to be the three professions most often ruined by amateurs. On the other hand, these would seem to be three professions where some new positions and fresh faces should be the most welcome. Each year, just a little after the contest season, there is always an eager new crop of leather columnists and writers. Within a few months, most are burnt out and their words slowly fade away from newspapers, newsletters, websites or weblists. Many get discouraged after the second or third scathing critic or after a few missed deadlines. Some didn't realize it would be this much work or expected maybe the community would be grateful for their efforts. Some lacked the discipline and some, we suspect, simply ran out of things to say.

Why it is that people think they can write for publication right off the bat with no training, no experience, no direction? Does anyone in their right mind decide one day after watching the Health Channel: "That surgery thing doesn't seem so tough. I'll just perform Dad's operation myself." Or do they act as their cousin's counsel after watching a few back to back "Law&Order" and "Matlock" reruns? Assuming that you can write well just because you can read well makes no more sense than assuming a good drunk necessarily makes a good bartender.

Like any other craft, writing is a skill that is learned and honed. For the most part, this sort of writing is not magic, there's no trade secrets outside of study and hard work. The tradition of community journalism goes back to small town newspapers who looked after the day-to-day concerns of small, isolated, tight-knit settlements. The proud lineage of advocacy journalism includes William Lloyd Garrison and the crusading abolitionist press that brought down slavery.

Community Journalism

Many years ago, I taught Journalism 101 classes at a suburban community college. Most of my students, if indeed they actually did pursue employment in newswriting, were likely to write for small, local community newspapers. Of those who didn't, some ended up assigned to write their employee newsletter, company press releases, or volunteered to write the newsletter for the local Lions or Jaycees. This was the early 1980's, and although everybody loved the Woodward and Bernstein ("Investigative Reporting") portion of the course, the "Community Journalism" section was eminently more practical.

Now there is the Internet— Man's highest achievement in communications. Twenty-eight million websites all screaming into the cosmic void: **"I EXIST! . . . and I have a cat."**

In essence, twenty-eight million community reporters. The medium has changed, but the dynamics and principles are the same: Community reporting involves serving a specific, narrowly focused, limited audience. There is still the challenge of placing that limited community in the larger context of the world (the old "local angle"). There is still information and language that is native and specific to that community, which either must be understood or translated for outsiders. People still like to read about themselves or someone they know and see their picture.

There are ways to make the job easier and ways to make it harder. The most fundamental way to make it easier is to not do it all by yourself. Chief cause of burnout is the time, energy and expense of rushing from one event to another, but veterans do not actually attend every event they report on. Those who survive many years writing community news have learned to use a network of sources: Friends, club corresponding secretaries, marketing and press managers, bartenders, titleholders, etc.

Too many people (including some reporters themselves) see the leather community reporter as an all-knowing, all-seeing dispenser of wisdom and information from on high. Top-down kinda guy. More realistically, he is a harvester of bounty grown by others, who mills, refines and bakes the information into an accessible and tasty presentation for his readers. You can (taking the bakery analogy really much too far) end up with sweet, spicy, crusty or flaky results.

Advocacy Journalism

Many leather/SM columns, and indeed many gay publications, started as angry, activist shouts of defiance against mainstream media who either ignored or demonized anything to do with us. Today, a large number of gay and lesbian reporters work openly in those big, established mainstream media outlets that most of us rely on for our daily diet of news. Some news organizations even have a gay/lesbian news desk. Homosexuality is no longer completely ignored, rarely demonized and available through national and international media almost everywhere. This causes something of an identity crisis for the gay press with some voices declaring victory and proclaiming that there is no longer a need for the advocacy element to the gay press.

We in SM know the struggle is far from over. It is up to the gay press to represent as well as report. It is by developing articulate voices— wherever they can be heard and read— that we can inform, we can

educate and we can react when the rights of consenting adults are threatened.

Out Of Style

Every young writer has his unique "style" which he defends tenaciously against all critics. You rarely hear experienced writers speak of style, but young gay writers in particular are positively dripping in the crap. Luckily, most newswriting has no style. It is function over form. In short, if your personal "style" gets in the way of transmitting the required information— write novels or haiku. You are depriving the world of art and confusing the world of information.

The standard form of newswriting is called an "inverted pyramid" meaning that all the major information (who, what, why, where) is in the first paragraph, called a "lead." The lead paragraph is followed by successive paragraphs of lesser and lesser important follow-up and background material. This format is designed to grab the busy reader's attention and also makes it easier to edit. Since editors rarely read what they edit, if your piece is too long, they will simply snip a paragraph or two off the ass end, so, if you wrote your article like a mystery novel (all the goodies saved up until the climatic end) your article now publishes making no sense whatsoever. Oops.

Check what the standards are for your publication or website. Most editors are not grammar teachers and rather than correct your work, they're more likely to just toss the whole story. It makes their job easier if you do yours, and your work is tight, professional and spelled correctly. Consider having someone else proof your work before you turn it in. If you are serious about this, consider taking a writing course, or at least buying a dictionary or a copy of the *Associated Press Stylebook*.

Recording History

"But, sir, what will history say?"

"History will lie, as usual." -General Cornwallis to an aide just before his surrender at Yorktown

Beyond finding out where the motorcycle run this weekend starts or who won Mr. Buffalo Leather, producing good, competent, credible leather community reporting has long-term importance.

News is called "the first draft of history". What we discover in assembling leather history is that we often didn't get the chance to write a second draft. What little we have from newsletters, newspapers and magazines has become our legacy— the incomplete, the incomprehensible, the intemperate, the incorrect. The state of leather community reporting 15 or 20 years ago directly relates to efforts today reconstructing a leather history. If we demand more professional community news, we can expect a more understandable history for future generations.

Leather Journalism 101

Abraham Lincoln used to tell the story about the man who woke up in a coffin. Trying to reason out his situation, the man asked himself, "If I am alive, what am I doing here? If I'm dead, why do I have to pee?"

It's much the same feeling when asked to write the local leather column. Assuming you didn't run fast enough, there are ways to make it easier on yourself and easier on your readers:

■**Know your audience.** Know who you are talking to, what they want to know and how best to provide them access to that information. How is your work organized? Does your reader have to wade through paragraphs of chatty, self-indulgent trash to get to the meat? Is there any meat?

■**Know yourself.** Know why you are doing this. Money? Not bloody likely. Glory? Free tickets? Do you feel you have a talent

and time to contribute to your community? Do you have an agenda? A crusade?

■**Know your subject.** Network. You simply cannot be everywhere and know everything. Develop contacts in clubs, organizations, bars and businesses. Train them to check in BEFORE your deadline

■**Know your craft.** Never stop learning how to get the facts, but more importantly, confirming your facts. This is the way the successful journalist avoids protecting the guilty, hurting the innocent...and lawsuits. Never stop learning information, trivia, people and ideas. Never stop learning how different columns are written and presented. Remember: The immature artist imitates. The mature artist steals.

■**It's not about you.** It's about your reader. What do they want to know? What can you offer them? Do they really care what you think? Should they? Then tell them and tell them why. Do you have a unique perspective? Use that, but don't forget to bring them along. They need to feel included, like you are talking to them.

■**Make deadlines, not excuses.** There is always a solution. Your reader, and in particular your editor, is not interested in why you didn't get the story in time, why your column is 250 words short or 2 days late. They don't care that you got 384 days and times correct; you got their event wrong. Strive for accuracy. Your reputation does not rest with brilliant but unwritten story ideas or good intentions. You are judged by the quality, integrity and reliability of your results. Try thinking *inside* the box.

■**Be kind.** We all like to dish, we all like a little dig now and again, but there is a thin line between witty and bitchy. You, great fairy, have the power to both hurt and heal— so use your powers only for good.

If you must toss something from your lofty leather columnist's

pedestal, err on the side of bouquets instead of bricks. Compliments and congratulations, rather than complaints and condemnations. They hurt less when the angry mob throws them back at you. Keep in mind that it's a long, long way to fall.

Boot Black Traditions Where The Leather Meets The Road

Among my most prized books is a fragile volume, a 1909 printing of *Tom the Boot Black* by Horatio Alger, Jr. (1832-1899). "Horatio Alger stories" entered the language with hundreds of rags-to-riches, hard-work-and-honesty, strive-and-succeed dime book tales of young men who climbed from poverty to success. With stories like *Ragged Dick- Or, Street Life In New York With The Boot Blacks,* Alger did much to imprint boot blacking on the American mind as humble but honest service.

Boot blacking as a profession goes back to the Roman legions, to specialized servants who cared for boots and leather armor. Nearly every army since has had bootblacks and cobblers either in their ranks (like the armourers who repaired and maintained weapons and armor) or among the industries following the camp (with the laundresses, prostitutes, gamblers and liquor distributors).

Eventually, shined footwear became one of the checkpoints in the image of a civilized man: A tie, pressed suit, neatly cut hair (and shave) and polished shoes. Thus, boot blacking became an essential service. In the United States, boot stands sprang up on every street corner, in every bus and train station, in airports. Having your shoes professionally shined for a buck or two was an affordable decadence. From the Army PX in Biloxi to Dearborn Station in Chicago, from Times Square to the Port of San Francisco, bootblacks were a servant class that even servants could afford. There were class issues to boot blacking; there were racial issues.

There were also sexual issues. Many of the "professions of the street" in big cities for young boys such as newsboys, messengers, shopboys, baggage boys and bootblacks were associated with homosexual prostitution. There weren't all that many options for a poor young man who had forsaken farm and factory (and perhaps brushed with the law once or twice) and gentleman looking for male sex knew that these youths were largely available, unsupervised,

103

already entrepreneurial, in constant need of cash and unlikely to go to the police. In 1866, Horatio Alger himself was forced to leave the ministry and Brewster, Massachusetts rather than face a public hearing that he extracted more than just book material from a few of his young subjects.

Bootblacks And Leather Bars

Boot blacking is still a subtly semi-intimate and semi-public act of service that has never really lost that sexual undertone. It is a logical and eminently practical tradition for a community in leather that requires constant maintenance.

In the early years, leather bars were more than merely alcohol dispensaries. They were centers of community, communication and of commerce. Enterprises such as coat checks, independent magazine and cigarette shops, in-bar leather stores and bootblack stands sprang up within the bar and became coveted franchises. Sometimes these sub-businesses paid rent to the bar for exclusive territory. Sometimes they were encouraged by the bar simply to add an atmosphere and a service for their customers (and one which did not involve adding yet another person to the payroll). As long as they were honest, did their job and kept the bar owner happy, eager entrepreneurs could hang around the bar all weekend and meet all the tricks he wanted, while earning enough to restock supplies, buy drinks and taxi fare. On a good weekend, perhaps more than just break even. In the days before fat travel funds, titleholders would earn their way to out-of-town contests through the bootblack stand or the coat check. Clubs could raise funds for their charities with a bootblack or two at bars, events and runs.

Like many leather traditions, boot blacking suffered through the 1980's as its ranks were decimated and the culture of the leather bar marketplace dissolved. To try and preserve an eroding craft, Harry Shattuck, bartender and bootblack at the Gold Coast in Chicago founded the first International Bootblack competition as part of the

International Mr. Leather (IML) weekend in 1993. In 1999, the contest was split: Mr. Bootblack at IML in May and Ms. Bootblack at the International Ms. Leather (IMsL) currently held in July. Once an exclusively male symbol of grooming and dominance, boot blacking has seen a surprising renewal in the leather community among women.

Either End Of The Brush

For seventeen years, my father insisted that his sons maintain mirror shines on our good Red Goose Sunday shoes. I hated it. Through Navy boot camp, the inspecting officer seemed to have a peculiar erection for spit shined work boots. I swore at the earliest possible moment, I would never polish another boot again. Sure enough, the bootblacks of at least a dozen countries kept my tall, custom-made sea boots maintained for six years.

Not only did it save me from a task that I loathed, it felt good to be sitting back in the cool shade with a drink and a cigar. Like a benevolent colonial lord, I sat high on my throne as the young man respectfully went about fussing and brushing at my feet. One could feel like a king for the princely sum of 20 rupees (400 yen, 50 baht, 2 dinar, etc.).

Customer demand, of course, is part of what keeps bootblacking alive. Footwear will tend to need care and inevitably there will be people like me who see no joy in buffing boots. Quite apart from the actual service rendered, however, part of that feeling of kingship comes back every time I get my boots polished. It is as basic as any exchange of power in the leather/SM experience. There is a sensuality and a nostalgia in the smell, taste and feeling of the boots, the polish and the sweat. The experienced should not be rushed, for it takes you back to another, simpler, slower era.

On the other end of the brush, the bootblacks I have talked to have almost as many reasons and explanations for their interest as there

are bootblacks. Some consider it a professional skill or craft; others are dedicated fetishists who just can't keep their hands off boots. Some are attracted to the idea of servitude and for some it is a sort of nightly performance art. Some are serious about the money or competition, and some just like to get their hands messy. Some like the transformation of taking what was scuffed and dirty and making them gleam. Many can't quite put their finger on why or maybe have never really dissected it too deeply. They just do it.

How to Treat Your Bootblack

True gentlemen are not judged by how they address royalty, but by how they treat waiters, valets, maids, barmen and the like. The boot blacking experience not only displays the skill of the bootblack, but the experience, sophistication and grace of the patron. Unfortunately, the service nature of boot blacking, over-active libidos and low lighting (mixed with the alcohol generally served at the same venues) can lead to some poor presumptions and crashing faux pas.

No groping, spanking or taking liberties. Even if you are familiar with your bootblack this is not a good idea— some jerk will see you and figure that's what's expected. Treat the transaction and the bootblack with professionalism and respect. All bootblacks are not bottoms, so don't make assumptions.

Bootblacks are rarely paid by the bar or space that they occupy. Sometimes prices will be posted but that often means that the house or a charity gets that amount and the bootblack keeps only additional tips. If no price is posted, don't panic. Most of the time this is done to allow a certain flexibility in pricing. Between $5-10 is minimal for simple shines, plus a small tip. For high boots or boots requiring extraordinary effort, more generosity is expected. Don't be cheap and don't flash your tip about in that see-how-much-I'm-giving-him, suburban yokel fashion. As you thank your bootblack, palm the appropriate number of bills in a discreet manner (bad form if he counts the money in front of you).

A bootblack should engage you at least enough to determine what you want. No two boots are exactly the same and neither are the standards of any two boot wearers. Some will just want a touch up, some demand a mirror finish and some don't know. After six years wearing a white uniform, my thing was checking to make sure no polish gets on my trousers. Other than that, since I am never closer than about five feet, seven inches to my boots (or anyone else's), I suspect I am a fairly easy customer. For a detailed critique, ask a bootlicker.

Some bootblacks are quite theatrical—lighting the polish on fire and buffing with gymnastic flourishes. I never thought heated polish was worth the danger of setting off the sprinkler system, but to each their own. Like cab drivers, they can be a great source of directions, gossip, tourist information or who's married in the bar and who's just cheating. Some come supplied with extra bootlaces, leather repair kits, rubbers and the bartender's phone number.

Boot blacking has to be the most unique and utilitarian of popular leather fetishes. A symbolic exchange of power and an actual exchange of money that can be legally performed in public. It combines sexuality, service, history and tradition with the dignity of labor and the sensual feel of grease on leather. Theirs is a restorative art which makes us all look better.

The Secret And Mystical World of Leather Clubs
From Bike Clubs To Show Clubs

One of the oldest and most old guard of institutions is the leather club. Steeped in tradition, shrouded in myth, they are viewed by many as the gay equivalent of Shriners: Dressing alike, riding motorcycles in parades, traveling to conventions together and seriously over accessorizing. Also like the Shriners, they have tended to be tireless source of service and fundraising for community causes.

The past 10 or 15 years have taken a lot of vigor from the club scene. Many of the founders and leaders of these groups passed away. The very secret and underground nature of these organizations assured that much of the traditions and culture died with them. The mainstreaming of leather and motorcycles has made clubs less of an imperative, as did the dispersal of the large, concentrated urban leather communities.

But lately there has been a renewed interest in clubs, in organizing leatherfolk with similar interests and a spate of new clubs. In several smaller communities, the old leather clubs are as strong as ever. Many communities, which cannot support a full-time leather bar, can support one or two fully-functioning and vibrant clubs. In many small communities, the clubs ARE the existing leather community.

Club Scene

I have to be careful using that term. For leathermen of a certain age, the "club scene" will mean local motorcycle, uniform or levi/leather organizations. For a newer generation, it is bars, saloons and dance clubs.

There are many sorts of clubs represented in the leather community. Some are primarily social in nature, some are service oriented, some stress education and mentoring and some (thank God) are mostly sex clubs. Some are spiritual clubs that unite leatherfolk of similar beliefs. Others excel at events and elaborate celebrations so thus

are labeled "show clubs." There are even a few who still require that members own a motorcycle, although most have relaxed their ancient restrictions against Japanese bikes (which was a raging debate at one time).

The early clubs were very narrow in focus, purpose and direction. Motorcycle clubs, fisting clubs, bondage clubs. Eventually, leather clubs became more generalized and broadened their scope to include a diversity of kinks. Coming full circle, many of the new clubs which have sprung up recently like the Men of Discipline, Masters & Slaves Together, the Next Generation and Boys of Leather clubs once again focus on very specific desires and identities.

Organization

Many clubs were organized along the lines of fraternities or social service organizations with officers and meetings resembling any suburban Jaycees or Kiwanis. Some have organized along the military or VFW model, but just substitute "President" for "Commanding Officer" and the structure is pretty much the same.

What is interesting is that the same organizational dilemmas are faced by a new generation…only in slightly different terms. The inescapable process of defining who and what the group is remains the same. While we debated the need for uniforms and the admission of women, I heard of a new group of submissives seriously weighing the question of whether a submissive could actually wear the title of "pledgemaster."

Club Colors

Thankfully, club brothers are among the most well-labeled of gay men. If you start reading vests at any leather function, you usually know name, rank, hometown, recent travel and perhaps even a little about his sexual tastes. This has distinct advantages.

A club's "colors" refer to the emblem, the club logo, usually in

the form of an embroidered patch. The colors can be framed and presented to a bar or another club as a gesture of friendship or in return for some service. Mounted to a standard, the colors can be trooped like a flag or banner during official ceremonies. An honorary or associate member may wear a smaller version of the patch but mostly you see colors on the backs of club members, stitched to an overlay or vest of leather or denim. This identifies him as a member and prevents embarrassing incidents of incest among club brothers in dark corners.

Actually, some clubs have definite rules about removing or turning their club vests inside out before engaging in any nefarious activity. As much as they explained how this served the cause of honor, I always suspected it was because they did not want the entire club to be held responsible for another member's mediocre performance. Other clubs made sex in their colors part of initiation or bonding rites.

Pins & Pinning

Along with the colors, you will see all sorts of badges, pins, plates, emblems and gewgaws on vests. Some of these may have a special memory or distinction to them. I used to wear my original Navy Good Conduct Medal just to watch it tarnish before my very eyes with each debauch.

Many club member's vests are so heavily covered with pins that what was once a simple leather vest now weighs 30 pounds and is completely bulletproof.

Most pins fall into two categories: Friendship pins and run pins. Friendship pins usually bear the logo of the club and are given as a sign of affection, friendship, brotherhood of unbridled lust. Run pins are a badge of survival commemorating each run or event attended. There are also bar pins, titleholder pins, commemorative pins and personal pins.

The act of pinning someone with a friendship pin was a tradition in itself that has, necessarily changed over the years. On his knees, the experienced pinner would open the pinee's button fly, usually taking the opportunity for an oral quickie (decidedly expanding the concept of "friendship"), and attach the pin to the crotch of the jeans. The last day of any leather weekend, the scene was repeated continually on the floor of the wind-down party. Leather bars were fairly used to seeing it, but if it was done in a somewhat less liberal location, club brother may stand in a tight circle to form a human curtain, shielding the action from prudish, prying eyes or the local constabulary.

I understand that in some parts of the country this is now called a "Texas pinning" to distinguish it from a less amorous delivery. More cautious times and the rise of pansexual events have dictated certain changes.

Back then, one could always spot the particularly active and/or popular attendees by the cluster of cloisonné around their crotch and carefully examining which direction he was pinned. For the traditionalist, the club pin was worn upside down until you had done a member of that club.

Initiations & Pledges

Much has been written about club initiations and lurid secret rites in friction fiction and bondage porn. These days the reality is likely to be much more tame although the requirements and ceremonies vary wildly from club to club.

Usually, someone who is either invited to be a member or expresses interest is accepted as a pledge first. This allows the club and the potential member time to get to know each other. Today, that might involve some period of community service, fulfilling certain obligations or checking off a list of accomplishments. Then the pledge is initiated into the club, after which he is a full member.

After having crossed the Equator more than once on a Navy destroyer, gone through straight biker club initiations and having been a guest at a couple of college fraternity hazings (primarily because I was one of the few they knew old enough to buy liquor) I can attest that not all initiation rituals are quite so genteel. But even the most bizarre contained a grain of twisted practicality.

One initiation rite borrowed from the original outlaw bikers was a ceremony whereby all the members in good standing would break in a pledge's brand new club colors by urinating on them. The pledge would then have to wear the soggy vest throughout the ceremony.

Kinky, yes, but it had practical value for a tribe who, on long road tours, would not bother to stop when it was more efficient to piss in your jeans and let the wind dry them. Might as well get used to the concept and resolve inhibitions about bodily function.

As imprudent as it is today, the sexual initiation of a pledge bonded brothers of a sexual club in a very unique way. A top forced to perform bottom service as a pledge got a rare look at life on the right side of the hanky. Likewise, the club got to see if he was going to be a whiney top every time something unpleasant had to be done.

Simply put, the initiation rite seals the acceptance of a new club brother in a way he does not easily forget.

Runs, Events & Virgins

The traditional gathering of clubs is a bike run. Usually a road trip, the club would saddle up and travel as a group to a campground or remote location where they could party and cut loose. Other clubs might be invited and often the final location was kept secret to ward off tourists and cops.

Today runs can be annual events, often held at the same place each year. If you have never been to that particular event, you are a run

"virgin" until you have successfully survived one. The host club takes care of most everything from registration to the last show while guest clubs might sponsor the main bar or a cocktail party. There are still rustic camping trips, but there can also be "In Town" or "Hotel" runs that take over a hotel or resort for the weekend. Some runs are even catered affairs.

Typically on a weekend, the boilerplate run begins on Friday evening with everyone arriving and a big meet & greet party. Friday night is serious cruising. Saturday may be motorcycle skills competitions or games where guest clubs try to rack up points towards prizes. Saturday night is the big dinner, a parade of colors and a show (anything from campy skits to full-blown production numbers). Often the annual run is when the host club installs new officers or welcomes new members. Saturday night is for nailing the trick you were cruising last night.

Sunday is generally reserved for recovery and winding down. The prizes and awards are given out (including the "pig award" for the most successful and dedicated slut of the weekend), good-byes are said and leave is taken.

Tradition

There is a rich tradition of ritual and symbolism in club history—I have only been able to touch on the basics here. Much of leather history is contained in archives, records and newsletters diligently recorded and dutifully saved by club secretaries. Those specific rituals and traditions may vary from club to club, location to location, but the reasons we came together, the camaraderie and fellowship that we shared was the same and it can still be felt.

Most of my coming out in leather was done among leather clubs. In less tolerant times and less generous places, my club brothers looked out for each other, annoyed each other, raised hell with each other, fought each other, cared for each other and buried each other.

So, this is dedicated to my fallen brothers: If you guys ended up somewhere warmer than Heaven, you are in deep shit—not because of any divine punishment— but because you bastards never could pack enough ice for a whole damn weekend of hot weather. And wherever you are, save a place at the bar for me.

Advice For The Ambitious Leather Business
Cowhide, Cash And Conscience

Someone once explained the difference between "involvement" and "commitment" by using the example of the typical ham and egg breakfast. The chicken, it could be said, was involved in the making of the meal while the pig was committed.

In the same way, many titleholders, weekend warriors as well as teachers, writers, leaders, club officers and very dedicated and sincere individuals are involved in the leather community. Someone who owns a business in the leather community, however, is most definitely committed. Baked, smoked, sliced and served.

There is always a combination of admiration and suspicion that greets someone who makes their living in the leather community— often derisively put as "making a living off the community." Still, the list of most admired leather folk more often than not includes those whose careers and commercial interests have served our tribe/ subculture/ nation/ community. Tony DeBlase, Chuck Renslow, Joseph Bean, Marcus Hernandez, Mikal "Daddy Zeus" Bales, Alan Selby, John Embry. For the most part these were talented men of business who might have done much better elsewhere building less precarious, more mainstream and more lucrative careers. Instead, they pioneered leather businesses.

Of course, a book could be written about running a leather business— if only business itself didn't keep us all so busy. In case you are thinking of founding a business or buying an established one, maybe a few of these observations will help in your quest to establish the next leather empire. If not, perhaps they can just let you see leather businesses a little more sympathetically.

Ice Cream

When I was young, I loved ice cream. All flavors, cones, splits, sundaes, you name it. A new flavor came out and I was right there

115

at the Baskin-Robbins, tasting the new one and hoping they didn't retire one of my favorites just to keep it at "31-Flavors."

Then one summer I worked at an ice cream parlor. After four months of serving ice cream, packing ice cream, hauling ice cream and cleaning up ice cream, I didn't have much of an appetite for the stuff for the next 25 years. It is an inherent danger of mixing passion with paycheck. Some people have told me that the most dedicated and enthusiastic celibates are those who have spent some time in the sex industry.

Know Thyself

It is easy to allow reverses, difficulties, annoyances and frustrations with the business to color your outlook on the leather community and on your leather journey itself. The time to find some way to preserve your personal and private pleasures is before you begin. You buy insurance to make sure the business survives financially if something happens to you, so it is only logical to insure that you survive spiritually if something happens to the business. Just as a straight small business owner protects his sense of self worth and his family from possible reverses, there is a core of oneself—one's gay and leather identity and sense of place in the community— that you keep in reserve, just in case.

For some, this is not a problem but for others, once they have invested in a personal enthusiasm, a loss is devastating. Sometimes, you never regain a taste for ice cream.

Know what you are, what you want and what you are willing to trade for it. How much of your passion and your identity (not to mention cash) are you willing to commit? For example, some tops have turned themselves into cottage industries: Websites, books, workshops, videos, radio talk shows, calendars, signature dungeon ware, etc. After all that effort, they complain about loneliness and lack of privacy because they are now too well known. That's

something like a whore an orgy who finally finds someone willing to pay. Count your blessings, count your money and don't kvetch.

Business First

Most disasters happen when a gay business is more gay than business. Being a community enterprise does not remove you from the regular day-to-day dynamics and requirements of any small business. You are not immune to ruthless competition and rapid changes in markets, technology and environments.

You must have a business plan. A marketing plan. Permits and licenses. Proper accounting procedures. You must secure financing, hire competent help, work within the law and prevailing business practices. You must establish accounts with vendors and develop customers. Contrary to the "new economy" touted by now extinct dot-commers, it's helpful to have a product and some sort of path to profitability. Watch the bottom line.

If you don't know anything about business generally or about your product specifically there is nothing magic about being a gay business that will save you. You have to either hire an expert with that knowledge or learn very, very quickly. At a certain level, the mundane, daily grind is the same selling beer, boots or books, hot chocolate or hot chaps.

The Flake Factor

If the concept of "gay time" is ever mentioned during business hours, if you have ever had to cool an employee in heat from pursuing the UPS delivery man, if you have ever endured a long explanation about all the very personal reasons something could not be done on time or had to explain why a "bad hair day" is not a valid emergency, you have encountered the "Flake Factor." It is the lack of professionalism, a lack of standards, respect, self-esteem, honor— and sadly often we get away with flaky behavior in the name of being gay.

Professionalism is not a dirty word from straight, starched corporate America. It does not mean that you cannot enjoy your work, that you must stifle your creativity or repress your individuality. It means you exchange goods and services that are a fair value for what you charge you customers. You ask for the fair value of the supplies and services provided by your vendors. You expect fair value of the time you buy from your employees. Make sure that everyone knows the measure to which your business is expected to operate. That way, they have the option of meeting the measure or moving on.

Many entrepreneurs, on the other hand, have a difficult time dealing with good employees. Once they get the right person plugged into the right position, they refuse to let go and let them do their job, insisting on micromanaging. They just have to tinker and interfere. Maybe they feel threatened by talent, or maybe part of the personality of the commercial creator is an inability to delegate— but the result is talented people getting frustrated and going elsewhere. Some bosses don't seem happy until they *have* to attend to everything personally after they managed to carefully surround themselves with morons. Let good people do their jobs.

Community Relations

Of course, as a community business you are expected to "give back" to the community. You will be presented with opportunities every day in the office, every time you open the mail and every fourth or fifth ring of the telephone.

Give what you can. Treat it like a regular business expense and set a limit. Budget a certain amount of money or in-kind donations and stick to it. Don't give amounts or at times inappropriate to your cash flow. If you have spent your limit say, "I'm sorry. Can I put you on the list for next year?" Don't confuse promotional considerations (which should show a return) with donations (which do not have to).

Be prepared to back up your claims of "10% of all proceeds go to helping widows and orphans." We've heard that one before. It's a

good idea to prepare some sort of financial statement showing how that 10% was actually arrived at and that the charity acknowledged receipt of your check. Be careful of how you word your claims so that they stand up in public opinion and the press.

You have to have limits when it comes to your generosity, because your leather community knows no limits when asking for free stuff. They do not understand that merely standing in your place of business costs you rent, payroll, utilities, permits, licenses, taxes— it doesn't matter if they are there to spend money or ask for a donation.

In a way, it's not their place to know your trials and travails. Trying to explain will be as frustrating as it is unsuccessful— better not to try. Just leave it all as part of the backstage magic, slight of hand, the man behind the curtain. Let them only marvel at Oz, the Great and Benevolent Leather Entrepreneur who makes it all appear out of thin air, but never tell them how the trick is done. Dull facts and sweat ruins the magic.

Chairman Of The Board

There is an advantage of being a community business considered a community asset. The substantial drawback, however, is the collective ownership so many others seem to assume in your business. Every social occasion, dinner out or just a shopping trip becomes an opportunity for this vast, rambling self-appointed board of directors to advise you on matters in which they may have absolutely no background and which is, quite literally, none of their business. Doesn't matter: You have a leather business, they own a piece of leather, therefore they are an expert.

Mostly everyone advises you about what additional risks you should take, what additional money should be spent on and how courageous you should be. It's very easy to be courageous with someone else's money. It's not their career at risk, not their life savings, not their retirement fund, not the second mortgage on their house. It's yours.

The late "Daddy Philip" Turner of Daddy's Bar in San Francisco used to handle it this way: After patiently listening to some rambling, insistent and unrealistic list from a customer who could hardly stand in front of the bar, let alone had ever worked behind one, he would slowly turn and say. "So, how is that leather bar of YOURS doing?"

Trusted advisors, managers, minions, employees, lovers, partners are all very important support, but their motivations are not always the same as yours. It is up to you to establish limits, guidelines, controls, budgets and oversight. It's lonely at the top. Work groups in large corporations can afford to manage by consensus, but the sole proprietorship must be an autocracy. One tries to be as benign a tyrant as one can, but while everyone will claim a piece of your success, you will most certainly be left alone with your failure.

Mine is just another opinion, but it is always my advice to succeed if at all possible.

Loving Your Living

As John Embry, creator of *Manifest Reader, Manhood Rituals, SMR and Drummer* magazines and the Mr. Drummer contests, said of his career in a recent interview, "Wouldn't switch it for the world. I'm sure there might have been things that were more distinguished, but I've met a lot of very wonderful people. Talented people. Great people."

All of us would love to have the sort of occupation where we wake up and can't wait to get to work because it is exactly what we love to do. Having your own business in a community you love can be that way if you keep perspective, if you surround yourself with good, talented people, if you follow sound business principles— and if your business is successful. Above all, success tends to blunt criticism, fulfill ambitions and warm the heart. Failure can be educational, but that's about it

120

The Meaning Of Community *A Response to 9/11*

There has been a very vocal debate in the past few years as to the nature of the Leather/fetish/SM/bondage community/ subculture/tribe/nation/anarchy. It is not identifiable in the way that a neighborhood, a religion or an ethnicity sets a group apart. Membership is not regulated by origin or reviewed by a central committee. Individual interpretation and nonconformity is considered a strength, not a reason for expulsion.

It may be an ancient tribal instinct, but has been said that a community best identifies itself in a crisis. As the tribe galvanizes against a common enemy or danger, its borders, leadership and values become more distinct. We have seen this happen before in the Leather Community, and watched its considerable strength mobilize against an undefined enemy that killed from within. It the last few weeks, once again, we see the boundaries, the purpose and the true nature of our community.

Sexual, Social and Political

In a recent article, *Sash Rash: The Mainstreaming of the Leather Subculture* by Jim Hunger (*SF Frontiers*, Volume 20, Issue 11), it is heartening to hear Tony Mills quoted as saying:

"I think that one of the great things that I have learned is not to close myself off to people just because we are into different things or I'm not into them or they're not into me but to really go for the friendship and connection."

Hopefully we do not all have to serve a year as International Mr. Leather to discover this. My earliest involvement in the leather community was social and political as well as sexual. My club brothers were my friends and we banded together for solidarity, to make changes and raise money— first, with fundraisers for legal defense funds and later, for AIDS-related causes. Yes, we were looking for a specific type of sexual partner, but just putting on a

leather jacket and chaps could also be a very public act of identity and defiance, depending on the time and place.

We were bound together by ropes and chains much stronger than any we use in the dungeon; we shared our common experiences and struggles, the lives and the deaths. Those who did not understand misinterpreted our petty squabbles and arguments. We were simply testing and proving the bonds- like a bondage bottom struggles against the ropes. We found reassurance at that point where the restraints tighten and give no further. Sometimes, there is no greater freedom than bondage.

These were the men who were there through the triumphs and the defeats. We shared holidays, birthdays, anniversaries and vacations. We were there when each of us opened those first HIV tests. These were the men that were there the night my first partner died. They were the best of cheerleaders and the harshest of critics. They were family and church when families and churches had turned their backs on us.

I have traveled from city to city, from leather community to leather community and have seen the same elements: A smoldering sexuality and a camaraderie that extends beyond bedroom or dungeon. In short, those who dismiss the parts of the leather experience that do not directly relate to getting themselves laid are blind to a bigger, richer picture.

What now?

Our world has fundamentally changed once again. Without mentioning the reason specifically, we call, email, and check up on each other. We touch the borders and feel the comforting limits of the close bonds that tie us one to another. Our differences still exist, the pettiness has not evaporated, our passions still lead us in all different directions, but we have once again defined our membership in a unique community.

We are more than merely a pool of potential partners. We share more than knot-tying techniques, bars, contests and accidental fetishes. Those who do not understand this, do not understand us. A community is where you seek refuge when the world seems to have gone mad. The people you hold on to, rant at, cry with and brace for what's ahead. They know you are not quite yourself today. You know that they need some extra attention today.

Imperfectly perhaps, but together, we heal and we carry on.

The Death of Kings *An Obituary for* Drummer

"The tumult and the shouting dies; the captains and the kings depart,
Still stands thine ancient sacrifice; A humble and contrite heart.
Lord God of Hosts, be with us yet; Lest we forget, Lest we forget!"
- Recessional (1899), Rudyard Kipling

Never Neglect To Bury The Dead

When the legendary Spanish military leader and knight to the King of Castile, Rodrigo Diaz de Vivar "El Cid" died in 1099, the battle to defend the city of Valencia from the Moorish king was not yet over. Myth has it that his lieutenants lashed his corpse to their commander's horse so he could continue to lead the charge. The last days of battle were finished by troops lead by a piece of rotting carrion tied to a horse.

When the life goes out of our sacred leather institutions, we tend to desperately want them to go on, sometimes beyond what is decent and healthy. Instead of letting them pass honorably into history as we should, we look to a savior that will resurrect the dead or at least put together an acceptable illusion of life. Both miracles and honor seem to be running short of late.

It has been announced that the production company who has produced the International Drummer contest for the past two years has declined to seek contract for a third year. Pundits and chatrooms echo with speculation about what this means. The headlines trumpet, *"Is Drummer dead?"*

The End Of An Era

Drummer magazine survived for 24 years, through four publishers, three owners, 214 issues, half a dozen offices, over a dozen editors, earthquakes, strikes, two major recessions, several injunctions and other minor litigation. The voice that was *Drummer* magazine is silent. The organization that nurtured artists, answered the curious,

conducted business and pushed the edges of sexual expression no longer exists. The *Drummer* archives, undisputedly the world's greatest collection of current and historical leather/SM photos, art and information, is gone. Attempts to produce an online magazine overseas without the history, the images or that rich voice of commentary and fiction have failed to spark interest or revenue.

It goes without saying that things are very different now then they were in 1975 when the magazine began, or in 1981 when the Drummer contests were launched as a promotional outreach for the magazine. The world is a much different place. Technology and communications have advanced. We live in a multi-media, multi-tasking, micro-targeted world. The worldwide leather community has changed. Our needs have changed.

In 19 years, the Drummer contests selected 22 International Mr. Drummers and 12 International Drummerboys. Now the International Contest, forced since 1999 to survive without the magazine, has no producer. Drummer has risen from the dead before, but by all observable measures of business life— financial, credit-worthiness, activity, assets, public opinion and trust— there is no discernible pulse.

Should we resuscitate? Is there anything essential, anything familiar left?

What Is Indispensable In Our Community?

We are told by a corporate spokesman that "no one person is indispensable" to the glorious "tradition" of Drummer. Since when are we slaves to the institutions that were built to serve us? Any institution that purposely separates itself from and disregards the community it serves, that considers individuals so lightly and respects so little, has lost any mandate to loyalty in the name of "tradition".

Do brandnames count more than people do? Could it be we mourn the passing of a name more than the passing of the men who built it? That would be sad, for if there was life to Drummer, if there was a "tradition" to be respected, then it was in the people created it, who gave voice and image to it. They made it an accurate reflection of a community, their voice and their times.

Typical of so much of the "new economy" arrogance, some thought that the irreplaceable history, the people, the pride, the publication and the product were "dispensable" and that the name alone would still remain valuable. They were bad gardeners, who believed that if they stripped the bark, branches and leaves, chopped up the trunk, cut the roots and wrung out the sap—that somehow the resulting stick would still be a mighty, living tree and not a dried scrap of firewood. They were wrong.

There are many separate voices in our community now. With expanded choice hopefully comes the expanded wisdom to seek those that add to our journey and dispense with those who obscure the way. Those in our community who live off gossip, misery, misinformation, rumor and "dish" are dispensable. These uncertain times are their playground. They would do well to look more closely at the lives they seem to admire: Hedda Hopper, Louella Parsons and Walter Winchell paid dearly for careers that feasted on the lives of others and all three met wretched, broken, lonely ends.

Drummer is also dispensable. As difficult as those words are for me to finally write after a long struggle, people are much more important and will remain so long after the name fades to an historical curiosity. This is a sad and/or even noteworthy milestone for only a few of us— most don't really care. An entire generation wonders what the fuss is about. They carry no memories and feel no sense of loss and that is perhaps the strongest argument yet that the time has come for requiem rather than resurrection. Private ceremony, family only.

Requiem For A Heavyweight ™

Drummer is a properly registered and duly protected brandname. Great effort has been expended to make sure it is that and only that. Many great brands have passed into oblivion: Studebaker, Bell Telephone, PanAm and Eastern, WebVan.com, the Jackhammer and the Arena. They will soon be followed by Plymouth and Oldsmobile. Communication, transportation and libation continue on.

This leather tradition of ours has survived oppression, intolerance, epidemic and ourselves. Ancient people used to tremble at the uncertainty and the danger upon the death of a king or chieftain but usually, once the tumult and the shouting was over, the people and all that ever made them a tribe remained. Eventually, everyone went home and moved on.

The Color Of Leather Pride, Preference, Prejudice and Presumption

I may be naive, but I have always viewed leather as a fairly colorblind place, or at least as close to it as one can get. A somewhat outcast underground, we tend to judge folks by criteria (albeit sometimes just as shallow, arbitrary or unfair) other than race. My criteria for cruising a man in leather was always pretty basic: Was he cruising back? Color, race, religion, size, age did not matter. If it did matter at all, it was the opposite reaction— I usually wanted something completely different than me. Never was much attracted to short, middle-class, middle-aged, blue-eyed, blond, skeptical, Western, leathermen— which left a wide range of interesting options.

I leave the door open to the idea that I just don't "get it" because I'm very, very white— but I have never filed people or experiences using those labels. I just takes 'em as they come, and quite frankly, I don't really check the color when they come. I have met many wonderful people whose cultural, economic, religious or ethnic background was something they reveled in, something they ran from, something they ignored or something they alternately reveled, ran from or ignored depending on the day, month or time of day.

Therefore, I have always left it to others to comment on the details of minority issues under the theory of "You're closer to the fire, YOU tell me how hot it is!" For the past year, they have been telling me how hot it is. The questions of inclusion and race in our community are certainly something for all of us to consider and while it may not be my place to frame the answers, at the very least I have some thoughts on how to define the questions.

And the questions are intriguing: How much does one's racial identity, gender, age, language, religion, cultural bias, one's appearance, one's Catholicism or Protestantism or other individualisms impact on the dungeon? How about in our community clubs and institutions? How much should it?

Once upon a time, "gay" was equated with "misogynist." If one did not have sex with women, you had to hate women, right? This simply reinforced the despicable nonsense that a woman in this society was worth only her value as a potential sexual partner. Thank god we have grown beyond that and today one is allowed to have warm, close, meaningful social, economic and political relationships with women while choosing sex with males.

Where does preference become prejudice? Where does curiosity become cultural voyeurism? If one is interested in only Asian men and none other, is one as guilty of racism as someone who is repelled by Asian men? Is it right to fetishize race? Is sexual attraction something that is subject to the usual measure of prejudice, like employment or access? In a sexual subculture, how do we separate attraction from how we treat a certain race or subgroup as members of a community? Is an outlaw, anti-hero, unequal, rebel society, born in bars, dungeons and other dark places, really expected to carry the banner of inclusion, fairness and enlightenment?

Even the questions are liquid, ever-changing. Consider the "Tiger Woods" syndrome: It is no longer possible to draw the distinct and immutable lines between races or ethnicities. Which of several blended ethnicities might you be responding to? Our preference, like our prejudice, no longer falls into nice, neat boxes on a census form.

Like I said, intriguing questions—are they my questions? What part do I play in any answers?

Coincidence, Envy or Bad Manners?

Many people blame race bias for the failure of "mixed" relationships. Let's face it: It's tough for two people of ANY cultural background to build a life together. How much of it is a factor of race? If two people are of the same race or background, does that guarantee success? The view of culture as monolithic and impermeable is

usually fiction. Some cultures that get called "Latino", in reality, don't even share a common language. The "Black experience" in America is no longer the same journey for every African American, no more than the "majority experience" is same for all who share whatever that might be. Indeed, particularly here in California, you have to seriously reevaluate what is considered "majority".

The entire subject of "interracial relationships" sounds like a relic of the 1950's, but it seems it is not. Talking about this article, friends reported that they receive comments from complete strangers about being with someone who looks pretty much like them ("So, you don't date outside of your race?") or someone who appears very different ("So, you don't like your own kind?"). In my mind, both these statements speak more of ignorance and impertinence than racial attitudes. A lack of manners and education, rather than a prevailing community mind. And most likely to be said by someone who is very much alone to a couple showing obvious affection.

Myth And Fantasy

We need to be careful with myths. We need to be as careful dispelling them as we are preserving them. They are sometimes intricately interwoven with our fantasies and fetishes. As we have seen lately, attempts to demystify, deconstruct or destigmatize can unravel the delicate (yes, delicate) fabric of SM fetishes.

Is it possible to have an incorrect fantasy? Are there some we should we just keep to ourselves and never try to bring to life? The Jew and the Nazi? The Latino gang and The Captive Cop? The Plantation Slave Rebellion? Yes, these images are cartoons, one-dimensional cardboard cutouts, stereotypes, but we are all about the exchange of power and these are powerful images. What do these fantasies say about how we actually view other races and other cultures in our "daylight" lives? Is there more than one social/political/sexual level to our community? And are these images acceptable on any level?

130

Add to those: How do we treat straight people? How do we treat the old? The unlovely, the overweight, the just-not-my-type? For that matter, how do we treat the gorgeous? Like morons? Like furniture? Like trophies?

Then the clincher: What can we actually do about these deeply personal attitudes except just talk?

Through The Lens

In his new book, *10 Lenses: Your Guide to Living and Working in a Multicultural World* (Capital Books) Mark Williams has come out with 10 "lenses" that people tend to view diversity issues through. This makes sense to me and takes the discussion beyond just a good/evil, prejudiced/non-prejudiced, bigot/non-bigot level. The 10 lenses are:

1)**Transcendental-** Those who focus on people's shared humanity. A Gallup poll reports 40% (the most often picked of the ten) of respondents who have this as their primary lens.

2)**Colorblind-** Second most common lens. Those who see people as individuals and ignore ethnic, racial or cultural factors.

3) **Multiculturalist-** Celebrates different cultures and the contributions each makes to the society as a whole.

4)**Integrationist-** Those who want to merge different cultures into a cohesive group.

5)**Meritocratist-** Believe that talent, skills, hard work, intelligence will succeed (or should succeed) regardless of race, religion or culture. If you are productive and successful, you earn your place at the table.

6)**Assimilationist-** Believe that different traditions, cultures and

identities should be submerged for the greater good of all.

7)Elitist- Class, family, roots, wealth, social status should be the determining factor for success. This may or may not involve race, religion or culture.

8)Victim/Caretaker- Feel they are suffering the generational impact of past oppression and that they are due compensation from society. Or they feel ancestral guilt for past oppression and feel a need to compensate.

9)Cultural centrist- People who believe the way to improve the welfare of their cultural group is to accentuate and promote its history and identity.

10) Seclusionist- Those who believe the only way to survive is to separate themselves from other groups. They might feel that other groups diminish or dilute their traditions and experiences, by another group's positive attitude or by their mere existence-- much like the idea that the existence of same-sex marriage will erode opposite-sex marriages or straight couples "invade" a gay neighborhood.

Certainly one can apply more than one lens at a time. Which are a few of the lenses that you use and which are some that you react negatively to? Try to dispassionately weigh the pros and cons of each.

Take for example "assimilation" as one way a minority deals with the majority. It is a very loaded concept these days, but for just a moment, suspend judgments of "good" or "evil" and examine it (and each of the 10 lenses) in terms of practicality, societal losses and benefits and as solutions to problems of discrimination. Assimilation as a social solution, I would argue, is less than ideal because it is inefficient and misguided. It usually occurs when neither side really understands the other well enough— in other words, the minority usually ends up assimilating into a distorted, incomplete view of

the mainstream. Both the majority and the minority lose out on the potential contributions of each side and something is lost that might have made the society as a whole stronger and deeper. Conclusion: Assimilation may or not be in itself an "evil", but it decidedly deserves to be discarded as an inefficient and ineffective option.

Measurement

The questions then become: "How does the leather journey differ for a person of color (disabled, senior, etc)?" "Are our community institutions discriminatory and if so: Who (specifically)? How? And what do we do about it?" We must decide what lens or lens-combination is most suitable for our community. For example: "Is our goal to be colorblind or to celebrate the unique and individual qualities that we all bring to the table—including our culture, beliefs, ethnicity, age and abilities?"

And finally, we must have a way to measure our progress. Society as a whole has never quite agreed on a standard. Everyone uses a slightly different yardstick, so which will the leather community use to track itself?

Some have suggested that the number of people of color who are represented in or win international leather contests. Some have suggested the number of inclusion or "POC (persons of color)" presentations or workshops at the annual Leather Leadership Conference to be a measure of progress. There was even suggestion that the frequency of Non-white covermen on skin magazine could quantify racial attitudes.

My reluctance is well known to consider titles (even international titles) as a measure of leadership, advancement or a measure of most anything for that matter. Ditto the agenda of the LLC. Most editorial and art direction decisions in pornography are made on the basis of availability and profitability, not social conscience. Unfortunately, profits pay printers— if you find one that accepts merely social conscience, please contact me.

Some have suggested that an ideal society would be measured by accomplishments which are celebrated as individual achievements, not as "the first Latino this" or "the first Asian that". A society which accepts and glories in the entire rainbow of differences and permutations as beautiful contributions to the species—not to a segment or division of that whole. Others argue that this is too optimistic, that the milestones are still important.

Some people go beyond that, further than I can imagine, to a place where men play with the powerful images of race and ancient hatreds as sexual toys that gratify and satisfy but do not hurt or destroy. A place where proud White masters and proud Black slaves live and don't have to deal with any baggage outside of their own skins. Where the power of hateful words only have power within the fantasy dialog of a dungeon, but mean nothing anymore in the society at large. As I have said before, one must be careful with fragile fantasy and myth.

Human Equality

John Adams wrote, "That all men have one common nature is a principle which will now universally prevail, and equal rights and equal duties will, in a just sense be inferred from it. But equal rank and equal property never can be inferred from it, any more than equal understanding, agility, vigor or beauty. Equal laws are all that can ever be derived from human equality."

We are a subculture that not only recognizes but also celebrates the innate inequality of human beings. Master and slave. Dominant and submissive. Daddy and boy. Trainer and pup. With that in mind, what standards of equal access and equal responsibilities still need to be articulated? At what point do we step too far, putting ourselves in the position of regulating the private fantasies that people share or their libidinous preferences?

Maybe it's because we've been kicked out of a lot of places

ourselves. Maybe it's because in leather, we, too, are visibly different and therefore present the bigoted something to target. The leather community has sensitivity about inclusion that you would be hard-pressed to find in other communities. Not perfect, by any means, but neither are some of the vague and ill-defined calls for inclusion that the community is expected to respond to. Changing institutions, by-laws, rules or procedures are fairly easy compared to changing human hearts. Justice, human dignity, equality, respect— if they are ever to truly exist— will not be based on the fear of consequences, but on the love of these qualities. They cannot be merely enshrined in our institutions, but we must find a way to build them into our lives. As the poet Julien Benda said of peace, "It will not be the abstaining from an act, but the coming of a state of mind."

In leather, there is shared commonality and shared risks. When there are more reasons to share our common humanity then there are differences that divide us, that is when we huddle together as a tribe. In other words: Our community is what we share; what divides us is that which we do not know, what we will not or cannot share. Therefore, what creates divisions and misunderstanding? Not the exchange of ideas, not discussion, not debate, not even disagreements. Only our silence, fear and ignorance.

Preaching To The Unperverted Writing For A Vanilla Audience

How would you explain your SM/leather journey to someone who knew nothing about kink? How would you address the subject of fetish sex to readers who might be completely unaware or even hostile to alternate forms of sexual expression? Truly "virgin territory".

I recently had that challenge when I was invited to write a column introducing SM in a decidedly vanilla magazine called *Numbers*. The magazine has been around forever and is known for smooth, harmless, cloned models and mild, suburban fiction—a classic, corporate skin magazine. It was a unique opportunity to reach readers who might be interested in BDSM activity, might even practice a little pain or bondage, but may not identify it as such. The nature of the publication imposed certain restrictions on how the piece could be written, plus the fact that the magazine had to be sanitary enough for the Canadian market. The list of kinks and behaviors that Canadian Customs do not want to see reads like a really good weekend in Ft. Lauderdale

Like physical restraint, sometimes writers find great freedom in restriction. I found I actually enjoyed writing around the obstacles and squirming within the straitjacket of guidelines and cautions. How to approach it? Writing for *Drummer*, there was an insatiable appetite for more explicit, more shocking, more extreme. It was in-your-face and top-of-your-lungs.

This was the opposite: how to say it without saying it? How to cram the length and breadth of an entire experience into just 1,000 carefully chosen words? I have seen other writers tackle similar territory. There were several different ways to go and other writers would have made other choices, but rather than a listing of methods, warnings, safety or heavy messages, I wanted to introduce the subject by removing some of the intimidation. At the same time, addressing the curiosity that most folks have without taking away

the exotic thrill. The column (reprinted for your evaluation here) was called *Wildside* but was known privately between the editors and I as:

Mildside

I was always one of those kids who ran with scissors. Not the rounded safety kind but the big sharp ones with long blades and the enameled black handles. It wasn't that I was particularly self-destructive, it was just that I was in the middle of something that seemed important at the time and the scissors needed to be from there to here very, very quickly. The concept of doing something forbidden and dangerous was just an added bonus.

My adult life has always been a bit the same. I have always wanted to see and experience as much as I possibly can and sometimes in the exploration lays the adventure. And the kink. And the danger. An uninhibited exploration of sexuality is at the same time exciting but intimidating to begin. Publishing and editing the iconic magazine of gay alternative sex (*Drummer*)— and years of writing and involvement before that— I got asked a lot of questions by people who were curious and excited about some wild, underground thing they had heard about, but always believed "I could never do THAT!"

So what is it that excites you? The stuff you don't tell anyone. Anonymous sex in back alleys? Bondage? Bikers in black leather? Role playing scenes like "The Inmate and The Prison Guard" or "The Bad Soldier and His Sergeant"? I would like to present a few tips for those who think they want to begin that journey beyond the missionary position, explore a little spice beyond basic salt and pepper. Maybe in the future we can address more specific information to help you on your way (and most important, make sure you come back alive). Today, however, just the basics:

-Don't play by the rules. This is your safari, and the idea is to move

beyond the frontier. There are no rules out here. Remember when you first came out? When you broke through that closet door, they couldn't find splinters left behind. This is your "second coming out" into a world of pleasure that defies convention (and occasionally gravity). Don't let anyone tell you are doing it wrong if it is working for you and your dance partner.

There are some rules you can't avoid. State, local and federal laws and most Newtonian Rules of Physics— be careful with those. Toy with the ones that say things like: "That is not right" and "That would feel silly."

-See Life in a Different Way. Thought this was going to be about sex, didn't you? Well, it is. Creative, white hot, unconventional sex. To overuse the phase even further, try "fucking outside the box"— unless, of course, you get turned on by boxes.

Explore the world of sexual alternatives using an artistic eye. Try to look at contrasts and relationships in a new and different way. The relationship of pain to pleasure, bondage to freedom, squalor to beauty, rebellion to responsibility, the tawdry to the sublime. The mixture of yin and yang that exists in everything.

- Plan Ahead. Bringing a fantasy to life is a tricky thing, particularly if it involves complex props and hundreds of extras. And yes, some moments in life are scripted: well thought out, carefully planned, dramatic, rehearsed even. These can very well be moments that burn an image in our memory. They communicate just the right message, at exactly the right time at just the right volume. And sometimes spontaneity is merely poor planning.

I used to hide several handcuff keys at strategic locations throughout my apartment. They came in very, very handy. Take some time to plan it all out. Think about the logistics, the important details and, for just a moment, how to get that stain out of the carpet. These are things you definitely should NOT be thinking about during the act itself.

-Have An Open Mind. True tolerance lies, not so much in proving that all people share commonalties, but in accepting— even appreciating— the differences. You are not going to like everything someone else does, but that is not required. The buffet of human sexuality is nearly infinite; skip the salad, double up on the entrees and try a new dessert you've never heard of.

Each time I think I have just heard about everything that might turn on a human being, someone presents me with something just a little different. Some of them cannot even be shared in an adult magazine, but one thing I am sure of: Out there somewhere, there is someone for everyone. Someone, somewhere shares your fetish.

-Feel Free To Decline. The old joke goes: What does a true masochist say? "Beat me, Beat me!" What does a true sadist say? "No." Feel free in your journey to pick your own path and always feel free to not pick others.

Desperation is rarely pretty. Go slow. Don't bite off more than you can chew and don't inflict more than you are willing to put right. Consider all options, but be smart about your choices. Think. For example, some folks consider gunplay or Russian Roulette to be an intense turn-on. Personally, I would pass on that one but if you insist, use a revolver and not an automatic. Much more sporting that way. After all, we do NOT like to lose readers unnecessarily.

IV. Some Assembly Required *Emergency Leadership Skills*

Advice For The Ambitious Leather Leader Power, Politics And Pity

"The fault, dear Brutus, is not in our stars, but in ourselves."
-(Wm. Shakespeare) Julius Caesar, Act I, Scene 3

We put a great deal of faith in our leaders and icons—be they titleholders, teachers or just folks that seem to get things done and have stuck around long enough to be fixtures. We put a great deal of faith in "community" and "tradition" although we cannot always clearly define exactly what those include. What everyone does seem to have is a clear idea about what the "community" should be doing or when the "community" falls short. I would suggest we are equally as unclear on what exactly to expect from our leaders . . .except to expect a lot.

It is said that the cruelest thing that one human being can do to another is to disappoint them. And we are disappointed on a routine schedule. We are disappointed that the community is not more nurturing towards newcomers. We are disappointed with hollow words and inactivity. We are disappointed with hypocrisy and failure. We are disappointed when our community institutions collapse from neglect. We are disappointed that there isn't more of this or less of that. We are disappointed that "they" don't do something about it.

We are they.

And we all have the choice to lead, follow or get out of the way. As we prepare for the sixth Leather Leadership Conference, perhaps it is the proper time to examine the role of leaders in our community. What do we expect?

After many years of knowing titles and titleholders, the idea that a "titleholder" and a "leader" are (or should be) one and the same is something I cannot yet take seriously. So, "Advice For The Ambitious Titleholder" will be another, separate column for some other time. These are a few notes and suggestions addressed to all those in our community who are called upon by circumstances, capacities, community or by their own ambition to lead— to those who seek protection both inside and outside the visibility of a leather or community title. Also to those who look to the stars for help, solutions, wisdom or someone to blame.

Get The Damned Thing Done

There is little a sailor fears more than a fire at sea. That's why Navy basic training includes extensive fire fighting training for everyone, no matter their rank or rate. When you discover a fire aboard a small ship in the middle of the ocean, you haven't the luxury of calling 911 and letting professionals arrive, evacuate the area and put it out. You are trained to start fighting the fire yourself and sound the alarm yourself. Your life and the lives of your shipmates depend on it.

If you see a need in your community—someone who is sick, lonely, hungry, neglected or abused—you can immediately start to put out the fire. The experts, the professionals, the officers and the stars may not have recognized the same need you have. They might have their hands full. Harry Truman is often quoted about inheriting the presidency, "A day doesn't goes by when I'm not reminded that someone else thinks they could do this job better, but I really don't have time to worry about what I don't have. I'm too busy doing what I can with what I've got." Don't tell anyone, but that is leadership beyond degrees, experience, titles, background and workshops. Just get the damned thing done.

There is a ridiculous notion that to be a leader, one must first have followers. Nonsense. People jump on a bandwagon only if it looks like it's going somewhere. Do what needs to be done, do what you

can and others will come along. . . or not. Either way, as long as something gets done or gets fixed or at least gets started. It's not about being in front of the crowd, it's not about the recognition, it's not about qualifications, it's not about grand ideas or promises. It's all about the work. The results. Put out the fire.

Duty, Honor And Kissing Ass

It may be difficult, in a society which has taught us that there is nothing more important than to be yourself (and a subculture that praises individuality) to grasp the concept of representing something other or larger than oneself. It is an ancient concept, once known as "duty".

When I was an employee handling customer service concerns, I would often have to take responsibility for a problem I didn't necessarily or personally cause. On behalf of the company, I would have to accept responsibility, apologize, and try to find an acceptable solution. Personal vindication (or even being "right") was rarely part of that solution.

Likewise, community leaders represent a constituency bigger than just themselves. They must be pleasant to unpleasant people because it serves a greater good. They must be tolerant of views they do not share. They must make peace when their blood is boiling for a fight. They must put others first. What some would call "kissing ass" is actually merely being "gracious" and getting along because there are more important things at stake. It is seeing beyond oneself and personal pride. It is doing your duty.

I Don't Do Politics

Pity. If you "don't do politics" you are worthless as either representative or leader.

By definition, your "politics" is that bundle of beliefs, values and principles that you bring to your position. Once you express a desire

to effect or improve your community, you leave private life and become a political animal. Without your "politics" you might as well stay at home.

Every arena has its own dynamic of power, principles and the resolution of conflicts. Sports, entertainment, law, religion. If it weren't part of corporate America, the guy who draws Dilbert would have no career. The leather community is not exempt from the normal patterns of human interaction.

The question therefore becomes not IF you play politics, but HOW you play. Fairly? Skillfully? Humbly? Seriously? Honorably? Foolishly? Timidly? Successfully? How do you apply your position, your people skills, those qualities that make you stand out from other people? How do you decide when to speak out and when to keep quiet? What alliances, concessions and compromises are you able or willing to make to accomplish your goals? What good are you?

Politics as often been called "the art of the possible". To that end, start with what is real, what exists, what is provable and practical. There is much in life that is difficult, undesirable, unattractive and unfair but solutions start with a realistic view of what IS—not what should be. Then look for possible solutions somewhere between what exists and what is ideal. Dare to dream, but never confuse dreaming with being awake and making progress.

The Critics

An old saying goes that the instant someone sticks their head up above the crowd, there will always be some son-of-a-bitch ready to hack it off. If you fancy yourself a leader and no one criticizes you, either they are talking behind your back or you have done nothing important enough to comment on.

Theodore Roosevelt once wrote an eloquent and definitive reply to

critics which began, "It is not the critic who counts," but rather, "The credit belong to the man who is actually in the arena; whose face is marred by dust and sweat and blood." Roosevelt praised anyone who tries, who leaves the passive spectator's seat to "do something" and in the doing, ennobles himself, earns a destiny for himself, rather than accepting whatever is handed to him.

He concludes that, win or lose, as long as you have tried great things, your "place will never be with those cold, timid souls who know neither victory nor defeat." To do nothing is the only guaranteed way of never being subjected to criticism

The Cult Of Personality

It has been said that wealth, power or influence can destroy a man unless he can accept his position as a gift from someone else, a stewardship that he administers on behalf of a community, a cause or a god. If for one moment he believes that he himself created that power, he is doomed. Something larger than himself is supposed to save most leaders from selfishness, corruption, despotism or zealotry—or from creating a Cult Of Personality.

A COP occurs when the entire organization is dependent on one individual. Everything must process through one person. Leather leadership leans towards the autocratic to begin with, but even the most well-meaning leader can easily create this situation accidentally when he shoulders more and more, not wanting to bother anyone by sharing or delegating. Unfortunately, if the chief becomes disinterested or incapacitated, everything that has been built collapses. We saw this time and time again as the best of our community passed away without having trained their successors. The cause, the goal and the community must be separated from any one personal destiny. From Day 1, the wise leader trains and mentors those who will succeed him. Each generation must plan for their eventual displacement.

Just as one should not confuse duty for martyrdom, one must constantly be careful not to confuse strength and arrogance. The difference between, "It is right because I believe it to be right" and "It is right because I say it is right." Too often, everything gets lost in the in the frustration and despair that sometimes comes in the middle of an event or project. As the old saying goes, "When you are ass-deep in alligators, it's hard to keep in mind why you wanted to drain the swamp in the first place." Once the key to survival becomes just dealing with the alligators, you're screwed. Find some way to periodically regain perspective.

Leadership often visits those who are unprepared and undeserving. It can also take one unaware. Some folks toil for years, focused purely on a goal— building organizations, coalitions and whole communities to support that goal, oblivious to the fact that others have begun to depend upon them and look to them for solutions. You didn't run for a title or go though all the right workshops. You didn't carefully build a powerbase and bank the favors that everyone owes you. Even so, all of a sudden you are now a leader and it only remains whether you will be a successful leader or an unsuccessful one.

Winning The War

According to Sun Tzu in his famous treatise "The Art of War" there are five essentials for victory:

"1) He will win who knows when to fight and when not to fight.

2) He will win who knows how to handle both superior and inferior forces.

3) He will win whose army is animated by the same spirit throughout all its ranks.

4) He will win who, prepared himself, waits to take the enemy unprepared.

5) He will win who has military capacity and is not interfered with by the sovereign."

145

Simply put, you have the opportunity for success when, 1) You pick your battles and causes carefully. 2) You know what to do both when in the lead and when falling behind. 3) You surround yourself with those who share your vision. 4) You have done your homework: The unglamorous, unrecognized "gruntwork". 5) Having done your homework and made yourself capable, you are allowed to succeed by the community.

The Sin Of Pride Community Projects And The Seven Deadly Sins

"There is none so righteous as an ex-sinner who finds salvation and none so enthusiastic as an ex-choirboy who discovers sin."

For many of us, that famous collection of "Seven Deadly Sins" was always more of a shopping list than a dire warning. What few people know is that it is actually a hidden (if somewhat loose) outline for certain community projects.

After six years of operating at various levels of the San Francisco leather community, I finally figured I knew a little something about how things worked, who to look out for and how to look out after myself. It was equally apparent that one of the most thankless and least likely jobs to enhance one's reputation was to be in charge of assembling the San Francisco Leather Pride Contingent for the SF LGBT Pride Parade each June.

The Leather Contingent is one of the largest, single contingents in one of the world's largest pride parades. An estimated 1 million people either participate in the Pride Parade, attend or watch the live TV broadcast. After years of effort, the Leather Community has clawed their way up from the back to the first quarter of the Parade.

The job consists simply of getting 400 very independent-minded folks all pointed in the same direction at the same time, then get the hell out of the way. It also entailed trying to get them to anchor their expectations in practicality, adhere to deadlines, fill out forms and a myriad of other small details that resist each other like a force of nature. Guaranteed to please none of the people, none of the time.

The people who had put together the Leather Pride Contingent the last few years refused to do it. The first meeting to discuss a Leather Contingent was called by the SF Pride executive director in March.

The notice went out far and wide but besides the director, I and only two other people showed up— and none of us had ever put together something like a parade contingent before. That is basically how I ended up with this prize.

I learned some humbling lessons in community dynamics, but also a great deal about the Seven Deadlies (Envy, Anger, Gluttony, Sloth, Lust, Greed and Pride) as well:

Envy
Since we would be responsible for one of the Parade's honorary marshals (a beloved elder in the leather community), I decided that this would be a good opportunity to begin a tradition of having our own "Leather Marshal" for the Leather Contingent. This would allow us to honor our own regardless of who the Parade as a whole selected for their Grand Marshals. We had someone to start it off and thereafter, the volunteers that put together the Contingent could pick the Leather Marshal. Suddenly, I was bombarded by howls of protest by critics who were envious of the affection this man holds.

There had been so much in-fighting in the past that the Leather Contingent had splintered into 3 or 4 different groups by the time the previous Parades hit the street. I felt like the Inquisition extracting confessions as I tried to get the people with experience to tell me the most basic of information: How did this work last year? Who did they contact about this or that? Answers, when they came, were often vague or wrong.

There was a spat over what we could call ourselves, claiming that an individual registered a name years ago and "owned" the contingent. No one seemed to know for sure what the actual requirements of the SF Pride committee were. It turns out that even the banners and flags used in Parades past were owned by individuals who guarded them as if they were sacred relics to be handled like the Shroud of Turin. It became apparent that many were envious of anyone taking the job and having success in areas where they had been unsuccessful.

A little research at city hall and a few filing fees, and we had all the names we could want or need, this time registered to a community-wide organization instead of an individual. An invitation to an out-of-town color guard put to rest the use of sacred relics. One by one, obstacles were worked through or worked around.

Anger

Most anger, it is said, is born of frustration. The Leather Contingent is frustration personified, but never more so than the morning of the Parade when folks so generously contribute their frustrations on top of your existing ones.

Even with the best of intentions, people say the most inane things when they are trying to be reassuring. They would come up and say, "It will all work out- it always does every year." Well, of course it all works out because every year some poor, stupid son-of-a-bitch is working his ass off to make sure it works out!

Then there are the ones who appear mere minutes before the Parade starts and want to rearrange things. They don't like the order, they would like to do this or that, or they would like to add a 40-foot truck at the last moment. Sweltering in the sun as six to twenty different people compete for your attention, your explanation of the long vehicle permit process, the rules and requirements of the Parade Committee, the needs and concerns of 23 competing organizations and the months of delicate negotiation which resulted in the existing order of things comes out as just one word: "No."

Need further explanation? How about: "Fuck No".

Large projects like this require planning and cooperation. If you are not willing to be involved in the planning, you have only the one other choice once those plans are set: Shut up and cooperate. If you don't like it, my job is open next year. I suggest you start early.

Gluttony

After it was all over, I was approached by the former chairman of the Leather Contingent and told that I did a good job, considering that many people had had their doubts about "letting" me organize the contingent (Gee, I wonder if any of those folks were at any of those early meetings?). With great magnanimity, they would "consider" keeping me on in a "limited role" next year.

Beg pardon?

If this was a tactic designed to infuriate me into remaining in charge another year, it nearly worked. Either I am nearly that dumb, or nearly that infuriated. I am not, however, nearly that much a glutton for punishment.

Sloth

In some communities, the leather experience tends to be very participatory. People arrive at an event a little early, roll up their sleeves and ask, "What can I do to help?"

In some larger cities, however, the community tends towards spectators and consumers. They pay their money, get their ticket, find their reserved seat and expect to be entertained. The most vigorous activity is the complaints if they don't think they got their money's worth.

I can remember Pride Parades that were liberating because it was risky, exhilarating because someone might see you on TV and know that you were gay and a member of the leather community. I remember a contingent of people marching with paper bags over their heads because they were teachers, parents or government employees who still had too much to lose. Neither too long ago nor too far away.

In a way, maybe the real triumph of 30 years of Pride Parades actually rests in those people who do nothing. We have fought and

won the right to be complacent. To stay home because it's (yawn) just another Pride. To leave town because we don't want to deal with the traffic, the tourists and the mess. Since there is no risk to our jobs or positions if we march, we don't.

We have won the right to be as lazy and apathetic about freedoms we have only recently secured as the majority of Americans are about the freedoms they have always enjoyed. Hoorah.

Lust
Actually, one of my favorites as cardinal sins go.

As it turns out, Lust regrettably had little to do with the planning and execution of the Leather Contingent. A little more lust (either for each other or for life itself) might have put petty squabbles in a larger, global and more important context. Like maybe sex.

At the very least it would have gone a long way to make some of the folks less cranky.

Greed
I kind of like Greed, too. It is a great motivator (not as good as Lust, but fairly reliable).

I suppose that everyone who participates in a gay pride parade of this magnitude wants something in return. A little time on TV, the rush of marching down Market Street to the cheers of millions, a little exposure for their club, business or organization, or maybe just the feeling of contributing. With 24 different groups competing for limited and highly subjective returns, however, some commonality of purpose is required. As in business partnerships, we must realize that as one of us profits, we can all prosper. A united effort benefits all parties.

I don't really know what held the troops together except that instead

of fighting among themselves, I presented them with a common enemy: Me.

Pride

Certainly I owe a lot to the people who have organized the Leather Pride contingent before me. They laid great groundwork but like most visionaries, with each accomplishment they seemed to add additional baggage that had to be dragged along the eight-block parade route.

Our goals were 1) to keep the Leather Contingent united, 2) to improve our live TV coverage, and 3) to improve the relationship between the SF Pride Committee and their largest contingent. We were successful in each, and I take a few indulgent seconds of luxurious pride in the accomplishment. But beyond the fights and the organization, there was has to be more to Pride.

The SF Pride Officials had hounded us for weeks about allowing big gaps to open up in Parade and sure enough, halfway through the parade route, a quarter-block long hole opened up right in the middle of the Leather Contingent.

Dutifully, I ran back to try and hurry folks up and close the gap. As I walked back to rejoin the main part of the contingent, I found myself marching down the middle Market Street, completely alone, in front of a crowd of nearly a million people. Suddenly, I realized that I was not alone, that this was not an empty space in the parade. That space was filled with the ghosts all of the friends, lovers and club brothers who still march with us. It was an awesome experience, and it affected me most unusually. In full leather, in front of a million people, I was crying.

I was able to pull myself together by the time I caught up with the rest of the group. Immediately, I had to get back to the task of dealing with safety monitors, vehicles and directions. Everyone just thought it was sweat running down my face, and I explained my

eyes were red from the sunscreen melting off my forehead.

We may march for many different reasons, but the important thing is that we still walk together.

Get It Done Overcoming Operational Paralysis

A leather titleholder is scooped up by police when a private scene gets out of hand. A community elder loses everything in a devastating fire. An angry picket line forms outside your BDSM educational conference protesting the "immoral influences" inside. A hatchet piece airs on local TV about "Sex Slaves, Whippings and Torture in Our Town…Don't miss the shocking video tonight at 11:00!"

What do you do? Me, I take a deep breath and a little history.

History— far from being long dead and carved in stone— is a living and dynamic conversation with many different sides and new information surfacing all the time. The past always has something to say to how we live and work today.

Take the words of Admiral David Farragut during the battle of Mobile Bay during the Civil War (also known in some quarters as "The War For Southern Independence"). Every schoolchild knows Farragut shouted, "Damn the torpedoes, full speed ahead!" as he sped toward the enemy. One imagines this courageous commander dodging the hurdling streams of subsurface projectiles and pressing forward.

"Torpedoes" at the time were not the self-propelled underwater missiles we think of today, but referred to stationary, moored explosives. Farragut was steaming full ahead into what he knew to be a known, fixed position minefield. Now what do you think: Courageous or stupid?

Sometimes you will be required to step up to a job, a project, a problem or a situation that no one else wants to face. There is something unpleasant and difficult to be done and you get to do it. There is damage and you have to fix it.

154

Emotions are running high. The community may be scared, angry, divided, unclear about which direction to go. The battle rages around you. How do you clear your head of all the extraneous noise and focus on solutions?

A Hero Ain't Nothin' But A Sandwich

Although full speed through a minefield is often unnecessary and highly unrecommended, there are those times when the only course possible from Point A to Point B is right smack dab through the middle. It's a lousy position to be in and your only choices are A) to do the best you can with what you have or B) run away, leaving somebody else to deal with it. One option has the very, very small possibility of being hailed a hero; the other has the near certainty of proving oneself a coward.

In the desperation of battle the options may be obvious, but in the seemingly small and tedious challenges faced by a relatively comfortable and complacent leather community, the distinctions are more subtle. There seems to be few immediate threats to our community or one's own, personal sexual freedoms. With little risk to doing nothing, there appears to be no need for courage.

Courage is not the absence of fear, but that which— in spite of the fear, the difficulties, the risk and the odds—drives us to do what we know must be done. When faced with an emergency or problem, "DAMN 'EM!'" can be both a defiant mood-setting sentiment and a somewhat silly memory tool for the steps required for problem solving:

Define the problem.

Assess the damage.

Map the strategy.

Neutralize the opposition.

Execute the repairs.

Measure the results.

Define the problem.

You can't go very far without figuring exactly what is wrong or clarifying what the goal is. Get the facts straight. Was there a miscommunication? Is there a real problem or is someone overreacting? Was there actual damage, and if so...

Assess the damage.

How far have things gone wrong. Is it repairable? Should it be fixed? How do you fix it? Where did it go wrong and when, if ever, was it right?

Map the strategy.

Come up with a plan. Take an inventory of what you have and what you need. Do you have the right tools, supplies or skills? Do you need help? How long have you got? What will it take to fix (or at least mitigate) the damage? What are your priorities?

If the job looks too big, how can it be divided up into smaller components? Can work be delegated to other individuals or groups? And at what point do you justifiably panic, scrap the first plan and shift to "Plan B"?

Better also come up with a "Plan B."

Neutralize the opposition.

You now have your plan. You know the obstacles in your way. Reduce or eliminate the potential problems before you start. If you need to make peace with individuals or groups who will oppose you, do it. If you will need permits, licenses or permission, get them. Co-opt the opposition by making them a part of your solution.

Remove the known obstacles to your success *before* you begin; and don't worry, you will have plenty of unforeseen problems crop up to keep it all exciting.

Execute the repairs.

This is the hard part: Do it. You have what you have, you know what has to be done, you know your deadlines, you have the plan, the help...now set the date and do it.

Measure the results.

Follow through. How well did you do? Did it work? Is the problem fixed? Will it require maintenance? Occasional replacement parts?

I used to sit down with my staff after every issue of a magazine or each event and do a page-by-page "post-mortem" on the project. What went right, what went wrong, what worked but could work better. It was tough at first, but we found that eventually we were talking about very trivial details—which meant that we had improved the product to that extent.

Some folks hate revisiting their work. They don't take notes, they do not listen to criticism nor do they invite evaluation or suggestion. They tend to repeat the same mistakes year after year, contest after, contest, project after project, stunting any growth or maturity. This condemns the work, the community and the people involved to a blissful but endless, stagnant, perpetual adolescence.

Landing vs. Crashing

Too often, our leather community seems to prefer "management by gravity." Many projects are allowed to just fall into place. Consider that the main difference between an aircraft landing and an aircraft crashing is a certain amount of over-engineering. The end achievement of both is essentially the same: The plane eventually rejoins the earth. One result, however, is considered more advantageous than the other.

To get the result you want, it is not wise to rely solely on luck or gravity. True progress is guided, planned, cultivated and nurtured. It doesn't happen by accident.

You must be able to invest enough of yourself to fire the project with your passion, but keep enough distance so that you can accept constructive criticism without being personally devastated. You must actively guide the work, but separate the success and future of the project from your own personal destiny. You can stamp a project with your personality, but never your ego. This requires a delicate balance that is best not left to chance.

Entering the minefield is not the hardest part. That is something that *can* happen by accident. What takes planning, and what measures you as a leader, is coming out the other side in one piece.

When Good Events Go Bad Or, Why Did My Last Fundraiser Tank?

Maybe it's that theatrical gene. We seem to be a community that revolves around events, fundraisers, leather contests, motorcycle runs and productions which require some basics of lighting, sound, event planning and logistics. Some folks have a talent for it, some don't. Like writing leather columns, some people persist for years regardless of talent.

It's really not fair. Titleholders with no experience or professional background are judged on how well they plan and execute events and how much money is raised for local charities. Clubs can live or die by successful runs and bar nights. For those brave unsung heroes who face the daunting task of planning events and fundraisers, I can offer a few very basic suggestions for events of all sizes. (Note: If don't see this as ever applying to you, thank your luck, just sit this one out— and never, ever miss the meeting when they assign committee chairs).

Nothing went the way I planned it

Two questions: 1) Did you actually have a plan? and , 2) If the plan didn't work, why and was this necessarily a problem?

Many amazing discoveries are made by accident. Gravity. Vulcanized rubber. Duct tape. When events take an unexpected course and the results are positive, experienced planners just smile wisely and say, "Yes, that's exactly the way it was supposed to work." Sometimes, they are actually believed.

A few scribbled notes on a cocktail napkin the night before the event, however, is not a "plan". The more advance planning the better, but understand that the purpose of having detailed schedules and budgets are to alert you when you are off schedule and off

budget. So, even if everything didn't follow the grand scheme, your advance work serves an essential purpose.

Eventually you will have made all the mistakes, but the key is to learn from each one. If your expectations did not meet the reality, you must first determine where the problem was: Your expectations or reality? Did you miss something you could have foreseen or did your unstoppable force meet an immovable object? Once you know where the breakdown occurred, it is time to decide to either to modify the plan to meet reality or to bend reality to conform to the plan. Both approaches can work, given enough time and sheer force of leather will. Outside of that, simply repeat the annual event planner's sacred mantra:

"We'll fix that next year."

Nobody Showed Up

This would be the responsibility of the publicity committee. What kind of publicity did they generate? The word needs to get out often, everywhere and early.

It begins with that nasty advance planning thing again. Did anyone check out what else is going on that night? How early were decisions made so the word could get out? Did the finance committee change the ticket prices four times in two weeks?

Posters are great. Where did they appear? What did they look like? Hint: If you are advertising primarily in bars and clubs, a poster which cannot be read from 4-6 feet away, in low light, after a shot and a beer is a waste of trees-- no matter how sexy and artistic.

Was there notice in the local gay or gay-friendly newspaper? Did you plan on deadlines? It does little good for a monthly publication to receive notice of your event 30 or even 45 days before the date. It's too late. Make sure they have all the correct information at least

2-3 months before you expect it to publish. Same with weeklies. Call and ask when the closing date is for the issue you want to appear in.

Don't forget the websites. So many communities now have excellent community bulletin boards. Maybe they will let you post a few photos of this year's event (happy shots of folks who just won the wet jock strap contest or kissed the guest porn star) to generate interest in next year's event. If no website exists, maybe a friend could create a website just for your event and start arranging links with most of the known Universe.

Today it is fairly easy to spread the word about an upcoming event through a short, carefully worded email. Make it look like juicy community gossip and everyone you send it to will pass it on to their entire address book, who will send it to theirs, and so on, and so on.

I Had 20 Volunteers-- Now I Have 2

Trust me on this: you CAN fire a volunteer. Free help causing problems can end up costing you more than hiring a professional. Volunteers require respect, they require adequate materials and time to do their assigned task. . .and they require you to expect the very best they are capable of.

That said, good volunteers should be treated like gold and they still must be paid. Paid attention to, at the very least. Budget a few bucks for the volunteers. If they have been working all day without a break and some of them seem to be dropping from hunger, perhaps you could send out for some sandwiches? Are they identified as "your staff?" Make sure they don't get hassled by security or the house staff. Set up a water or soda tab at the bar or arrange for drink coupons. Watch their backs and they will watch yours.

Did you thank them? Did you spell their names right in the program?

Insult them from the stage? Oh yeah, it happens. At a contest Meet and Greet recently, a member of the community had stepped forward at the last minute to make dinner for several dozen hungry contestants, judges and volunteers. From the stage, a well-known leather MC actually insulted the homemade pasta dish that was served while I watched a stunned expression on the cook's face. Confine your sadistic side to the dungeon.

The Bar Doesn't Seem So Happy To Work With Me This Time

Is it because you plastered their men's room with posters for your last event— which was held at a competing bar? Bars are our community meeting houses and social centers but each is also a business. They must pay the rent, meet payroll, taxes, bills. They must compete with other bars for business. Be a little sensitive to this before you throw a hissy when the manager has no room for 150 flyers which encourage his customers to go elsewhere.

Whether it's a leather bar, hotel or a rented hall, your relationship with your venue is very important. Of course we expect our community businesses to be cooperative, but are you? Was the entertainment appropriate for the venue or did the bar clear out at the drag diva's first screech? How labor-intensive are you to work with? Did you whine and pester the manager about every little detail? Did you assure him that you would provide your own scenery and then demand tape, hammer, nails, lumber, paint and a couple dozen strong stagehands? Did that little naked revue at your last event cause the state to suspend their liquor license for 30 days? Funny how those minor things can affect your welcome.

Did you make any money? A successful event makes beneficiaries, bars, volunteers, sponsors and community happy— and success breeds success. Make sure you follow up your event with press releases including who won, how much was raised and how much fun was had by all. It makes that next event so much easier.

All I Got Was Complaints

That might not be such a bad thing. If those complaints mean someone cares about what you are doing and is willing to help you improve the product, you have won half your battle: You now have folks engaged.

On the other hand, there is always a rash of recreational bitching. The great Jerry Roberts taught me a trick years ago that seems to take care of the ones who just kvetch to hear their own voice: Print up some pocket-sized volunteer cards with blanks for name, contact information and position volunteered for. When someone comes up to you with a complaint, hand them a card, ask them to fill it out and tell them there is a spot on that committee for next year's event. Since Jerry made that suggestion years ago, I have never actually had someone take and fill out a card— but it silenced their complaining very quickly.

I Will NEVER Do This Again!

Sure you will. It gets easier each time you pull a successful benefit, run or dungeon orgy together. You build up a surplus of ideas over the years, favors owed, a closet full of props and you have already made most of the mistakes at least once. Like any family reunion, there are rewards and hazards to any gathering of our vast, diverse and dysfunctional kinkdom. Like a lot of edgeplay, however, half the thrill is the rush when it's over and you realize you have survived.

Twenty Things One Should Never Say Into A Live Microphone Amplified Survival Tips

At certain times of year, across the mountains and plains of this great country of ours, like moths to a flame, idiots seem to flock towards microphones.

In bars, at contests, fundraisers and events across leatherdom, there are open mikes that will find their idiot. Still, the mistakes made by amateurs around live sound equipment seem to be fairly common and fairly avoidable.

Unfortunately, I have often been called upon to say a few appropriate words even though I tell them I am a writer. I hate public speaking. In oratory, there is no opportunity to edit, to rewrite, to run spell check or make corrections like there is in print. On the plus side, unless you are being recorded there is no permanent record of what was said, so while in print it's rough to later claim, "I never said that!" it will occasionally work if it was only spoken. So, for the record, I present this list of things to avoid- and things that I have never, ever said into a microphone:

1) *"Are we having fun yet?"*
You're looking for a few seconds of placeholder while you come up with what to say next. Sure, I know this sounds like a great audience participation, "get 'em shouting" sort of rouser…but in fact it is a definite no-winner.

It forces people to stop, to think, to check, to evaluate. Are we having fun? If no, is that my fault or is it that moron up on stage? If yes, do I really have the right to be having fun when there is so much hunger and misery in the world? Either way, it shatters the illusion that the event was trying to create.

Trust me, it's best just not to go there.

2) *"Can you shut up back there? Can we have it quiet for just a minute?"*

164

It's a crowded bar doing what bars do. For whatever reason, you are on the public address system. There is only so much you can ask for. It is up to you to deal with the situation, not the other way around.

You are asking people to interrupt their lives and conversations. Assuming they are having a good time, you are asking them to stop. You are asking for the purposeful commerce of the bar (which pays rents and salaries) to cease. You better have something damned important to say.

It better be right up there with announcing the second coming or pointing out the fire exits because the building is burning. If you demand that much attention, and then blather the same useless "community and unity" speech that six speakers before you did, your audience will be justifiably miffed at the deception.

3) *"Now, listen up. This is important…"*
Never tell them what you are saying is important. Just go ahead and say something important.

You can, however, repeat your message if you think that it's worth it. Take a look at the repetitive cadences of many of the world's great speeches. The same message is repeated again and again, put in different words, served with different flourishes. Give your audience the opportunity to discover for themselves the importance of your words (which is much more effective) and by the time they soak in, you have already delivered your message a couple more times.

4) *Anything spoken in a language you are not really fluent in.*
A few years ago, a titleholder delivered part of his step down speech in such abominable French that the current animosity between this nation and France can probably be traced to that fateful evening. A few words can be charming—like "Ich bin ein Berliner."—but much more than that can cause serious international damage.

5) *"This may sound stupid but..."*
Why would anyone say this!? Why not just paint a target on your belly and hand out a few dozen throwing knives? An audience's capacity for compassion is hardly infinite to begin with; but why break your own leg just to get a head start on disaster?

6) *"I would usually not say something like this about someone else..."*
Then don't. This line generally comes before something you will later regret saying.

Making a speech is a lot like hunting. Don't point your gun unless you intend to shoot something. Make sure you hit what you are aiming at and make sure you kill what you hit. In either case, a merely wounded animal can be very dangerous.

7) *"Someone who needs no introduction..."*
...usually gets the longest. Yeah, we know. It's an old joke, so why do people keep doing it?

Avoid being a cliché. Be brief. An introduction should not be longer than whatever or whoever it is you are introducing.

8) *"I am so happy to be here in Toronto."*
That's not really a bad thing to say...except that it was in Vancouver. Beware jetlag.

9) *"We're doing this for you."*
That may very well be. Many wonderful things are done in the name of the leather community. However, if I were about to say that to a diverse gathering of leatherfolk, I would take a moment or two to make doubly sure of the sincerity of my motives.

Folks do things for a lot of reasons: recognition, fulfillment, ambition, ego. All of those reasons are perfectly valid, but if you say that you act in the name of others, don't be surprised if those "others"

start asking for some level of accountability and involvement. By invoking their name, you have granted them that right.

10) *"We've all worked so hard and sacrificed so much."*
Martyrdom is a volunteer position. Not appointed, elected or selected— ultimately, you choose it. So, don't prattle on and on about how you or your committee have done such a heroic job against impossible odds.

For one thing, if you make your work sound like crawling through the Gobi Desert you will NEVER be able to recruit new volunteers—particularly for your position— meaning you will be stuck doing this forever. For another thing, you will cause folks to question your judgment. If the job is so awful, why do you still do it? Aren't you smart enough to either make it easier or else leave?

11) *"This may get a little complicated, so bear with me…"*
This should be obvious: Do not try to present complex ideas to a crowd that has been drinking and is mostly united by the search for sex. If you feel you have to warn folks about it, it needs rethinking.

12) *"I don't care what you think…."*
This also should be obvious: Do not piss off a crowd who own their own vast collections of torture devices, both manual and electrical. If you don't care what we think, step away from the mike and don't waste our time.

13) *"Frigging," "A-hole," "Ka-Ka," and other kindergarten euphemisms*
The story goes about some prudish old biddies who approached Bess Truman (wife of President Harry Truman) to complain about the President's famously foul language. Citing everything from the decline of morals to the effect on America's youth, they were specifically complaining about the Chief Executive using the word "manure." Mrs. Truman sighed, "It's taken me 30 years to get him to use that word."

167

General George S. Patton used to say about addressing his troops, "I give it to 'em loud and I give it to 'em dirty. That way they remember it." If you want to raise the level of discourse by avoiding off-color words completely, fine— but using cutesy little fill-ins for offensive words is like trying to remain a partial virgin. We are pretty much an adult community, we can take it. It sounds silly and paternalistic for people addressing a leather crowd to substitute childish gibberish for perfectly respectable obscenities. If that's where you are going, you might as well go all the way with every "fuck," "shit," and "asshole" you need to get your point across. We have fought for the freedom to use bad language, so say the words with appropriate relish.

14) *"...and I'd to thank Jim. I mean John. Oh, is it Jerry? Well, you know who I mean."*
Everyone screws up names and titles occasionally—that is still no excuse. If you need to, take a moment or two to write some notes. Get it down on paper so that you say it right. Don't "wing it."

15) *"And don't forget the event tomorrow night at the other leather bar down the street."*
Oops. Did you just use one bar's good graces (and sound equipment) to suggest that all his customers pack up their money and take their business to the competition tomorrow night?

Depending on the business climate and location, some bars or businesses have no problem with that sort of community cross promotion. Some of them do. It is best to check it out before you get yourself in trouble.

16) *"Also with us tonight is Mr. Leather Cuddles 1987."*
Often, leather events will have a "protocol list" which makes sure that current titleholders in attendance are recognized from the stage. Some events have volunteers who walk around making sure they get all the names and titles correct. Sometimes it is a self-sign-in. At a Mr. San Francisco Leather Contest not long ago, the reading of the

protocol list took nearly a half-hour of the program!

Reading name after name after name begins to morbidly resemble a reading of the dead and thankfully, most events have dispensed with this practice. However, if such a courtesy is extended to you please confine yourself to any title you currently hold that you actually had to compete in a contest for. I know you are very proud of that sash you won four or five years ago or the pet name bestowed by your leather family, but it is now time to move on.

17) "... 'Nuf said?"
Probably the stupidest line of printed or spoken word. If enough has been said, there would be no reason to point that out so dramatically. If there has not, then you have just admitted that, even though you have not completed your task of enlightening your reader or audience, you have run out of things to say. In either case, it is for them—not you—to decide when they have had " 'nuf."

18) "It's great to be here tonight at the RRCC with the MTLC and the NLA to raise money for NCSF and the HRC."
We sometimes tend to speak in such insider jargon and acronyms that folks outside our little circle need subtitles to translate the alphabet soup. For the benefit of folks not quite as inside as you, please explain at least once during the evening that "NCSF" is the National Coalition for Sexual Freedom (or is it Neolithic Conference of San Francisco?) and that "NLA" is the National Leather Association (or is it the Nebraska Legal Academy?).

19) "Uhmm, er...ah, gee, I wasn't really prepared to say anything tonight..."
Some surveys say that people fear public speaking even more than death or financial ruin. Why then do people leap onto a stage with no training or preparation?

Being born gay you obviously have natural abilities for flower-arranging, fashion, interior design and witty public speaking, right?

Well, for those of us who missed the Noel Coward gene, the only remedy is hard work, maybe joining a Toastmasters International group or practice with lots and lots of notes. Winston Churchill was said to have spent an hour of preparation for every minute of a speech. Spontaneity can require a lot of practice.

20) *"I would like to apologize for the recent unfortunate incident which involved kitchen utensils, a waiter and various forms of livestock."*

Don't ask. I'm just saying that you should never get yourself into the position that you are forced by court order to say something like this. That's all.

A Study In Power Politics Are We Still Boycotting Coors?

This question came from the manager of a popular leather bar when approached to carry Coors brands. He asked me because I had an article in a recent Folsom Street Fair Program which also featured an ad for Coors Lite. Then, of course, my editor at LeatherPage.com, Joe Gallagher, has made his opinion regarding Coors abundantly clear.

You're trying to get me in trouble with my editor, aren't you? All of them at once.

History

For those of you who don't know, nearly 25 years ago Coors Brewing Company had a rotten reputation of active discrimination. They had a little problem with race, unions, greens and gays. Actually, they had a little trouble getting along with much of anyone, which added up to one Rocky-Mountain-sized attitude problem. As a result, a boycott of Coors and Coors products was initiated by a wide coalition of unions, Hispanic and African American organizations, environmental groups and finally, the gay community. The story of how these disparate factions united is an important and inspiring chapter in gay history specifically and activism in general.

The boycott against Coors in San Francisco, crafted by an alliance between the gay community and the powerful San Francisco unions, made the brand virtually nonexistent in the Bay Area for decades. It was one of the first exercises in gay political power cooperating with unions and essentially made the political career of one Harvey Milk.

Today

Coors backed down on their anti-unionism. They instituted environmental controls and tough anti-discrimination policies— even domestic partnership benefits. One by one, those other

partners have made peace with Coors. Even in San Francisco, you can see Coors products in some union houses (bars) and you can find Zima or Killians Red (Coors products) in some gay bars. The local distributor reports that the bar which sells more kegs of Coors than any other customer is a gay bar. Coors Lite advertises in gay publications and sponsors gay pride events across the country. Company publicity machines are quick to parade Scott Coors, openly gay family scion. A poll conducted by the *Leather Journal* in November 2000 asked: "Should the Leather community accept money form Coors Brewing Company?" Slightly over two-thirds of those polled said it is time to get over the boycott and restore normal business relations with Coors.

Usually for me, the fact that a majority supports something is reason enough to be particularly skeptical. But the question gets even more interesting.

The main objection today is that Coors profits, through the Coors family, funnels money to antigay causes that have fought same-sex marriage and legal protections in Colorado, Hawaii and elsewhere. Organizations like the Heritage Foundation. The Heritage Foundation, however, also received donations from, among others, the Amway Corporation, USWest and over $100,000 in one year from United Parcel Service.

In a diversified, global economy, to what extent do we penalize a company for its history or the behavior of its stockholders, officers or a minor subsidiary? Aetna, New York Life and other insurance companies insured human beings as the property of slave owners. Daimler-Chrysler made tanks during WWII—for both sides. Should gay publications turn down ads from any of these on principle? Should a gay writer or artist turn down an assignment from a publication who doesn't?

Pulse

In an attempt to get an objective "read" of prevailing public opinion on the subject, I did a few simple Internet searches with some interesting results:

-Coors competitors Anheuser-Busch (Budweiser) and Philip Morris (Miller Beer) also have active boycotts against them. So do nearly every major US corporation, several states, cities and dozens of countries. Some of the Disney boycott sites were a hoot.

- In addition to the gay boycott, an organization called RAMP (Restore America's Moral Pride) calls for a boycott of Coors for offering same-sex DP benefits. So is that Rev Fred Phelps fellow (the sub-human creature that pickets gay funerals and maintains the <godhatesfags.com> website).

-Randomly entering "Coors" and "Coors beer" into several search engines curiously came up with the same website on "the health benefits of drinking urine"— I am not kidding.

This was far from an exhaustive and scientific search, and results will vary each time you enter keywords and from search engine to search engine, but it did prove two points: 1) Calling for a boycott is the western secular equivalent of issuing a fatwa. Some work, most are ignored, some are plain silly, and, 2) It's a very weird world out there. If "the enemy of my enemy is my friend," what do you do when you find yourself standing on the same side as RAMP and Fred Phelps?

Should you boycott Coors? We all have to gather whatever data is available and choose for ourselves. Jumping on a bandwagon is not always the best form of transportation—but then again, neither is walking with questionable companions. Perhaps the better solution would be to allow the marketplace to decide. Not only the commercial marketplace of beverage sales, but the marketplace of

ideas where an assortment of messages and positions are put forth in both advertising and editorial. If it is not yet time to end the boycott, it is certainly fair to examine if it still enjoys the popular mandate it once did. At what point does a sinner obtain redemption? Is redemption possible for the sins of Coors?

Personally

Since it becomes a personal issue at that point, I, personally, don't drink Coors or Coors products. 24 years of habit is hard to break. Then again, Jack Daniels is distilled in a dry county of Tennessee where you can't even buy liquor— but somehow, that is hypocrisy I can understand.

As an editor and publisher, Coors never advertised in *Drummer*. Of course, the fact that they were never asked (and very likely wouldn't if they were) made the decision not to take their money pretty easy. My one experience with Scott Coors was when he was introduced to me at the last International Drummer Contest held in San Francisco. The then current IML and a prominent San Francisco leather writer wanted complimentary VIP tickets for him and I said that we would be happy to have Mr. Coors attend—VIP tickets are $65, standing room only for $30. No checks.

I was severely criticized for that— and from some very surprising people. Fuck 'em. I generally bought a ticket to each Drummer contest myself (some of the best protection money I ever spent) so that when some self-important mooch wanted free tickets I could pull it out and say, "It's for charity. If I can buy a ticket and I'm writing the checks, so can you."

You see, I try to be an equal opportunity curmudgeon. If you steadfastly maintain hostility in all directions, eventually you find your guns pointed towards the right enemy.

V. Where The Elite Meet To Beat *Surviving Leather Contests*

Advice For The Ambitious Contestant

According to the Emperor Napoleon, *"Between the sublime and the ridiculous is but a step."* Likewise, between January and June, well over 100 leather contests are held in the United States. This is the season when leather and ambitions come out of closets across America, get buffed, polished and refitted to run for more titles than are contained in Burke's Peerage. Like any other minor nobility, leather titles have their share of stars and statesmen, inbreeding and madness, the invisible, the inspiring and the insufferable, embarrassments, thieves, whores and much less interesting characters. For those thinking of running— either to or from the warm embrace of the spotlight— and those who are just amused by it all, a few insights, tips and suggestions:

What You Should Know

What should one know going into a leather contest? Who was International Mr. Leather in 1982? What year did IMsL begin? Who was the last publisher of *Drummer* magazine?

True, some people do treat the judging process like an oral history final, but the most important question to have down is: Why are you here? You will be asked again and again, in many different ways, by any number of people, by your loving boyfriend and by your own nerves. Do you want to get laid? Do you want a platform from which to promote your favorite community cause? Do you want to launch a porn career? Do you want to show up an ex-lover who said you'd never amount to anything? The right title can do any of these things (or not) so to keep all in perspective, focus and have an answer ready. If you know nothing else, know yourself.

If you still fear that history final, I would suggest the *Leather History Timeline*, a sort of kinky Cliff's Notes, originally written by Tony DeBlase and available through the Leather Museum and Archives. Extra points given for answering the other three questions above.

Your Fellow Contestants

Who will you compete against? Experienced and distinguished leaders of the community? Will winning a title bestow on you the mantle of leadership?

An impromptu poll of contestants for the last International Mr. Leather in Chicago revealed that the average guy with a leather title has less than three years in the community. Many times, running in a leather contest is one's first public acknowledgment of any interest in alternative kink— a sort of "second coming-out." Think of these contests as something of a "Cowhide Cotillion" for debutantes of debauchery.

Contrary to popular misconception, "leaders" are not chosen in this community by how well they walked across the stage in a g-string— not that we haven't identified some eventual leaders who look damn good in next to nothing.

It *is* a competition, but being at your best does not necessarily refer to percentage of body fat or to body counts. Backstage at a contest can be a pressure-cooker, but this is not a first season rerun of *Survivor* and you are not Richard Hatch. Bonding between contestants can be similar to going through bootcamp or high school or other intense trauma together. Remember that a contest is only one night and only one person goes home with the title, but there are much more exciting things to go home with and the friendships and contacts you make will follow you as long as you wear cowhide. It is also worthy of note that Miss Congeniality gets invited to all the better parties.

176

About the Judges

Judging panels for leather contests are notoriously made up of folks who have been around awhile— which means they have pretty highly-developed opinions about the contest and themselves. Many contestants will carefully study each member of the panel to determine by reputation what questions and hot buttons each might have. This can be successful only up to a point.

I have assembled judging panels consisting of people I have known for years, only to see them evolve into a completely different creature when thrown into a room with ballots. The resulting beast is much different from the sum of its parts. This is one reason why I always have to stifle a laugh when I hear the inevitable whispers of "collusion" from those unhappy with the judges' choice. It would be miraculous to get egos such as these to "collude" on what to order for lunch, let alone which direction to throw a contest.

A Word About Your Sponsor

Most leather titles are sponsored by leather bars or businesses. Most gay leather businesses are run primarily by one very busy and harried owner or manager who is the lynchpin of the company. In the swirl of personnel, taxes, bills and other day-to-day business concerns, the lucky titleholder can command his sponsor's attention somewhere between a leaking toilet and new equipment financing. These are generally wonderful, caring human beings and it's nothing personal, but time and money are very finite resources.

You, however, are not without resources, talents and skills. Remember? You said so in your 90-second speech on "community and unity." Your self-reliance and initiative, your networking with other titleholders and other guides, will gain you so many things that public whining about an unsupportive sponsor will not. Keep in mind that your commitment as titleholder lasts for just a year, while many others commit their lives and livelihoods.

About Everybody Else

Be nice to EVERYONE. A contest is an exercise in grace under pressure, but the head you just bit off might be the stagehand that saves your ass or a judge's boyfriend. Once again, a contest is a lousy way to choose a leader, but it is a pretty accurate way of picking out the bitch from the rest of the litter.

A contest can exist for many reasons: To beef up a slow bar night, to promote a magazine, as a fundraiser and some contests seem to survive out of sheer habit. But all are gatherings of a far-flung, rambling, rowdy and dysfunctional family. Understand that folks have their own reasons for attending and participating just as you have your own reasons for competing. The first four or five years I attended IML, I never did quite make it to the actual contest. Have fun on stage but keep in mind that your audience has instruments of torture back in their hotel rooms.

Smile at the press, feed them, flirt if you must, but for godssake don't talk to them.

A one-year wonder. Sash trash. You will hear it all by the time your year is up. This community's average treatment of new titleholders is nearly as unpredictable, outrageous, shameful, ungrateful or undeserved as the titleholders themselves.

Tread softly. Passion and eagerness are traits that people easily mistake for arrogance and recklessness. Go slowly. Don't trip. People have only one greater delight above lifting up heroes and icons, and that is to watch them fall in flames. Be careful, be gracious. Make sure that your words are always sweet, substantial, nourishing, healthy and not bitter, poisonous or sharp— for inevitably you will end up eating them some day. We all do eventually.

An IML Memoir **Memories of My First IML**

I am nearing my 20th consecutive Memorial Day Weekend spent in Chicago at the International Mr. Leather Contest. I have been a volunteer, a vendor, a contestant and covered IML from the press box. I have a storage locker full of t-shirts, seen over 1,000 contestants, been through three or four host hotels, a half-dozen contest venues and countless shuttle bus breakdowns. It has been brutally hot, it usually rained at least once during each weekend and a couple times, it snowed.

IML has been an annual pilgrimage. A milestone that marked each passing year. Some of the people I see there only once a year are closer to me than others I see every week. A lot began during those weekends and it was at IML that I met the people who would later be very important to the unique little fate the Universe had in mind for me: Philip Turner, Dave Rhodes, Marcus Hernandez, Tony DeBlase and Martijn Bakker, to name just a few. Employers, mentors, colleagues, opponents, vexations and friends. I have stories and memories— some of which I won't be able to tell for a while yet. Some I would like to share with you now.

We are all followed by the ghosts of those who have touched our lives. Some dark nights, they might walk beside you. Occasionally, they may seem to be chasing you down. Maybe another time, they are a bit more distant, staying just at the edge of your awareness— a benign, watching, comfortable presence We have all known times when our ghosts seem to travel just a little closer than usual, because we need them close.

My First IML

My very first International Mr. Leather was with my first lover, Mark. He was five years younger than I and, being somewhat unsure about relationships or the extent of his twists, I had never told him of my past experience in leather. When he started working at the local leather bar, we "discovered" it together and began a wonderful

exploration, limited only by my guilt at not being completely honest with him from the beginning.

For his part, Mark was "grand gay". The adopted son of wealthy parents, he always joked that there was a small European principality somewhere that was missing an heir. He believed that nothing was too good for him and those who surrounded him— and all of us who adored him had to agree. He would put on elaborate, formal seven-hour dinner parties, with a wine for each course, which would impress his guests to exhaustion. Nothing was done until it was overdone. His view of what was proper was straight from an Merchant & Ivory movie.

I was a boots and Jack Daniels sort of guy, only a few years out of the Navy, who didn't even trust garages to change his oil (a real man takes care of his own lubrication needs). It was enough of a surprise that this man was in love with me, so I wasn't about to screw it up by revealing my sordid past with bikers, bad boys and serious SM. That was before he presented me with a sling he had made with knotted rope and chains from pictures he had seen in a Mr. S catalog. Showing a previously hidden interest in both kink and carpentry, he had turned the wine cellar I had built to store his vintage Bordeaux collection into a dungeon.

When he decided to tackle leather, it was in his usual, no-halfway-measures style. Our travel plans for Chicago and our first International Mr. Leather Contest rivaled Allied preparations for D-day. I bought him a leather jacket and he computerized our schedule and packing list.

Packing for the trip, he asked what tie I would be wearing to the Meet-the-IML-Contestants Reception. I looked at him quizzically and said, "I don't think it's that kind of event. Don't you think they would all be in leather?"

"Absolutely not!" he snapped back, "It's a reception. There are rules

about how to dress for a reception." I had learned by now there was no point in arguing with his concept of the rules in proper society, so I dutifully packed a conservative silk tweed sport jacket, dress slacks and subdued striped tie. I at least convinced him it was not the occasion for a floral pattern.

The plan was to swing by the Contestant's Reception on the way out to a nice dinner and a stop at the Gentry, a fluffy gay little piano bar on Rush Street in Chicago. After a little Michigan Avenue culture dressed to the nines, we would then make the transition into leather and hit the bars up north.

We walked into the reception and wouldn't you know it, not another tie or silk jacket in the place. Of course, we were the only ones not in cowhide from head to toe, which consequently made us quite a topic. They must have thought we were lost, Mormon missionaries, security or some sort of foreign press because we got more attention than the contestants did and photos of us that night turned up in the IML program a few years later. With his usual aplomb, Mark wore our faux pas like a boutonniere and worked the shocked room as if this was how he had planned it all along.

He never did admit his mistake, but we never went to another contestant's reception in ties. It did, however, become tradition to pack dress clothes for a downtown evening the first night of each IML thereafter— our little time together before the orgy.

Chains and China

We had seven years together; exploring a world that included as many slings and harnesses as it did tuxedos and champagne. Some good years and some bad. Together we founded a local leather club. Bitten by the contest bug, he won a state leather title, which I also won a few years later.

The year after he died, I was a contestant at IML. I took the Levi/ Leather Daddy sash we had both worn to IML for its first time, but I

didn't place too well. A great experience and once again I met some fantastic people, but my heart really wasn't into the competition. Certain traditions, however, continued no matter what.

Each year, my first night in Chicago I put on a jacket and tie, polish my shoes and go out downtown for dinner and a couple of dry martinis. The Gentry on Rush has since closed, but you can still find a quiet lounge between the drunken frat boys and the Hooter's wannabes. I have even been known to order two and leave the other one behind for Mark. Then I go back to the hotel, climb into my skins and begin the weekend.

You see, sometimes it isn't about the leather. Sometimes it's not about getting everything exactly right and following every rule. Sometimes it isn't even about rutting sex. Sometimes it is about a human connection that transcends our five senses, as well as time, death, change and memory.

What Do We Expect Of Titleholders? Minimum Requirements For Icons

Quite a milestone in 2003 when the first man from the United Kingdom was selected as International Mr. Leather. For many years, the concept of leather titles and leather contests has been a somewhat difficult sell to folks in the UK. After all, my English friends would point out, they have had a 1,200-year head start with aristocracy to discover that titles often come with little in the way of solid job description or actual purpose.

When talking about leather titleholders outside of that exclusive little circle itself, the most common question is, "Well, what do they do?" Out of a few thousand titleholders that have come and gone in the leather community, only a relative handful evoke the dimmest light of recognition, let alone are perceived as having made lasting contributions to leatherdom (or life) as a whole.

Even those who are the greatest supporters and producers of contests occasionally wonder among themselves. One such international contest producer voiced suspicion that this is what passes for mental health screening in our community: Identify the truly dangerous ones and mark them with a sash so we can keep an eye on them. Rather like tagging killer sharks, rogue bears or mad dogs.

Several very prominent contest veterans have opined that to run for a title, one must have a very fragile or damaged self-esteem to begin with and therefore titleholders must be treated with great care, lest they break. I strongly disagree. If we are to continue to elevate people to these sorts of positions, if we continue to perpetuate the myth that these are somehow "leaders," we insult them by coddling and patronizing them. From those to whom much is given, much is expected.

People's expectations of titleholders can be unreasonable, unrealistic, contradictory and frustrating. That is an excellent excuse for many to not even try. For those who wish to be more than merely

a name in a chronological listing of those who have held your title in the past, may I present some suggestions?

Dog Shows And Dilettantes

Many folks figure a titleholder should just get through their year without being arrested or ending up in a front-page scandal. That's fine for some. Some just try to show up to most local events, supermarket openings and fundraisers. That's great— better than many. Some go beyond to show up at IML, IMsL, MAL, ABW and the rest of the alphabet soup— ask them what they did their year and they will give you their travel schedule.

Let's face it: Any prize Pekingese manages to show up to all the right dog shows. Just spending your travel fund (should you be so lucky to get one) is not a note-worthy accomplishment.

So, what DO people expect? If you wish to make an impact, what do people look for? What makes the sort of titleholders that folks look back on and say, "Oh, so THAT'S what titleholders do..."?

Money. The bottom line: Money talks and bullshit walks. If you raised a ton of money for community causes, that counts for something. Many times, the leather community has won initial grudging respect from mainstream gay or local charities because we kept their lights on or their doors open. It may not seem like the most fair or noble sentiment, but cash speaks very loudly and makes friends very quickly.

Solutions. Even if fundraising is not your forte, do what you can do. See a need and fill it. Write a book, create a community resource, revive a local title or event, start a police-community liaison program. Create a new community business or service. Make sure that leather elders in your community get to their doctor's appointments, assemble a manual for fundraising, start a dinner or in-person discussion group. Even if your grand projects

and great ideas are unsuccessful, keep going, keep trying and keep putting yourself out there. And remember, ideas are a dime a dozen. Everyone has ideas. The payoff is in the execution, the translation between concept and reality.

Travel. It's not just being there, but what did you do when you were there? Did you give a workshop? An inspiring speech? Did you mediate a local dispute? Talk to the local media? Did folks feel better about themselves and their community after you left?

Response. It doesn't have to be extravagant, but people do expect more response from a titleholder than what they would get from any magazine centerfold, a store mannequin or a waxworks. A warm smile, a handshake and a greeting (even though you might find the person unattractive). A few lines in answer to a letter or an email, even just thanking them for taking the time to write. If you need to set aside a couple quiet, exclusive hours each week to deal with correspondence, do so.

Scale. It may not be your destiny to take on the entire world. Even international titleholders find they sometimes need to step back, make their contribution on a local level and on a manageable scale. There is a difference, however, between downsizing and disappearing. It requires balance and we expect you to work out those issues. Remain accessible, but not overwhelmed. Those global contacts you have made still deserve the courtesy of an occasional note or correspondence even though you are focused on work in your own backyard.

Longevity. Most people in the community expect you to be a one-year wonder and then disappear (and we are thankful when some titleholders oblige by vanishing) but a few ex-titleholders run counter to type and stick around. They are committed to this community and continue to work day after day, year after year long after the titles and the certificates of appreciation and the nominations for Man of the Year run out.

Stability. Viewing things in the long haul also gives you a healthy stability and perspective to work through temporary situations and minor annoyances. You are expected to be somewhat stable. It is your right to try out a new personality, a new name, a new public image every week, if you want to— but that behavior does not inspire trust or confidence. "Stability" means folks know what to expect from you. They know where you stand. When you give your word, you are expected to keep it. When you make a commitment, you are expected to follow-through. Treat people and issues evenly, if not consistently.

Archive. This could also be called "publicity." Either way, you need to tell people what you are doing. If you are a bit shy about putting out press releases or writing newsletters, get someone else to do it for you. We expect to hear about you. This is important. It may seem a bit self-promotional and it also may seem a bit scary. I suspect that the reason that many people don't like to talk about their accomplishments is not modesty, but that it opens their deeds up to criticism and scrutiny. But it is worth that minor risk.

We do not have a long history. For many reasons, it has not been very well recorded or preserved. The record of your accomplishments (even your mistakes) is a vital contribution to the collective pool of experience that is our leather tradition.

You could say that what a titleholder might do to make a contribution to his community is pretty well what any other person would do. You also might say that you don't care what people think about your performance as a titleholder-- to which I might reply, "That sounds like a healthy attitude." But neither yours nor my healthy attitude will stop people from evaluating and judging titleholders— and I can guarantee that many will use one or more of the above criteria. You can bet your sash on it.

Advice For The Ambitious Leather Titleholder
Icons, Idiots And Image

"Never make excuses, never let them see you bleed and never get separated from your luggage." –three rules for foreign correspondents from Wesley Price's "Professional Comportment For Writers"

The same advice serves titleholders well. Excuses meet with little sympathy even if you can reasonably call them "explanations." Most weaknesses, wounds and signs of humanity should be reserved for only your closest and most trusted, tolerant friends. And you must always keep track of your baggage—both that which contains your leather and the emotional cargo as well.

Regardless of what they did before, every new titleholder gets all sorts of advice. You could have been in the community 20 years or 20 minutes, it wouldn't matter. Sometimes it actually comes from people who know what they are talking about. Keep a certain historical perspective. Remember that in spite of your sash, there are leaders, teachers, activists and business owners in our community that have been at this much longer than you. They do it day in and day out, year in and year out and they will be doing it long after your reign is a leather contest trivia question.

Look, there are exceptions to every rule, but you are not likely to make profound, earth-shattering changes in one year. You just haven't got the time. So here are a few suggestions to help you take a hard look at what's realistic and what's possible.

Get Over It

While you hardly want to second-guess the judges who selected you, everyone has their doubts from time to time. Am I smart enough? Do I know enough? Am I wise enough? What the hell am I doing?

It is natural for a new titleholder to come to his or her title with an odd combination of swaggering arrogance and sheer terror. Elevation to such attention is inflating, but also threatens to expose every insecurity—real or imagined— a combination not unlike keeping your pet porcupine in the same room as your designer inflatable furniture. It often prevents new titleholders from seeking the advice, counsel and resources required for success because it would be too terrifying to reveal that they could use a little help.

This is the first hurdle that the titleholder must get over: There will *always* be someone more experienced, with more skills in some areas, someone who knows more and is more beloved. If you see these people as competition instead of resources, you might as well make that call to the first runner up right this minute. There is a reason so many ex-titleholders are so bitter. A title is isolating enough as it is, but when you purposefully close yourself off, you guarantee that you will leave your title less experienced, less wise, less skilled and certainly less beloved.

Security

A continuing phone scam has plagued the leather community for at least six years, where caller or callers have been working people's generosity and compassion for a few hundred bucks.

The rip off works with a late-night (usually collect) phone call from someone posing as a well-known community figure or titleholder. The caller tells a tale about having been beat up, robbed or losing his identification and can you wire him $100 to get back home? Since this person is prominent, the reasoning goes, he will be able to pay you back just as soon as he is back home. He wants you to wire cash in a way that it can be picked up at any Western Union office without positive identification.

This cynical and calculated scam plays on our fear of bashing, our

desire to help those in need and the giving nature of our community. In addition to our generosity, they also prey on that sense of isolation, the need to belong and a titleholder's insecurity.

Don't believe it. Remember that as a titleholder, your attendance at events is public information, your bio is printed in each program where you appear as a judge, MC or whatever and personal information is available from interviews, websites and newspapers. A simple Internet search can turn up all sorts of tidbits. Are you listed in the phone book? These guys are good; they do their homework.

These guys are actually too good. In the course of a busy weekend, few of us notice an overwhelming amount of detail about someone we are not actually trying to score with. It's only human. It's also only human to respond to: "I am really an admirer of yours. I saw you in Chicago and you really made an impression. I've read everything you've written (oops, that only works for me). You are one of the few people I could trust." Don't fall for it. Be suspicious of anyone who notes those sorts of details about you.

Victims seem to be chosen very carefully so that they are close enough to want to help, but not close enough to positively identify the caller as an impostor. It continues because the individual losses are too low for police to bother investigating and it counts on people who are too embarrassed to step forward and say they were victimized. Western Union officials refused to comment on the case.

If you get a phone call like this, **do not— under any circumstances— send any money.** The easiest and safest response is just not to accept the call. This protects you and denies him a victim.

If you decide to accept such a call:
1) Offer help in some other way (Can I call someone for you? Can I drive down and pick you up? Let me call the local police for you. I'll have a member of the local leather club come and pick you up.)

Ask a few questions. Certainly before you do anything, confirm that the "victim" is not sitting safely at home.

2) If you are still not sure, call a friend or other leatherfolk. Ask them if this sounds right. The scam counts on isolation, so don't try to solve it alone.

3) If you suspect it is a scam, immediately call the police on separate line or a cell phone. Try to keep him on the phone while the police instruct you what to do.

4) If you have caller ID, be sure to note the number (we are told it has usually been a pay phone.)

5) Try to get him to call you back (you don't have your wallet, the battery on the phone is giving out, you have to find your glasses, etc) or get a number or some sort of contact.

6) Follow the instructions of your local police. If they are not familiar with this scam, put them in touch with the San Francisco Police Department who has been dealing with it for some time and can brief them.

You might be in a jurisdiction where the police are less than enthusiastic over calls from the gay community. If you can figure out where the call is coming from, try the police there. Efforts to catch the thief or thieves have so far been unsuccessful. The best strategy seems to be to for as many people as possible to be aware and protect themselves from being ripped off so that eventually the scheme will no longer be profitable.

Generally, a titleholder's interaction with the public is warm and rewarding. Don't become paranoid—just be smart, be aware. *Never,* ever give out personal information about someone else without his or her express permission and watch what personal information you let out about yourself. You might want to set up a separate email address or even a phone line for "title business" only. Use a post office box or have your sponsor or club forward "title"-related mail for you, instead of using your home address.

Onward And Upward

Many titles go on to compete at a regional, national or international level. That's fine—go, do your best. These larger competitions can be a great experience. But don't miss your entire year getting ready for the next level. Serve where you were chosen to serve.

Quite frankly, if your entire focus is higher titles, you are likely to be disappointed several different ways. First, it is at the local level where you are most effective. It is as a local titleholder that you will actually write the reputation that will follow you for the rest of the time you wear skins. Further, only one person a year goes home with the grand prize. If you concentrate solely on higher office and end up disappointed, you may blind yourself to the wonderful opportunities you can experience and the tremendous good you can do.

No matter how far you go, one day you will step down from your title(s). At that point, you can really begin to build what you want to accomplish based on the foundation you have laid during the 365 days you had in your title. Make sure you establish a solid foundation.

Required Reading

Many contestants and titleholders have asked me what books I would recommend for their journey. You never know what piece of arcane, trivial information will eventually end up saving your ass, so all I can really suggest are some of the volumes that came in handy for me.

Like you've got time to read. . . .

It's a wide-ranging, diverse community. Instead of reading every obscure scrap on everything from political activism and leather history to the physiology of pain and forbidden fetishes, try specializing in an area that holds particular interest for you. It is not required for you to share or even understand every facet and activity

of your constituency, just keep an open mind and an open heart.

Everyone, of course, recommends Guy Baldwin's *Leather Contest Guide*. I didn't find his book and read it until long after many, many contests as a contestant, titleholder, sponsor and then executive producer of the International Drummer contests. I'm afraid, Guy, by then it was too late to save me. Jill Carter has a new book for titleholders out, but I have not been able to get a hold of a copy.

People think I am kidding, but there is much about dealing with people and the public in *The Prince* by Niccolo Machiavelli and *The Art of War* by Sun Tzu. I have also found useful management advice in *Command At Sea* by Cope & Bucknell. *Lies My Teacher Told Me* and *Lies Across America* by James W. Lowen are excellent workbooks for analytical thinking. I am much too fond of *The Pessimist's Guide to History*. Most titleholders seem in need of a dictionary. Fantastic Four comic books were moral lessons with great pecs—not to mention that the villains came up with some pretty exciting torture and bondage routines. Read a few etiquette books, not for which fork to use, but for the philosophy and spirituality of courtesy, honor, service and social form: Try a little more Emily Post and less Larry Townsend.

You just never know when wisdom may sneak up behind you.

Knowledge And Understanding

I don't think anyone is quite prepared for the expectations and demands that some people will have when you first walk onto the stage and into the glaring spotlight that a title can present. Much of the advice that you hear will be the hindsight of people who wished they'd had a little warning about what was coming at them. You might even hear from a few who have forgotten that they were told exactly what would happen. They just didn't listen.

Knowledge and understanding do not always arrive at the same

time—one of those sadistic little jokes designed by the gods to keep us humble.

Cassandra Crossing

Cassandra was a Greek prophetess who was given faultless powers to see the future by the sun god, Apollo. Later, in a fit of rage, Apollo cursed her so that, although she would still have true vision, no one would believe her prophecies. In this tradition, I have advised titleholders from a local bar contest winners to international titleholders. Sometimes they listened, sometimes they didn't. Of course, not being blessed by the gods with faultless sight, sometimes I was right, sometimes I wasn't—but if you stick around long enough, you eventually have made most of the mistakes you can make and still survive. And if you are lucky, this occasionally passes for wisdom.

So you can take it or leave it.

Making An Ass Of Yourself

If your contest was supposed to teach or test you, what lessons did you need to carry away? What did being a contestant teach you about being a titleholder?

Remember that fear of walking out on stage and making a fool of yourself? Keep in touch with that feeling, for it is a healthy and useful fear. Remember what they told you going into the judge's interview? "If you don't know an answer, don't bluff." Why did you figure that was suddenly NOT true once you had actually won? Bluff in poker, but never in front of a community so willing to offer correction, public humiliation and pain.

It's easy to make an ass of yourself:
- Speak definitively about something you know nothing about.
- Believe sincerely that along with the sash, you have been passed all knowledge and wisdom.

- Believe that your community will be forgiving if you screw up.

- Pass along information before you check it out. Never confirm appointments, events, facts or figures. Fill email inboxes across the country with multiple copies of every announcement, rumor, hoax and lame joke you can tack your name to.

-Instead of taking advantage of available resources or those with experience in specific areas, stumble ahead like you alone know what you're doing.

-Never follow up on what you promised to do or provide. Make it clear there are many tasks you consider beneath the dignity of a titleholder.

-Take the perks and privileges of your position more seriously than the responsibilities.

- Believe there is only one right way to do everything. Convince yourself that anyone who disagrees with you is not only wrong, but jealous, obviously unhinged and are attacking you and all the good you represent merely out of evil spite.

- Come to believe that you, personally actually deserve all of this fuss.

That should put you well on your way.

It helps to know your limitations. When someone asks you a question, ask a few in return: Why do you ask? What has been done in the past? Is there a phone number or contact I can get back to you with more information? Be realistic, whether it's a bar title, city, state, regional or even international title, keep in mind: One person doesn't exactly represent the whole of leatherdom. Next year it will be someone else. It doesn't stop wars or cure cancer. Don't drive yourself (or the rest of us) crazy. Lighten up.

On The Offensive

No matter what, however, there may be those who will bait you and attack you simply because you are a titleholder. If this doesn't apply to you, you are lucky. If it does, you are normal.

Don't take it personally. People like that aim at the highest and easiest target: Your title, not you. I try to assume the best of people and assign any unpleasantness to miscommunication or a language barrier—and not because I am a particularly nice guy, but because it is more efficient. I am fully aware they might be just exactly as hateful as they appear, but I do not have the time to waste being hurt.

Offense can only be given if one accepts it. Simply refuse delivery.

Take Care Of Yourself

The heroes of ancient Rome rode through the street to the cheers and adulation of the crowd in a golden chariot with a slave beside him that kept repeating, "Remember, thou art mortal. Thou art mortal." Not a bad idea for our leather titleholders. Not that you will often forget about being a highly fallible human being (there will be more than enough critics reminding you of your shortcomings) but rather to keep in mind that an ordinary person in an extraordinary position must be particularly careful.

Get enough rest. Remember to eat. Leave time for yourself and those who are important to you. Take time to build up your strength, take time to continue learning. Take time to do something completely unrelated to your title or community. Watch your moods and limit your self-medication. Don't overspend. Don't overcommit. Keep organized.

Showing Up

It can truly be said that half the job of a titleholder is just showing up. You support different community events by being there and being identifiable. You (and your title) are what you bring to the feast. While it is arrogant to insist on ovations and honors from every stage and a microphone to deliver your 50-minute leather soliloquy, it is equally unreasonable to expect everyone to recognize

you and register your attendance if you don't at least step out of the shadows and say, "hello".

How to go about it is a double-edged sword: If you keep a low profile, demur from signing your name to every event and project you are involved in, people ask, "Where was he all year?" If you aggressively make sure the host knows that you have arrived and how to announce you, if you end up smiling in the papers once too often, they will say, "Self-aggrandizing! Self-promoting!" Get over it. This game is not made for winning. You just strike a balance that you feel comfortable with, which is different from title to title, titleholder to titleholder, community to community.

The Submissive As A Titleholder

Few titles (with the exception of Drummerboy, now Leatherboy) prescribe a "boy persona" in their criteria. Most leather titles are just that—leather titles, not "top" titles or "dominant" titles.

Of the many international titleholders I have known, it is widely acknowledged that only a handful were indisputably tops, a few more could play top if pressed. The rest were most definitely (some quite proudly and loudly) boys, bottoms, slaves, etc. And why not? The most effective titleholders are almost always bottoms because they are less imperious, more tolerant of pain, discomfort or deprivation and know the value and techniques of service. Tops tend to piss too many people off— and don't particularly care if we do.

Therefore I will never understand some people's amazement when a proud submissive runs for a leather title, or the hesitation of fine, qualified, energetic men to run for a title because some fool told them that "submissives are not titleholders." Boys, you have my permission to say (respectfully) "pshaw".

A Little Bird Told Me

Finally, there is this story told to me when I was in the Navy by a

wise old chief petty officer from Alabama. It just about sums up my experience in the international leather community:

Seems there was this stubborn little bird who did not want to fly south for the winter. He was comfortable where he was and did not believe the older birds that winter was coming (having never seen a winter), so he waved good-bye and stayed put.

Weeks went by, it got colder and the little bird began to reconsider his decision. Finally, as the first snow began to fall, he decided maybe it would be best, after all, to head south. But it was too late. As he flew, ice formed on his tiny wings and he began to fall.

Exhausted and frozen, the little bird fell into a pasture—numb, unable to move—and waited to freeze to death. A cow in the same pasture looked at the pathetic creature, turned around and crapped right on the poor little bird! The bird was mortified! Not only was he going to die, but this stupid cow has nearly buried him up to his tiny neck in steaming, stinking cow dung! What could possibly be worse?

But after a few moments, the warm cow pie began to thaw out the little bird. He could move, circulation returned to his wings and he began to come to life again. He wasn't going to freeze to death after all! The little bird was so happy that he began to sing.

The barnyard cat heard the bird's joyful tune, came and plucked the little fellow out of the mess and tenderly cleaned him off. He then ate the little bird.

Now there are several morals to this parable, among them: 1) Everyone who shits on you is not necessarily your enemy. 2) Everyone who pulls you out of shit is not necessarily your friend, and 3) If you ever find yourself up to your neck in shit, it is best to keep your mouth shut.

Advice For The Ambitious Contest Judge How To Avoid Scandal

Abraham Lincoln used to tell the story of a man who was tarred and feathered and ran out of town on a rail by an angry mob. When asked what he thought of his predicament, the man replied, "If it weren't for the honor of the thing, I'd have rather walked."

It seems if you stick around long enough, you end up with the high-profile and dubious honor of judging a leather contest. In fact, due to the habit of making the outgoing titleholder head judge to choose his successor, some people don't have to wait very long. Certainly not as long as they should have to gain a judge's wisdom.

That might be a bit harsh. I don't think there are so many bad contest judges as people judging badly and then being badly judged. Blame contest promoters and producers. Unfortunately, few contest judges are actually given much in the way of instruction or direction. What does the contest expect of their titleholder? What qualities are they seeking? If you think of a contest as hiring for a position and of the judging panel as the hiring committee, most are expected to do their job with no idea as to minimum qualifications, duties and requirements, mission statement or job description.

Many judges, particularly recent titleholders and those new to the community, are not about to stand up and ask, "Pardon me, but what are we supposed to be looking for?" This goes against the image of supreme confidence and omnipotence that is usually required for survival at a certain level among leatherati. It shows weakness akin to bleeding into a tank of sharks.

Well, since you might not always get clear guidelines, and have reason to be afraid to ask, consider the following when you are asked to judge a contest:

Before You Say "Yes"

Consider the invitation very carefully. Do you have the time? Do you have the money (many contests don't pay judge's expenses)? Do you want to judge this contest? Should you judge this contest?

You may not be a big fan of a particular title, producer or contest. You may have been invited to judge for all the wrong reasons. You might just be overbooked or would rather spend quality time with your new Dutch terrier. If you decide to decline gracefully, chances are it will not be the last time you are asked. If you accept and are whiney, manipulative, demanding, visibly bored or contemptuous, the chances of never being asked to judge another contest improve considerably.

The same consideration should be given if you are asked to be head judge. Unfortunately, some contests automatically make the outgoing titleholder not only a judge, but head judge. This is likely to be the one panel member with the least experience and the most other obligations and distractions that weekend (such as what to sing for a step-down speech). It is perfectly OK to defer to someone else.

In our small, incestuous community, you may be called upon to judge former tricks, lovers, masters, daddies, slaves, boys, etc. You should have the capacity to put your bias aside as easily as you put your former beau aside, but if there is any reason to doubt that you can be fair, do the honorable thing and excuse yourself. At the very least, discuss it with the contest organizers or head judge.

And only an idiot would put himself in the position of judging a current trick, lover, master, daddy, slave, boy, etc. Like a wise manager told me when I started bartending years ago, "The only thing worse than actual dishonesty is the appearance of dishonesty. The best defense for the innocent is to never get in a position where you have to defend your innocence."

Do Your Homework

Many contests provide written guidelines for potential judges weeks before the event, giving ample time to review. These can include what is expected of the titleholder, what qualities the contest is looking for, what are the categories, how are they scored and in what order will they appear on stage, what is expected of judges and exactly what it would take to get fired.

If nothing is provided, it may be up to you to ask. Don't wait until 10 minutes before the contest starts, either. Hey, you accepted the responsibility— time to earn that "pillar of the community" mantle.

Do you know any of the history of the title? Can former titleholders be reached for comment or direction? If the title goes on to regional or international competition, what are the standards of the next level? Who were the judges last year? Everyone is looking to you for wisdom, insight and knowledge—or at the very least, to know more than the contestant. Try to be a little prepared. Try not to make an ass of yourself.

Being Judgmental

Judging a leather contest is indeed an honor. It is a stewardship, a trust on behalf of the contest sponsors and the community that is represented by the title you fill. It not only expresses trust in your actual decision-making powers, but it places trust in your ability to behave.

For the community and the contestants, you are on display as examples of what is honorable and honored in our little subculture. Ideally, the questions you ask are what leatherfolk should be concerned about and your behavior is a model of how to comport oneself.

Of course, don't fool around (or even flirt) with the contestants. Just don't. Find someone else to fool around with-- even another judge,

if you really must. Don't drink too much. Don't fall asleep. Don't talk about the proceedings or betray confidential information. Don't play favorites or try to persuade your fellow judges. Don't invest your ego into the process.

You are there to judge someone's participation in this contest process. Try to put any outside information you might happen to know aside. Like a juror, you must weigh your decision on the evidence presented in court, rather than on accidental and auxiliary rumors, history or hearsay.

Listen more than you speak. Be on time. Be engaged. Be respectful and know what you are talking about. If you don't know something, ask. Don't whine.

Think. What do I hope to learn by asking this question? What am I looking for in the contestant's response? Is it merely to determine which one of us knows the more obscure trivia? What is to be gained by an oral history quiz?

Stage Presents

The latest "new" idea for leather contests: Instead of having the judges interview contestants offstage before the contest, the interviews are done onstage, live for all to see.

First of all, it is hardly a new idea. Many backwoods bar contests are run this way and they're a real hoot. These were also the types of contest where the contestant who could hold the most shots of liquor and didn't fall off the bar was proclaimed the winner.

There is a reason that larger contests, however, took to a closed preinterviewing of contestants. With few exceptions, the interview is excruciatingly boring. To be fair, each contestant is asked roughly the same questions, over and over. It has all the entertainment value of watching paint peel. People are interested in the beginning of a

contest (when you meet the contestants) and the end (where you find out who won) but the middle tends to run very long and very dry.

The private interview is an opportunity for the contestant to relax and get to know the judges so they can get to know him. It is *his* time with the judges. I have seen some real sharing in judging interviews, some genuine exchanges and even some tears. Turning the interview into a stage performance destroys that intimacy and will give a less than complete picture of the contestant. Instead of adding integrity to the process, this can actually subtract it.

Lastly, most judging panels consist of folks to whom you do not necessarily want to turn over a microphone, particularly in a program that is likely to already be in overtime. Questions turn into speeches and the emphasis is taken off the contestants and placed on the honored and empanelled has-beens. This sentiment will not make me a popular contest judge, but there it is: If you are a judge, it ain't about you. Get the hell off the stage.

Let The Games Begin

Don't toy with a contestant just because you can (or just because some schmuck toyed with you when you were a contestant.

What do I mean by "toy"? Example: One year I spoke to several contestants for the same title that were absolutely convinced they had an inside track to win. Come to find out, the head judge made a habit of dining with local contestants headed for his contest, blowing enough sunshine up each skirt to brighten Seattle for a winter. Each one felt that they were an anointed one, which changed the way they related to other contestants and the contest. Watching what he had set in motion must have greatly amused the judge, but I doubt if it did much for the disappointed contenders when they realized they weren't so special, the poisoned relationships between titleholders—once again, it did not add to the integrity of the selection process.

Other judges have told me that they have purposely manipulated contestants to make them cry, pitted one contestant against another, encouraged jealousy, used misleading questions or head games. Some may call these tricks cleverly sadistic and tough-but-fair play in serious competition. I call them shameful.

The Art of Scoring

If you receive no instructions from the contest producers, here are a few suggestions to make scoring easier:

■ Some judges start at a midpoint (for example: 50 points out of a possible 100). Each time the contestant does something extraordinary, they gain points. When they screw up, they lose points.

■ Definitely avoid fractional (decimal) points and if possible round up or down to the nearest 5. This forces you to be more decisive, to think more critically and cuts down on waffling over one or two points.

■ Mark your scores clearly. Often these things are not read in the best of light and mistakes because of poor handwriting can be a real headache.

■ Only in the rarest circumstances should a perfect score or no points at all be given. Total disregard for safety, contest rules, respect or sportsmanship might rate a "0." Performing a verifiable miracle on stage could rate a perfect score.

■ Generally, a contest employs either standard or Olympic scoring. Standard scoring just adds up the numbers while Olympic scoring throws out the highest and lowest score. Although many people swear that the Olympic method is more tamperproof, my number crunchers have always said that it narrows the judging field and is statistically *less* fair. Besides, when the Olympic score is too close to call, what do they do? They go back to the standard scores anyhow. One method just wears a showy designer label.

Brain Surgery

Your job is simple. You have to find a way to see inside the contestant's head that is not abusive or leaves permanent scalp scars. Then you have to somehow quantify what you found.

You have within your power to make this a positive, pleasant experience for the contestants. Relax. Lighten up on the contestants and on yourself. It is not your job to be obnoxious. Be tolerant of differing opinions, as long as they are well-thought out and well-supported. Be tolerant of different traditions and different journeys. Be tolerant of fellow judges trying to get a word in edgewise.

Although it has happened, it's tough to get fired. Just so there was no misunderstanding (and to introduce the possibility that it could be done), I wrote this section of the official *Judges Guidelines for the International Drummer Contest*:

> *We hope that you are as honored to be a judge for the International Mr. Drummer competition as we are honored to have you here. You have all judged leather contests before and have our utmost confidence otherwise you would not have been invited.*
>
> *We are all interested in a contest that is above reproach. Therefore, just for the record, here are some examples of behavior that would lead to the dismissal and replacement of a judge:*
>
> *1) The use of the position of judge to sexually harass any staff member, contestant, sponsor or their guests in any way.*
>
> *2) Fraternizing with a contestant or sponsor or their guests in any way that could be construed as compromising impartiality.*
>
> *3) Excessive lateness or absence from judging sessions.*
>
> *4) Actively trying to sway the opinions of any other judge in favor of, or against any specific contestant.*
>
> *5) Having knowledge of attempts to "fix" the results of the contest and failing to report such activity to the Head Judge or Judge Coordinator.*

6) Allowing anyone, including employees or representatives of the publisher, to unfairly influence their decisions.

7) Discussing scores, interviews or any judging proceedings with third parties prior to the official announcement of a winner.

Why It Matters Insisting On Excellence

"I love America more than any other country in this world, and, exactly for this reason, I insist on the right to criticize her perpetually." - James Baldwin

I am often criticized for being too critical of others (and of myself, believe it or not). Just the other day I got a message from someone that I "ruin the community for those who don't take it so serious." I wrote back that the word she was looking for was "seriously"... which probably went many miles towards proving her point.

After many years of public service (including six years in the military), after much study of civics, history and political science and after running for public office, I claim the right to criticize my country— not because I hate her— but because I so deeply love her and I want the best for her. The same is true of my leather community.

Still, it is a terrible habit to only mention corrections or improvements and not the many wonderful things folks do and the insights that are shared. I apologize if that is how I have appeared. My only defense is the assumption that if something is correct, agreeable and right it doesn't need further comment.

But I take exception to the idea that this community and the essential issues it faces are not important. Nowhere is this more true than the strange, self-absorbed unreality of leather titles, contests and titleholders. I argue with those who see no need to discuss certain issues or perform to certain standards. Taking these issues seriously and confronting them skillfully does not preclude being happy, fun and obtaining one's next orgasm. While pursuing all of these, however, I will continue to insist on excellence from my community. This is why it matters to me how we present ourselves:

1) Because the way you communicate indicates care and respect.
If you care about the conversation you are having and you have
respect for the person to whom you are speaking, you will choose
your words carefully and try to be as clear as possible. It is the same
way when you write, particularly when your words are broadcast
widely through newspapers, websites, Internet lists or mass emails.

If you speak only in an insider language, using jargon, terms and
expressions only those in your circle can interpret, you frustrate and
annoy others. If you are sloppy and slap-dash, it indicates that your
audience was not worth the extra time to make sure your information
is true, that your message is clear and your spelling correct.

2) Because we have enemies and they are very good. You can
be sure that every statement coming out of the CWA (Concerned
Women of America) or the Heritage Foundation is spell-checked
and polished. Capital letters and punctuation are where they should
be, not sprinkled across the page like they came out of a salt shaker.
Every fact is checked, every reference is in place, every word is
carefully weighed and placed for maximum impact. They are written
specifically so they are easy for editors to pick up and put on a page.
They are very good at what they do, and they are very serious about
destroying us— both individually and as a community.

In case you hadn't noticed, we all have critics within our own
community as well. They delight in gossiping about the latest silly,
insensitive or inept thing the local leather diva has done or said. Why
hand these people ammunition?

3) Because I sincerely believe that we are better. This community
is one of the most open, generous, creative and intelligent available.
It is unfortunate that we are not better at communicating this and it
frustrates me when I suspect we are accepting something less than
our very best. Rather than discreetly correcting, offering counsel or
help to someone, it is much more insulting to shrug and accept that
lazy, lousy work is the best they can do.

4) Because it's not just you. You are now a titleholder or a committee chair or a director. You represent something larger than just yourself. You speak and act for an entire community. Dammit, you presume to speak for me.

We all have friends for whom we might write off a certain flakiness as just the quirks and habits that make them unique and special. "Oh, that's just George!" Well, when George takes a leadership position in the community, his habit of being 45 minutes to an hour late and his incomprehensible writing become a little less charming.

5) Because this is history. What you say or write is the record that will live on. Unless you write that next best-selling contest book, what you have to say on a day-to-day basis (particularly that which is immortalized in a public forum or publication) will be the sum total of your contribution to the collective memory. Do you want to leave behind your thoughts, desires and experience— or do you want to leave empty banter?

I was on line just the other day with someone who responded by quoting what I had written to a casual SM discussion list in 1998! She had saved everything that was discussed and could pull it out for reference. What you write must be finely tuned, it must be sincere and the best you know how to produce…because it will come back to haunt you eventually.

4) Because some of you are ambitious. You want to be IML, MsWL or take home a title from ABW. Well, the judges (and the judge's friends, confidants, lovers, club brothers and associates) read what you say and what you don't say. They will hold you to account for missed opportunities. How did you react to crisis? Were you a leader or did you hide? Even if you don't think it's important, they might.

5) Because it's easier. Think of it as an investment: Investing a

little more time upfront making sure what you message is tight, well-presented and clear, saves the further explanations, corrections, complaints, criticism and misunderstandings down the road. Do it right the first time.

6) Because it was once important. I know, I know…"leather, titles and the community are just a fun thing, not supposed to be serious." Even if you accept this as true today, it wasn't so long ago that taking a stand (such as filling a title, writing a column or organizing the community) risked careers, families, freedom and possibly even life and safety. Consider, just for a minute, that our leather community exists in a very fragile bubble of freedom and that bubble was built at great cost.

Take the extra time. Check your information. Check your spelling. Make sure the links work. Take a third or fourth look over that poster before it goes out across the state. Test to make sure the jpg sends and receives properly. Send the press release privately to someone else to look it over for you, before you send it to the newspapers.

It does matter. Be a professional about your position. Learn the skills of your craft. That is why forums and workshops and mentors exist. Take pride in your work and be good at what you do. Mistakes happen, but I find it easier to accept mistakes that slip by after my every effort to avoid them, as opposed to those annoying, foolish goofs that resulted because I simply wasn't paying attention. I can look myself in the mirror and know I did everything I could—and at the same time, I make copious notes on avoiding it next time. But if we don't demand excellence to begin with, we are too likely to settle for crap.

The measure of a titleholder or leader is not in being perfect and never making errors. On the contrary, this is the yardstick used to measure our success. It may be partially in avoiding them before they happen, accepting counsel and learning from the mistakes of others, skillfully correcting them or managing the damage once they

occur—but however it happens— we are still mostly measured by how we deal with mistakes...ours and other's.

Advice For The Ambitious Leather Contest Producer A Checklist For Contests

Regarding leather contests, we have offered advice in the past for contestants, judges, titleholders and others. But eventually, the fault of bad, boring or broke contests is not that of the community, past titleholders, the competitors, the volunteers or even the judging panel.

Every year we see contests that lose tons of money or are badly planned, titles that have no clear purpose or direction and judges who are not well chosen or instructed. We have heard that there is not enough support, that contests are a thing of past or that certain things are impossible—but the quality and integrity of any leather contest are squarely the responsibility of the contest owner, producer, sponsor or organizer.

Why do so many people decide to produce a leather contest when they don't know what they are doing? Why do otherwise sane folks jump into something without any experience or training in event planning, marketing, stage management, sales, accounting or any of the more than dozen skills entailed? And finally, after they prove beyond a doubt that they have no talent for it, why do they persist year after year, contest after contest? It would seem that someday, one would either get it right or get out. Most mistakes are so avoidable or so fixable by simply sharing the resources and experience (and even the mistakes) of others who have done similar.

How The Average Leather Contest Works

First off, does everyone understand exactly how the average leather contest is owned and operated?

There are many wonderful leather titles that are local and go no further. There is no regional, national or international level to them.

The San Francisco Leather Daddy title, for example, is not designed to go on to any other title. Founded in 1983, the title is actually owned by the AIDS Emergency Fund of San Francisco (AEF) and operated by the past titleholders as a fundraiser for AEF and other local charities.

Most titles are much different. They go on to compete at another level. Of those that feed into a structure of higher titles, there are basically two models:

The Franchise or Licensee System

Examples: Drummer, LeatherSir/boy or ABW. A central corporation licenses you to conduct a local or regional contest that feeds into their system. Local sponsors may sub-license from a regional sponsor creating an intricately tiered system. In most cases you cannot actually "own" the name— you merely license the trademark from the owner for the purpose of the contest. Rights to your contest can be withdrawn and granted to someone else. Some licensing just designates territories so there is no overlap, while others have a fairly strict structure that dictates things like judging criteria, scoring, promotions, logos, etc.

All of these national/international title systems are/were owned and operated by corporations. None are/were legally organized as non-profit organizations.

The Independent System

Examples: IML, IMsL, Ms World, International BootBlacks. Independent contests feed into a central event. There is no contract or connection with feeder contests. No controls and no central planning. They don't know where final contestants may show up from; it's a totally, free-for-all, open cattle call.

As the owner of your own such contest, you are completely independent. Your only obligation as a sponsor of a contestant in the

next contest may be to pay an entry fee (although I know contestants who have paid their own). You can come up with your own name, structure and trademarks. You can register the name, logo and marks as your own. You can make up your own rules. You can make money for yourself, use it to promote your bar, raise money for charity or just break even. You can even develop feeder contests into your feeder contest (example: Mid-Atlantic Leather). You, your bar or club can skip the contest and just appoint a titleholder.

Like the other systems, either individuals or corporations privately own the international titles. Even if they have a board of directors (or advisory boards), they still might be solely owned by one person. It depends on the corporate structure. None that I know of are organized as non-profits or qualify through the IRS for IRC (Internal Revenue Code) 501(c) (3) or IRC 501(c) (4) or other non-profit designation.

Therefore...

We can make four basic assumptions:

First, a name or a trademark (which is essentially what a title is) is considered an asset or property—like real estate or stocks. A nebulous community can't "own" anything, so who owns "our" community leather titles? A person, a business, a corporation or any duly incorporated non-profit with a tax ID number which can own such property. And the owner of the title is the one who makes the rules.

Second—yes— a title can be owned by a person, a business, a corporation or organization in trust for the larger community, however, whether or not that trustee is actually acting in the interest of the community (or exactly what IS in the interest of the community) can be matters of vigorous debate. It most cases it is not a legal obligation, but a moral and ethical one involving keeping the promises made in marketing and publicity materials. Inevitably,

213

such a trustee ends up acting in the interest of the contest (i.e.: self-interest) in order to survive.

Third, even though an independent can do whatever he (or she) pleases with his (or her) property, there are certain intangible restrictions to deal with. One is profitability (you can't alienate everyone if you are going to be financially solvent). Another is reputation and credibility (you want to be taken seriously by the rest of the tribe). Competitiveness (you want your contestant to have a shot at that higher title). Tradition. Integrity. Community benefit. Avoiding bad press. What "the market will bear." Since there is no central "Codes And Standards Review For Leather Contests" or "International Leather Title Operators Discipline Board," beyond state, local and federal law these are the only forces that keep contest producers and owners in line.

Finally, why is it important to be incorporated, structured, organized and so neatly legal? Why not keep it loose and uncomplicated? Very simple: Accountability. Handling your contest professionally makes sure that everything is above board. No questions. It protects the community from unscrupulous event promoters but it also protects you and the work you have put into developing a local title (lest someone steal it from you because you forgot to register the name).

Most importantly, it avoids sweating before an unsympathetic IRS auditor trying to explain why $12,000 of undeclared income went through your personal accounts and all you have to show for it are receipts from a beer distributor, a leather shop invoice for a something called a "custom title vest," rental for a ballroom at the Marriott and airline tickets for someone else to go to Chicago. Say "local leather contest producer" and he will look at you like you are speaking Venusian.

Titles should be a force for good in our community, not a source of misunderstanding, misery and contention. The more we understand about how leather titles work and how they are structured, the better

off we will be— and the more realistically we can approach titles as owners, participants, contestants, producers or titleholders.

A Checklist For Leather Contests

The following checklist is prepared for all contests, from bar contests and community fundraisers to international titles. This is not aimed at any one leather contest in particular, but at the contest system in general. You won't agree with all the suggestions (you might not agree with *any* of them) but each represents solid and documented experience. The options are yours and you are, of course, free to take the same stumbles again and again.

1) A contest must occur for a reason. Most problems between community and contest come because someone is unclear as to what the purpose, expectations or intent of the title may be. If your intention is to make a profit, fine— nothing wrong with that. If your contest is just fun entertainment to draw more people to your leather weekend— that's as good a reason as any. If you intend your titleholder to be a fundraiser or a spokesman— that's what you need to plan for. If you just think that your community really needs to be represented at IML and it would be fun to do— that's also a start (and something to bring up in therapy).

Here's a secret: Contest producers are driven by ego almost as thoroughly as contestants. They might say they are doing it "for the community" (they might even have themselves convinced of that) but they do it for that sense of accomplishment and achievement. Nothing wrong with that...it's the way great and difficult things get done: One stubborn human with a sense of personal investment.

But at the very least, **you** need to be clear about why you are doing this. You can pick and choose exactly how to convey that to the public, but being certain yourself at least helps avoid mixed messages that may come back to haunt you. Be honest with yourself. If your purposes are better served with a bake sale, an educational

seminar, an awards banquet or a stage show-- please consider those alternatives as well. Contests without clear purpose simply end up creating titleholders who don't know what they are supposed to be doing and a community who begins to question why they support them. It is an excellent formula for frustrated and even hostile relationships between the community, the titleholder and the title operator.

2) A contest must be successful. Different people will have their own measure of a success. Some measure by the bottom line (Did they make money?); some folks judge the weekend by if they got laid; some just figure the weekend is OK if nobody dies. But you have to measure. Do you sit down and evaluate afterwards what went right and what needs improvement next year? On some level, the event must address some of the goals and reasons you had in mind for it above in #1.

3) A contest needs to make a profit. Whatever you settled on for your raison d'être, your event still must bring in enough money to pay the bills. But if you plan to bring in enough to "just break even," that is too close to planning for a loss or deficit. Your budget should account for a cushion or surplus in case of emergency. If not, you are being financially irresponsible.

Some people have a problem with the word "profit" as if someone is buying yachts and hilltop homes with the proceeds of the local Mr. Topanga Canyon Leather contest. First, profit is simply a positive difference between income and costs (as opposed to "loss"). Second, anyone who expects to get rich off a contest (and didn't start 25 years ago) is a fool. Your chances are better playing the lottery.

Even so, don't plan for failure. Someone is investing in your contest. They invest their time, money or reputation. Who is investing in your contest and what will those investors consider a satisfactory return? Even volunteers and contestants need to get back a sense of accomplishment. Does it have to generate sufficient advertising or

bar revenue to justify the cost, or must it satisfy the hotel, bring in enough tourists to the community or enough prestige to the sponsors to be worth it? A contest that loses money year after year with no benefit (even indirectly) to anyone cannot survive indefinitely.

It can even be argued that that is a shameful waste of scarce community resources.

4) A contest needs to be a competition. Too many times we try to blunt the sharp edges of competition and take the "everyone's a winner" thing a bit too far. We lighten the load, treat the also-rans as if they had won and send all the contestants along to the finals. We have a contest even though there is only one contestant. While we mistakenly think this encourages more participation, what it actually does is dilute the prize and the contest into something not worth bothering with. The competition should be rigorous and the prize clear.

Competitors need to compete. That means a winner and losers and fair judging to tell the difference. When you start trying to monkey around with that, you take away any sense of accomplishment or triumph. As Thomas Paine once wrote, "That which we obtain too easily, we esteem too lightly."

5) A contest needs to deliver on its promises. If you promised the contest would start at 8:00 pm and end no later than 10:00, that is exactly what needs to happen. If you promised that the costs would come in under budget, you had better have a handle on your spending. If you promised your titleholder would be a leader and an ambassador for the community, your instructions to the judges better call for precisely that. If you promised that a specific amount of money will be in the travel fund, it needs to be there and you had better have the receipts to prove it.

Does that sound unfair? Things come up. Accidents happen. True, but what I have found most of the time is that the curtain didn't

217

go up on time due to poor planning; there was no budget; no one bothered to give any instructions at all to the judges; and some one decided that they could "borrow" from the travel fund. These are not "accidents," they are errors and they are preventable. That is your responsibility.

6) A contest needs to stay in scale. If you want to create a national or international title, great. Don't, however, start from the top down in a "if we build it, they will come" manner. What makes a title "U.S." or "International" or "World?" Do you simply invite the world? What national or international groundwork have you laid? Have you developed feeders throughout your targeted territory? Where do your contestants come from? Of course, you can call your contest anything you want, but don't be surprised when folks laugh at the presumptuousness.

If you wish to avoid the chuckles, the solution is simple. Either scale your name to fit your contest or scale your contest to fit your name. It takes a lot of work to plan, create, build and maintain a contest at a national or international level, but hey, it's been done. If you don't want to put in the time and effort, do yourself a favor and limit your moniker to the community or region you actually serve. The truth is in the packaging (and maybe a little modesty wouldn't hurt, either). Remember, it is always possible to upgrade later, but having to go from first class to coach is a whole different trip.

7) A contest needs to be doable. In addition to fitting your name, your contest should be scaled to fit your resources and your audience. The Busby Berkley number with the full orchestra and exploding volcanoes may be just a bit over the top for a small, local contest. Flying all the judges in may not be affordable for you (even though some other contest does it). Simplify. Make sure you are running one or two titles really well before adding yet another to the slate. Don't overreach. Most problems with community events happen when we try to do too much.

8) A contest should build on previous experience. We've been at this for nearly 30 years now. There are dozens of successful leather contests each year, so the good news is: This is not rocket science. From international to neighborhood bar contests in every size and description, you have a wealth of experience to draw from. Since most of planning is anticipating potential problems, learn from someone else's mistakes. There is no need to "wing it."

But beyond just the leather community, how does the local theater group make sure the show opens on time? How does the local arts festival construct a workable budget? Can you get copies to study as examples? How does the local farm or industrial show structure their sponsorship or ticket organization? Can you see their business plan so that you can write your own? How are grocery stores, used cars or yard sales advertised or publicized in your area? If you see something that works, adapt it for your contest. If you need to learn staging skills, accounting, ticket sales, program production—these skills are available. Go get them.

The bad news is: There is no excuse for bad, unsuccessful, unprofitable, redundant, ill-conceived or poorly-run contest after contest. The means exist to do it right and if you are not doing it right, that is a deliberate decision you have made. We won't (and shouldn't) tolerate poor planning, shoddy work and lazy accounting just because "we're family." It may be unintentional disrespect, but it is disrespectful nonetheless and we deserve better.

I believe that leather contests are still viable gathering points for our community. I believe that they are still important enough to discuss and improve. I believe they can be held to certain professional standards. I believe they deserve criticism when they screw up and I also believe in offering a hand to help them improve.

It's Good To Be 19 About San Francisco Leather Daddy XIX

On fait ce qu'on peut (One does what one can)

Many years ago, I was an officer in a leather club that was asked to sponsor a contest in a larger city across the state. Before recommending that we take on any responsibilities, I decided to go and check it out. Arriving some hours before the contest, I asked what I could do to help. The man in charge said, "Well, we're pretty much set up but we could use another contestant. Here's the application."

In a nutshell, that was how I became Wisconsin Levi/Leather Daddy 1994. Last Friday night I became a daddy for a second time when I was selected San Francisco Leather Daddy XIX.

Don't ask me why this title uses roman numerals. I guess that's all they had when some of these guys were young. The reason the title goes by number, rather than year, because it is considered a "title for life" meaning that the only way I can stop being Leather Daddy XIX is to die or move to Palm Springs—which is a San Franciscan equivalent to passing on.

Cigars, Anyone?

A daddy title is very different than most leather titles. It is less like Mr. Universe and more like the Irving Thalberg Award for Lifetime Achievement. Half the folks say, "Isn't that nice?" and the other half say, "What? Is he still alive?" You have to come to the position with some sort of resume. Most are "working titles" that carry with them certain responsibilities. Not so much cutting ribbons at supermarket openings, I guess. The San Francisco Leather Daddy, in cahoots with all the past SF Leather Daddies and the Leather Daddy's Boy, pull together several fundraisers a year. Ever since I came to Sodom-

by-the-Sea, the "Dads" have been my friends, mentors, volunteers and associates. I have admired their work as I watched from the outside.

A famous lion-tamer was once asked for some of his trade secrets. The interviewer thought perhaps it was where the beastmaster stood that made the difference. Did he stand to the right or on the left? Was he behind or did he face the cat? Exactly where in relation to the man-eating tiger gave one the best control? The lion-tamer answered simply, "On the outside." I suppose once one is inside the tiger, control is pretty much a non-issue.

Some things always seem easier from outside and a safe distance. Still, doing your job, yet not ending up as tiger chow is not easy, but I've done it before. They tell me that's why I'm the daddy.

What Did You Do During The War, Daddy?

Still, I am amazed at the reactions I have gotten. Well-meaning folks who congratulate me with visible sympathy. Not that I think that this will be a cakewalk, but I am a bit confused by the assumption that this will be "the toughest year of my life." Uhmmm, pardon me, but what would that make the last five years, or the 20 before that? Bootcamp was tough. LSAT's were tough. The first Bush Administration was tough.

Juggling an international magazine and an international contest was tough. I mean, you do the math: There have been 19 SF Leather Daddies. There have been only four publishers of *Drummer*. I used to get comments and complaints about the job I was doing from across the US, Canada and Europe. Now, my constituency is one very focused, if admittedly just as contentious, local community. I was doing 12- to 20-hour days, travelling to 25 cities each contest season. As Leather Daddy, I am expected to do four fundraisers in a year and it is highly recommended I keep my ass put right here. I think I can handle that.

I joined the Navy when I was 17. It was the first full-time job I ever held, but it gave me a healthy perspective on every other job I have held since: If I'm getting more than twenty-five cents an hour and no one is shooting at me—it's a step up. It's gonna be OK, this ain't my first time at the rodeo, boys.

A Working Parent

As honored and humbled to be chosen for the second time to represent my community as a Leather Daddy, this is not tough. There are folks out there who face unbelievable challenges everyday— and they don't get to turn over the job at the end of the year. *As for the rest of us, we do what we can.*

The line above is from the novel *"Lord Jim"* by Joseph Conrad. It can be interpreted and construed many ways but its simplicity and practicality is what always struck me. One does not need a title, a position, a magazine or even extra ordinary gifts to fight intolerance, ease suffering or generally improve their world. It need not be a flashy program, a worldwide movement or a thousand-seat fundraiser. You improve your world and your community with small, accomplishable efforts. You do what you can. You work with what you have. Pick up a piece of paper that's trashing your neighborhood, say a few kind words to a friend, put your change in the charity jar, check in on the sick, let someone else go first, listen to someone who's lonely. Create and support a leather family that cares for its own. Try to fix what is broken.

A title merely says to people "Here I am! What can I do for you today?" All those wishing me congratulation (or condolences) are invited to come along.

Although it's good to be XIX, I wish I had the energy of 19. Does this thing come with batteries?

VI. Beyond Upholstery Notes On Leather As Life

Plastic Leather, Plastic Leathermen The Material World

We don't know much about the exact origin of leather. Before early man discovered weaving fibers into cloth, even before he wore raincoats of straw and dried leaves, he discovered that when his own skin was not enough to keep him warm, he could purloin the hide of last night's dinner. Some approximate 2.5 million years ago, one of the original leathermen (we'll call him "Og") fashioned a pair of chaps out of skins and the whole thing began. In addition to being practical protection if he fell off his prehistoric hog, Og and some of his fellows believed that recycling parts of other species endowed him with the qualities of those beasts. The deer would pass along its swiftness, the lion its ferocity, the bull its strength and so on.

Of course, our community is not just a fabric choice. There are those who wear uniforms, denim, canvas or any variety of materials. But why are hides the enduring icon for the "leather" community? What about the other options that exist, particularly now?

Latex

The natural form of latex, which originates from the sap of a living tree, was originally used by South American natives to mold toys and offerings to the gods. It could finally be made into practical rubber products after Charles Goodyear discovered the process of vulcanization, quite by accident, in 1844. The gear of firemen, butchers, divers, construction workers and electricians, latex rubber is popular in medical scenes, water sports and other fetishes. Natural rubber is used in combination with any number of synthetic rubbers to obtain the right texture and properties.

Latex can be quite sensuous, as close as possible to nakedness but still retain the bondage of tight covering. Indeed, natural latex is semi-opaque and looks much like skin. It is brutally honest, as no imperfection, bump, bulge or ripple on the body inside escapes translation to the surface.

Lately many other man-made materials have been introduced at leather stores and events across the country. Traditionally tailored jackets, chaps and pants in new, synthetic materials are all the rage.

Neoprene

One of the more popular is neoprene, a synthetic rubber developed by Rev. Julius Nieuwland, C.S.C. in association with DuPont prior to WWI. Working on new acetylene-based poison gases, he found that if monovinylacetylene were treated with hydrogen chloride and the resulting chloroprene polymerized, neoprene would result. The new substance appeared on the market in 1932 under the DuPont brand name Duprene.

Most of the material marketed to the leather community today is roughly 23% nylon and 77% polyamide. It consists of a nylon jersey, which can be any color or pattern, and is infused with neoprene foam. It is form fitting, the black looks a bit like finished cowhide from a distance and one can add stripes and trims in one's favorite color from the hanky code.

Pleather

"Pleather," with the shiny finish that most of us associate with rain slickers and vinyl upholstery, consists of any number of combinations of polyvinyl chloride (PVC) and polyurethane (PU). Variations of these plastics have been around since before the Second World War. It is cheaper and easier to clean than leather and most forms are more durable and easier to repair than neoprene or latex. As much as the processing of hides into leather can get environmental and ethical panties in a bunch, the petroleum-based components of

pleather create such toxic runoff and residue that most manufacture of the stuff is conducted outside of the United States.

Leather

But these are not like leather. It was never alive and has no life force to add to the wearer, like Og believed. Good leather outlasts the wearer and is passed down from generation to generation, as each leatherman contributes part of himself. How can one absorb the virtues of a polymer? It can be clothing, but it cannot be a trophy or a legacy. These new materials are temporary, fleeting and fragile. It is no protection if you hit the pavement while riding. It is unforgiving and cannot be easily repaired. When it gets scratched or scuffed, it is ruined.

I am indebted to the men many years ago who taught me the difference between style and fashion. One's style is established and refined over time, while the winds of fashion are shifting constantly. One is uniquely and stubbornly you; the other seeks desperately to conform to the mob. The "new leather" may be amusing and novel for a time, but for me is hardly a replacement for what is tried, tested, solid and durable. The question remains: Is the leather that you wear or the leather community in which you participate part of your heart and your personal style or merely a fashion that you can put on or take off?

In short, these new materials, like some new leathermen are light, fun, sexy, they can even be easier and cheaper, but they lack the honor, the history, the dignity, the naturalness and the life of leather. They do not protect the wearer and they do not age well. The slightest damage can destroy them— but then again— they are designed to be disposable.

The Tyranny of Correctness Why Leather Is Inherently Un-PC

When you finally pin them down, most people have a rough time actually giving a definition of what is "PC" and what is not. Indeed, like the weather, everyone complains about the extremes of "political correctness" but nobody seems to do much about it. You often hear examples of sensitivity and deference run amok— but considering that for most of the history of Mankind, life was a pretty short and brutish experience, is it so terrible that the pendulum swings in the other direction for a bit? Is a surplus of civility, concern and kindness so awful?

In theory, even the most positive force can become destructive when applied irrationally. One of the most bizarre places that the modern cult of über-correctness and ultra-sensitivity intrudes is our leather SM world. Let's face it: We're really much more about inequality than equality, exclusivity rather than inclusion, sadism not sensitivity. Our community, like our sex, has always been by nature messy, loud, bruising, uneven and rambunctious. We're bad boys and we thrive on that. Why do we try so hard to push the leather/SM community into a mold for which it is clearly ill-suited?

It just doesn't fit. It makes as much sense as a painless flogging or water-soluble handcuffs. One of the problems with the new cult of "PC Leather" is that one is not allowed to speak directly or openly. We don't debate issues, disagreement is impolite, strong words and strong actions are rude. So instead, we dutifully recite the Mass of Community-Unity-Diversity.

The ancient founding catechisms of leather, the sacred icons of masculinity and of butchness as handed down from the apostles (St Tom of Finland and St Larry of Townsend) are in direct conflict with this new orthodoxy of pansexuality, gender ambiguity, political correctness and community politics. Let me speak my heresy

226

quickly before the Leather Inquisition comes to take me away:

In Touch With Your Feelings

There are many feelings I am not in touch with. I don't want to be in touch with them. It's been years and I haven't so much as sent a card. I disagree that to be honest one must hang out every thought and emotion for public display. I'm not sure that's even real honesty, anywhere outside a taping of the *Jerry Springer Show*. I have the right to be discreet, if I choose. Likewise, you have the right to just not give a fuck about my childhood traumas.

It used to be that you didn't have to explain that leather was butch. It used to be you didn't have to explain what "butch" was. I've been told that the concept is some sort of sick, archaic, patriarchal, hyper-masculine cartoon—but still, I'm rather fond of butchness.

Fussy is not butch. A leatherman is not to be fussy. One should not be broken up by every little thing. Delicate is not butch. Neither is dithering. One should keep one's temper. Maintaining control— at the very least over oneself— is butch. Allowing every whim and whimper to twist you that way and this is not butch. Direct confrontation is butch, but whining about a little criticism, correction or dissent to everyone except the person who made it is not butch.

Wearing a dress is many things, but it's not butch. For many years my club brothers insisted that I take part in the closing show of each run in drag. They insisted it would help me "bond" on put me in touch with my feminine side. I have never been in a dress; I have no desire to cavort on stage in a dress. If I did, I would have been down the street at the drag show instead of at the leather bar. I don't mind men who do drag (except that they tend to be much taller than I, cuter and generally they have nicer legs than I do). It can be fun and campy, but it puts me in no mood to "bond." As for my feminine side, if I have one, we have never quarreled so I feel it best to leave well enough alone.

Out Of The Pan, Into The Fire

I am a gay man, meaning that I prefer to have sex with other men. That means I like whatever it is that makes a man a man (which, understandably, is a whole other discussion). I have nothing against women, I have loved and had sex with women—but after much self-discovery and some therapy, I think I have a handle on all of that. No need to revisit it, thank you. At some point in one's life, one should be able to stop repeated experimentation and settle in to focus and refine one's tastes. And one should not be forced to apologize for it.

Watching straight folks or lesbians having sex is not educational anymore. Graduated from that school, advanced degrees. And that includes the foreplay to sex, whether that is seduction, a long public bondage scene or a thorough whipping. Not that I am repulsed or offended, I am just not interested. You go your way, I'll go mine.

Pansexuality, therefore, has limited appeal to me. I am very much a fan of inclusion, but community politics (please note that is the reverse of PC) does stop short of my dungeon door. I have no desire to share my playspaces or my hunting grounds with women or straight couples. Because I don't like them? No. Simply put, they are not what I am hunting and I am allowed that choice.

I have been chastised about not attending the pansexual play party at certain events. I deeply resent this nonsense that if I do not personally embrace some sort of pansexual play that I am a bigot. Folks, all of this struggle for sexual freedom has been so that people would have the freedom to fuck whomever they pleased, not so we could replace one moral tyranny for another. There is no difference between these and the religious fanatics who justify their beliefs by insisting that the whole world share them.

Being supportive, being social, sharing the causes we can support for one another— these are all excellent places to encourage inclusion and diversity. One's bed and dungeon is not. There are places neither

the Republican Party, the government nor my community have any business nosing around.

It's not like things haven't improved, either. Isn't it amazing how many zealots in the name of Old Guard are women? Sister, I love you, but most Old Guard would not have let you in the door. Men only. You would not have been allowed in their clubs, in their bars or at their events…so let's moderate your fundamentalist fervor a tad.

Truth In Labeling

We are leather, we label: Top, bottom, master, slave, daddy, boy, gay, straight, Mr., Ms, red hanky, blue. At some point, you are not inclusive if you try to claim these all (or none) at once, merely indecisive.

You organize your life the way you want to and I'll file mine the way it makes sense to me. I happen to find labels useful—and so do you, if you are honest, even the label of "hopeless throwback" which you are applying to me at this very moment.

Labels are very important, as long as they are our labels and not someone else's. Some speak of Victorian, Roissy, Gorian or Prestonian schools of mastery—as if those actually mean something. For a while "womyn" or "wimmin" were in vogue. Now "boi" and "grrl" are all the rage. Some submissives get hurt when you don't use a lower case letter on their name (Hello? *Sadist?* If I hurt you, I've done my job). Still others insist that by not knuckling under to their demands, you are (for example) "disrespecting all titleholders everywhere." No, trust me- it's only you I disrespect. Don't presume you represent an entire class of people. You need not get miffed on their behalf; it's not your job.

Sometimes I think the new variations are simply there so that in nearly any circumstance, someone can go "WRONG! You have now offended me." Look buddy, you are the one using some strange

229

configuration of English without letting anyone else know the rules, it's up to YOU to accommodate the real world. Since that world works by labels anyhow, why not settle on one or two that you like and that folks might understand?

I realize that life and leather do not always lend to neat, tidy labels, but I do see some value in a little organization as long as one does not get anal or militant about it. It's not critical, but I like folks to know at a certain point if they are gay or straight (I will accept bisexual or even a number on the Kinsey scale). If for no other reason, it's nice to know if you understand what I'm saying or I have to use the straight-gay, gay-straight subtitles. And while we are at it, a transgendered man who now identifies as male and sleeps with his girlfriend is, by definition, straight. He has gone through a hell of lot to achieve that identity, and I think he deserves that recognition. He may be welcomed and beloved, he may be included in many things, but he is not gay.

Many times our community is like the militant bicyclists in San Francisco. They insist on being treated with the equal respect due any vehicle on the road, but when convenient they pop up on the curb or blow off stop signs with pedestrian abandon. Well, which is it going to be? Are you a vehicle or a pedestrian? Which rules are you going to follow? Make up your fucking mind (and, yes, when there is a four-ton city bus driving up your ass, it *does* make a practical difference who and/or what you are).

We are not all alike. If it weren't such a taboo to discuss, we'd understand that better. The key to diversity is not cramming everyone into the same box. It is allowing everyone to pursue their own needs and their own liberation. Wisdom recognizes that those will not always be the same and that when you try to represent everyone, you soon cease to represent anyone.

I believe in inclusions, but I also believe in focus. You cannot always embrace the universe and get things done in your own back yard at

the same time—so it is useful to know the difference between the two. There are places where our issues and our energies converge with others, but there are also some forced and unhappy marriages in the name of "diversity." I appreciate and applaud the struggle of many people, they have my understanding, I will be an ally, but theirs are not my issues. Don't expect an excess of passion and priority when I am only a peripheral.

We really aren't very good at the unity thing even when we seem to have one, common goal. For some reason, that's when we like to emphasize the differences in race, gender, attitude and amplitude. Instead of concentrating on what brings us together, one hears long speeches about how diverse "we" are with the essential theme of: We're here, but we ain't you. Wrong speech. Are we that unclear on the concept of "uniting?" That is not the time to allow the progress of the whole to be subordinated to the sensitivities, demands or agendas of factions or individuals. That is a time for focus and priorities. That is the time to take "unity and community" beyond empty platitudes and into practical results.

Blind Trust

In the name of inclusion, we in this community have a habit of bestowing trust and respect where they are not warranted. We put up with the incompetent but well-meaning and even the destructive and the deceitful. We welcome criminals, dealers and predators into our inner sanctum— and then we are surprised when someone gets hurt. We dance around "impolite" talk of dangerous people and dangerous behavior— and then wring our hands when someone ends up dead or injured. We wouldn't dream of questioning or challenging anyone— so we end up believing the most idiotic things. We wouldn't be so rude as to ask for qualifications, references, bonding, resume or even a last name.

I will continue to be skeptical, to offer proof and verification— and I will demand the same from others. I will continue to be dubious of

people who expect credibility (and handle cash) using cockamamie, made up identities. Our experiences in life or leather may be very different, but based on what I have seen, I will NOT be automatically extending respect and trust to just anyone who pops up in a leather vest. I'm sorry, but I have spent too much time in the past 20 years cleaning up the messes of those sweet but naive souls who do.

Incorrectly Speaking

At the bottom of most revulsion over political correctness is an allergic reaction to censorship. We are told to watch what we say and how we say it. We are told to be sensitive and caring and how to do it. That is as about as far from the traditions of leather as you can get.

That is not real concern, either, anymore than true freedom is saying or doing every silly thing that pops into your head. Real concern involves caring for other people as people, not just as a demographic slot. Real freedom allows us to exercise our reason and intelligence; it involves thinking thoroughly and rationally about what one believes and why. Free men take personal responsibility for what they say (and what they don't say). They own both the content and consequence of their words. The evil of censorship is that it removes both— stifling debate and keeping people in a child-like state that never develops for themselves a sense of fairness, responsibility, concern, perspective, restraint or "correctness."

I really can't write much more. The mob is gathering below my window chanting, "Burn the heretic! Burn the heretic!" They must be serious: They are carrying their environmentally safe, safety approved, low-emission, clean-burning, renewable, recyclable, non-toxic torches.

A Night With The Doctor A Memoir Of Tony DeBlase

Many things have been written about the late Tony DeBlase, much by people who knew him a lot better than I did. I was just one of thousands of leatherfolk that his life touched and was the better for having brushed up against him.

Cramming For The History Final

I had seen Dr. DeBlase at the International Mr. Leather Contest for years. I may have even been introduced to him as our paths crossed in the intensity of the small hotel lobby of the old Executive House, but particularly when he was publisher of *Drummer* magazine, he was one of those lofty leather gods I saw from afar and would have been tongue-tied as a schoolboy to encounter one-on-one.

The first time we actually talked at length, I was an IML contestant. Actually "contestant" is a much too misleading word, for all its evocation of struggle, activity and glory. By then, I had been involved in the scene too long and had been coming to IML too long to get overly worked up— or to enjoy any illusion of winning. Generally speaking, it was a pretty laid-back effort. Kind of like competing in the Ididarod while your main concern is keeping fresh snow in the cocktail shaker.

My program was to take Chicago as I always had. No exceptions. It was my habit to grow a beard beginning in hunting season and shave every spring, and in spite of all counsel to the contrary, I was not about to allow a mere international contest to change my ways (today if I am ever tempted to shave, one look at those contest photos stays my hand from the razor). In response to the rules about contestant's drinking, I got politely drunk and mostly naked at Touché and bought shots for two judges. Like every leather event and motorcycle run before, my room guests knew their choice of refreshment: Jack Daniels and ice— and occasionally we ran out of ice.

233

At Man's Country Baths, owner Chuck Renslow, the executive producer of IML, was taking a shortcut through the club during a function that all contestants were supposed attend next door at the Bistro II. When he saw me lounging in front of the video, a head full of close-cropped brown hair bobbing up and down in my lap, I said, "Hello."

He said, "Aren't you one of my contestants?"

I said, "Yes, I am."

He said, "Have fun."

The day before my interview, however, I did have a moment of panic. I have never really bothered to learn who was IML in 1979, when the first Inferno was held and where the word "chaps" originated so I ran down to Dr. DeBlase's booth at the LeatherMart, desperate for a copy of his *Leather History TimeLine* for a last cram before the impending history exam.

I was impatient to get back to my room and try to memorize several centuries of history in one evening, but seeing my anxiousness, he asked if I was a contestant. Instead of rushing and filling my head full of useless trivia, we talked for a while and he put me at ease with myself, my own experience and my place in the leather Universe. He suggested I use the time to work on my speech instead (just in case I made the top twenty) so I might have something worthwhile to say. I did just that, and wrote a brilliant speech which I never got the chance to deliver.

Black Ink And Black Leather

But that speech showed up, in bits and pieces, in the welcoming speeches I gave every year at the International Mr. Drummer Contest after ending up first as operations manager coordinating the contest, and then as editor and publisher— the positions Dr. DeBlase had held.

At *Drummer*, the agreement under which he had sold the magazine put him on salary for a time as part of the purchase. I signed and sent his paychecks. We talked when things went wrong: late checks, disputes with the current owners, clashes over this or that. It was not a relationship designed to be pleasant and I was relieved when that period ended and I no longer had to serve as ping-pong ball.

Finally, on the Sunday night after the IML contest in 1999, Tony DeBlase agreed to sit down with me in the hotel bar of the Congress and talk. I was very proud of the bridges I had built to people involved in *Drummer's* past— some not very well disposed toward the memory— and hoped to iron out a cordial relationship. I was prepared to beg, grovel, apologize or cajole but none of my preparations were necessary. It seems he had wanted to talk to me for some time and only my silly fear had prevented this from happening years earlier. He was a mannered gentleman, with a keen curiosity and wry humor.

We talked about printing and publishing, the smell of ink and the invoicing tricks of unscrupulous printers. We talked of the community, of a passion for the written word and about all the forces we had fought to keep publishing. We talked about the direction of *Drummer*, what he had done in similar circumstances. We talked until the bar shut down but I did not want it to end. Moving to the lobby, I remembered the Jack Daniels in my room and asked, "Well, sir, I know it's not what you've been drinking, but I could bring down glasses and ice and we could continue this talk. I hate to take a half-empty bottle back on the plane." With a barely discernible smile he said, "OK, if you want."

I rushed up to my room, grabbed glasses and the whiskey, and quickly packed for my 6 a.m. flight. We spent the rest of the night speaking like old friends, but never once could I bring myself to call him "Tony." He repeatedly asked me to, but at the same time seemed to appreciate the formality so it was "Dr. DeBlase", "sir" or

"Doctor." There must have been a hundred or more people cruising and groping through the lobby, but he made me feel as if we were the only two men alive and the world outside our conversation did not matter. By the time we had polished off the bottle, he was ready for bed and I was ready to pour myself into a cab for Midway Airport. We emailed off and on the next year and I was looking forward to another long chat at the Congress bar, but in 2000, Dr. DeBlase was too ill to travel to IML.

I will treasure that night. Once again, he had taken a man who felt unsure, unworthy and out of place and given him the confidence to continue on his own path, his own way.

Clash Of Symbols What Is The Meaning Of This?

We love our symbols, icons, ciphers and emblems. The heraldry of leather includes the pins and ornaments we wear, the accessories (on right or left), our badges, baubles and plumage. I love just sitting in a crowd of leatherfolk, say in the lobby of the IML host hotel, and reading the various personal statements. It is a human library, filled with some of the most fascinating new editions, a few reprints and some of my favorite old volumes.

Since our symbols and statements tend to be very personal, this column may seem a bit personal and self-centered. Sorry. Not that a writer should not write about himself (it might be one subject in which he could be considered an unrivaled expert) but the danger comes when writers bore you when talking about themselves. That means that any criticism is actually personal. On that note, I'll keep this brief.

It's not that I purposely go out of my way to make a "statement"—I prefer to think of myself as merely "conventionally unconventional". Besides, I get paid to make actual statements rather than symbolic ones and would prefer that they speak louder than whatever I happen to be wearing. There are just a few things that have raised questions over the years, so here are a few of my personal symbols and some of the crap I have gotten about them:

The Tattoos and Piercings

"Wow, did you see that great spider web tattoo?"
"Those are varicose veins, I believe."

Tattoos and piercings: I haven't got any.

I designed tattoos for my shipmates in the Navy but I never ran across anything I could really see being enchanted with for years and years (or at least until such time I was finished with my skin). Trust me, I looked on five different continents and numerous islands. And

I'm really not that picky— I have shirts that I don't mind wearing 20 years later. Whatever the reason, I never did get around to getting my own tattoo.

I had a plain steel ring put through my left nipple in Amsterdam several years ago to seal vow I made in response to a promise made to me. The promise was broken, the vow expired and the ring was removed.

Any statement can ring shrill, derivative and desperate when overdone. We've seen most every body modification possible, so rather than being personal, artistic, creative and profound, some publicly displayed body art can quickly go beyond statement into a juvenile stamping, screaming cry for attention in a world where everyone and everything is screaming for attention. Every communication has an encoder and a decoder, and while I make no judgment about what it means for the person beaming their statement to the world, I feel it's fair to comment from the receiving end.

It also has something to do with being realistic. I just find it amazing when some people complain that certain career paths closed to them when visible tattoos snake up their neck and across the bridge of their nose. They seem to consider this an artistic critique. In further conversation, part of the appeal of their design was it's shock value, yet they are surprised when folks are, well....shocked.

It is a personal choice. As for me, I've still got my appendix, foreskin and tonsils. No contacts or glasses required (except for the occasional magnification). I still have even a few baby teeth along with most of my faculties and most of my follicles. Since I'm really running pretty much original equipment and— perhaps with a certain amount of fear— I figure that I'm better off just keeping everything "as is" this close to the expiration of the warranty.

The Jewelry

"When you go home to stay, this will remind you that you have been here, that you have been somewhere other than where you are from."

I have always worn as little jewelry as I can for safety reasons, if nothing else. Not only can it get caught in machinery but also it can catch the eye of potential thieves and muggers.

The exceptions are a cheap watch, the ring that matches my partner's, and a steel necklace from which hangs a single Sri Lankan rupee coin, worth a little more than a penny.

More than 25 years ago, after dinner with her family in Colombo, Sri Lanka's capital city, my young hostess put the coin around my neck, spoke those words and kissed me. I have worn it ever since.

The Ribbons

"So, faggot, you say you're a decorated veteran. What did they decorate you with? Pretty ribbons?"
"Actually, yes"

The ROTC boys from the University of Missouri were a little too stupid to know yet that "ribbons" or "decorations" refer to those colorful pieces of satin fruit salad on the chest of a real soldier or sailor that represent the medals and citations earned. They were also too stupid to avoid using the word "faggot" when completely outnumbered in the middle of a crowded gay bar. Both the language of symbols and the language of actual words require caution at times.

I have taken to wearing my decorations more often since September 11. They mean more to me and say much more than wearing a flag pin or FDNY button.

And for the record, the decorations that I wear are actually mine. The gifts of a grateful nation.

The Jacket

"Listen. This is my jacket. I bought it. I paid for it. The check cleared a long, long time ago. So, if the mood takes me, I'll wear it with fucking fuzzy pink slippers if I want."

The classic motorcycle jacket is standard issue equipment for most leathermen. I have had the same old leather jacket for almost 20 years. It looks like a 20-year-old jacket, too. But it was at least 10 years before someone was stupid enough to tell me what I shouldn't wear with it.

I like to get out of boots every once in a while and my second favorite shoewear are an old pair of Chuck Taylor high-tops in black leather. So, when some officious little twit felt the overwhelming need to loudly berate me for wearing "sneakers" with my leather jacket, I lost my temper somewhat (resulting in the above reply).

The most delightful criticism of my old jacket, however, came from Daddy Alan Selby, the honored leather Daddy of all San Francisco and the original Mr. S (as in Mr. S Leather). He was helping out in the office as I was working 12 and 18-hour days during an International Drummer contest, and one afternoon he frowned at my jacket and said, "That won't do. We can't have the publisher of *Drummer* magazine running around with his jacket looking like that." And without another word, one of the most famous and honored leathermen alive, the top of tops, the Daddy of All Daddies took off my jacket and oiled it up for me while I rested for a moment or two. I love that man.

The Tie

"This tie is from a US Marine Corps class A uniform and was a trophy from a very satisfied gunnery sergeant. But, if it's not butch

enough for your little gay soiree here, I'm sure I can round up a few
Marines who will be happy to discuss your fashion sense."

I wear a tie to many leather functions because—well, that's what I do. Usually it is a leather tie or a black uniform tie from my Navy dress blues. Once in a while I wear a khaki one and the last time I did, one community wag choose to chastise me for wearing something so "unleather" as a "beige tie". I'm sorry, I lost it once again. It amazes me that to deal with their own insecurities, some people will presume to tally what others are doing wrong and then have the effrontery and poor judgment to actually present the total to the person's face as if they should be grateful. Perhaps it's just a lame way to make conversation.

Since "casual Fridays" became a business norm, the suit and tie have become exotic, dangerous and alluring. I predict it will be the SM fetishwear of the future. Since every shopclerk, accountant and lawyer has a leather motorcycle jacket, leather hardly carries the awe-inspiring cachet it used to. If you want to really scare 'em, wear a suit and tie. They'll think they're being audited.

The Paddle

"Where's the river, buddy?"

I carry a paddle on my belt on certain occasions.

Now, it is not unusual for a leatherman to carry a flogger, whip or paddle on his hip. What is unusual about this particular paddle is that it is an actual paddle—as in "canoe".

It was a farewell gift from my club brothers. First, it is a traditional symbol of treasurers (when the British Parliament is in session, you can see on the table in the House of Commons a silver oar that symbolizes the financial authority of the state). The last post I held as an officer was club treasurer. Second, and much less profound:

Since I was moving to San Francisco they didn't want me "up the creek without one."

It also makes a damn good swatter. Frightening to bad boys and exciting to twisted pain pigs.

The Dinosaur

"There is a big difference between being a "dinosaur" and being a "fossil".

My dress leather hat has a silver dinosaur for a hat device. My title vest has a dinosaur on the back. I have, on occasion, given dinosaur gifts to various people. The dinosaur has been interpreted several different ways: Are you vegetarian? Is it a statement about your age? Your health? Did you work for Sinclair Oil? Is it because you are from California?

Its true meaning for me is in that gut feeling I get when people say these stupid things to me. Like I am the last of breed that practices a more discreet, more cerebral, courteous and less impertinent denomination of leather. If I give the gift of a dinosaur to someone else, it means that I feel I have discovered someone else who understands that more ancient and noble way of life. It means that this is someone I would be proud to face extinction with—drink in one hand, cigar in the other and some great stories to tell on the way to oblivion.

Everything I Know, I Learned From Motorcycles
Lessons From A Simpler Time

Once upon a dark past, motorcycles meant a lot to this community. Riding meant a lot to me. But like the community, I have grown established, old, sedentary, settled and safe. Nearly respectable. I zip around the country on planes, whisked here and there by taxis and airporter shuttle vans. In a new community, I must be more concerned with presentations, programs, grants, conferences and funding. In between all these very important and necessary things, in the occasional, quiet, unscheduled moment, a wild wind from the open road blows once again through gray and thinning hair.

These days, the call of the highway is a voice that seeks for younger men. Like so many youthful voices lately, it reminds me of my fears, my birthday, my brittleness and my mortality. But the men and the motorcycles at the very beginning made me the sort of leatherman I am, and like so many of the lessons you learn early, they stuck with me:

1) If it doesn't fit in the saddlebags, it doesn't go. I am still amazed when I see 14 pieces of matched Louis Vitton luggage parading through the lobby at IML. I could pack what I really needed for a weekend in the pockets of my leather jacket or bungee the rest to the back of the bike. If there wasn't room for it, guess you really didn't need it. Sure did keep things simple and unencumbered. Most people have way too much baggage.

2) Lean into the turns. Doesn't do any good to fight the bike, the road or gravity. Likewise, there are forces in the universe you just have to lean with because if you fight them, you will lose.

3) Know how to repair your own bike. I never knew a biker with AAA road service. It doesn't do much good out in the middle of nowhere. You develop a certain self-reliance and a

243

basic understanding of your machine because it can be a very, very long way between officially authorized, fully certified and warranty-approved Harley repair shops. Learn to do what you must with what you have. I mean, it's not like it's a brand new Volvo or something…

4) Watch out for Volvos. Some lousy drivers seem to gravitate towards certain cars or habits. It is important to be able to read drivers and try to pick which one is going to pull something unexpected which might spread you thinly over several miles of asphalt. You learn what to watch out for. Particularly while white-lining between the lanes you learn to read the "body language"— like the ones with absolutely no lane integrity, wandering and weaving all over, taking up the entire road. Those are trouble. Other examples: Volvos (because they think they're invincible) and those with vanity license plates (because they think they're immortal). I see a Volvo with custom plates headed towards me, I just pull over and let them pass. It ain't worth it.

5) Keep the rubber side down. Makes sense. If you notice that the rubber side of your bike is up in the air, that means there are only a couple of things between a hundred pounds of metal and a very hard and unforgiving earth. That would be just you and a whole lot of gravity. It's really best to do everything in your power not to get to this point. In life as well, one should make every effort to keep things down on the ground and stable because once you are hurtling through the air ass over teacups, it's not a good sign.

6) Watch your brother's back. Out on the highway (and in an unfamiliar town), you always watched your brother's back and always trusted that someone had yours. It made a big difference when you were being chased by an eighteen-wheel Kenworth or by other demons.

7) WD-40 or duct tape. The world's most basic repair kit: If it is supposed to move and doesn't, use the WD-40. If it isn't supposed to

move and does, duct tape it down. Reduce problems to the essential and you'll find it's easier to start repairs.

8) Chrome doesn't make the engine run better or faster. Chrome is cool. Chrome looks great and can make you feel like the biggest badass on the street, but it rarely has much to do with the essential functions of either going or stopping. Know what is decorative and what is not.

9) Say what you mean, mean what you say. Or else shut up. If you have something to say, say it directly, say it to the guy involved and be prepared to back it up. If you can't or won't— keep it to yourself. Don't dress a man down in front of the rest of the group unless you absolutely have to. Take it outside, in private. And what happens in the clubhouse, stays in the clubhouse.

10) None of us are getting out of here alive. The culture of biking and the realities of biking tended to develop a fatalistic point of view. Life, after all, is a terminal condition. For some, that was an excuse which led to wildly self-destructive behavior. For others, it led to an appreciation for each and every moment of the wonder, fragility and brevity of life. The realization that any ride could be your last could inspire you to wring every ounce of life from each trip.

It is both most frightening and most enlightening to have been in a position where choosing correctly means life and choosing incorrectly means death. The military presented a few of those sorts of life/death situations. My experiences in the saddle provided a few more. Such an experience strips your complex world down to its essentials and tends to reorder one's priorities. What you once thought was supremely important becomes trivial. What you once took for granted becomes a reason to hang on. Nothing quite as beautiful as the sunrise you didn't think you were going to see.

The great Genghis Khan, upon conquering the vast Chinese civilization, predicted that when the Mongolian hordes forgot

their tradition of riding horses and settled into the life of imperial bureaucrats and administrators that their empire would collapse. Sure enough, civilization and assimilation eroded the mighty Mongol warriors into merchants and politicians. I often wonder if the leather community is similarly tied to the mysticism of motorcycles. We were the knights chevalier of the road, mounted on steeds of steel that growled and snorted smoke, carrying us to adventures and conquests that terrorized the normal folks. We were young and fearless. But when we could no longer take chances and when the adventures ran out, what then? Everything moves and changes, comes and goes, as it is destined to do. A few very weary survivors buried a lot of noblemen, and the future of the empire is in other hands.

Afterword: Roads Yet Untravelled, Friends Yet Unmet

The Future And Its Inhabitants

> *"There came to him an image of man's whole life upon the earth: It seemed to him that all man's life was like a tiny spurt of flame that blazed out briefly in an illimitable and terrifying darkness, that all man's grandeur, tragic dignity, his heroic glory came from the brevity and smallness of that flame. He knew his life was little and would be extinguished and only the darkness was immense and everlasting. And he knew that he would die with defiance on his lips, and that the shout of his denial would ring with the last pulsing of his heart into the maw of the all-engulfing night."* -
> Thomas Wolfe, You Can't Go Home Again (1934)

This thing called "Leather" has always been my shout of defiance to the universe. I know that it is a much larger cosmos out there. I know that what I do might be small, narrow and insignificant in the face of that immensity. It may indeed be a futile gesture to shout at the deaf stillness of the ages, but it still seems like a necessary one. You never know, maybe I'll get a laugh in return.

Of course, many of the themes I touch on in this book—leadership, rumors, personal responsibility, organization— is hardly exclusive to people who identify as "leather." Like many communities— particularly those revolving around religion, education or art— our community has its ultra-orthodox and fundamentalist factions that try to issue immutable edicts on behavior and belief. Thankfully there are also heretics who run about to criticize, challenge and mock them. I understand that even graffitists and outlaw skateboarders are factionalized into camps of radicals and assimilationists. In other words, as long as there are pompous asses everywhere, guys like me will never run out of material.

As humans, what we have in common is so much more than what divides us. Once upon a simpler time, we knew that. Before we

evolved the luxury of drawing uncrossable battle lines between endless subcategories of politics, mysticism, class or net worth, those we encountered could be divided in basically just three groups: friend, foe or food. Civilization should have come with less threats and hostility, but unfortunately it did not.

Our biggest commonality is the way it will end for all of us: Saint, sinner, sadist or submissive, caveman or capitalist. It has even been suggested that human life and culture is defined by human mortality. Certainly one of the oldest themes in human literature is how to deal with the fragility and brevity of life. As Miguel de Cervantes Saavedra wrote in the greatest novel of all time, *Don Quixote*: "All things human, especially the lives of men, are not eternal, and even their beginnings are but steps to their end."

What we do in the meantime is truly a journey, a road we travel, rather than a static destination. We know (as surely as we deny) how the trip ends. Maybe that is why there is such violent disagreement between church, law, society and popular culture as to directions- why we are quick to call others "misguided" and "lost." We haven't much time and it's very important to assure ourselves we're in the right lane and all the other people are headed the wrong way.

Are all human stories basically just highway maps and visitor information brochures? The leather journey, like many paths, simply tries to make the best of the trip, grabbing whatever joy and making whatever contribution along the way. Leather is the philosophical opposite of mini-vans, strict timetables and prudent speed. Leather is two wheels, a full tank of gas and an open highway you've never seen before. Until they are well behind us, the turns, twists and detours; how we find our way, the people, the sights, the dead ends— are all a mystery. Here we share a few travel tips as best we can: This route works, that tour guide sucks, this view is nice, try that little diner if you get a chance. Pull off to see the Snake Farm, the Corn Palace or the World's Largest Ball of Tinfoil. Don't order sausage gravy north of the Mason-Dixon, cash is always accepted

and the further you are from a beach, the more you should avoid motels with a tropical beach theme.

Our measure is not in finally arriving at the "right" place at the "right" time but in the adventure along the way. It's the satisfaction of a race well run, a trip well traveled. Go with grace and with curiosity; set the mark as high as possible; insist on integrity and excellence; learn to appreciate the absurd. This is the shout of denial we can hurl back at those who expected us to arrive at carefully planned whistle stops of education, family or career just because it's written on the schedule. We won't be going that way, thank you.

Our part is to just get the most delight we can out of the passing scenery, our traveling companions and the experience. That's not so hard: Don't get in a hurry. Allow the other guy to go first once in a while. Don't litter. Tip well and be nice so you won't be embarrassed if you have to pass through here again and see the same people. I hope that this book served as a travel guide into the experience of the leather community. Maybe it even had something to say about traveling through the larger universe of modern life. If not, I hope it made you laugh once or twice. A few laughs always made long trips easier for me.

Dedication and Thanks

Thanks, of course, to Linda Santiman and Joel Tucker at Daedalus Publishing. Thanks to the editor and publisher of the LeatherPage.com, Joe Gallagher. My dear friend and editor Steve Lenius (it's only fair that I put you in a sentence fragment). For allowing me to reference their work: James Lowen and Mark A. Williams. For your professional expertise and evaluation: Spenser Bergstadt, Lenny Broberg, Michael Holeman, Brian Butler and Nathan Galbreath. For encouraging and/or pushing: Alan Selby, Joseph Bean, Chuck Renslow, Guy Baldwin, Midori, Jack Fritcher, Bob Wingate, John Embry, Jerry Lasley, Phil Ross, Karl Schuck, Lolita Wolf, Gayle Rubin and Donna Sachet.

Thanks to my many merciless critics and impromptu editorial review boards in the San Francisco community and on several online discussion lists. I know that if an idea passes your scrutiny, it's bulletproof.

The many people who have contributed to this work, but did not live to see it printed: Mark Love, John Scardino, Wally Wallace, Christopher Smith, Ed Ivy, Dr. Tony DeBlase, Scott O'Hara, Philip Turner, Eric Weinmann, Sterling Larsen, Bob Andrews, Virginia Nerheim.

This book is dedicated to my partner, Joe Granese. Whatever the good parts are, he inspired. Whatever the bad parts are, he tolerated.

Spirit + Flesh
Fakir Musafar's Photo Book

After 50 years photographing Fakir Musafar's own body and the play of others, here is a deluxe retrospective collection of amazing images you'll find nowhere else... 296 oversize pages, three pounds worth! This book is a "must have" for all serious body modifiers, tattoo and piercing studios. **$50.00**

Urban Aboriginals
A Celebration of Leathersexuality – 20th Anniversary Edition

As relevant today as when it was written 20 years ago, author Geoff Mains takes an intimate view of the gay male leather community. Explore the spiritual, sexual, emotional, cultural and physiological aspects that make this "scene" one of the most prominent yet misunderstood subcultures in our society. **$15.95**

Carried Away
An s/M Romance

In david stein's first novel, steamy Leathersex is only the beginning when a cocky, jaded bottom and a once-burned Master come together for some no-strings bondage and s/M. Once the scene is over, a deeper hunger unexpectedly awakens, and they begin playing for much higher stakes. **$19.95**

Ties That Bind
The SM/Leather/Fetish Erotic Style
Issues, Commentaries and Advice

The early writings of well-known psychotherapist and respected member of the leather community Guy Baldwin have been compiled to create this SM classic. **$16.95**

SlaveCraft
Roadmaps for Erotic Servitude Principles, Skills and Tools

Guy Baldwin, author of *Ties That Bind*, joins forces with a grateful slave to produce this gripping and personal account on the subject of consensual slavery. **$15.95**

The Master's Manual
A Handbook of Erotic Dominance

In this book, author Jack Rinella examines various aspects of erotic dominance, including s/M, safety, sex, erotic power, techniques and more. The author speaks in a clear, frank, and nonjudgmental way to anyone with an interest in the erotic Dominant/submissive dynamic. **$15.95**

The Compleat Slave
Creating and Living and Erotic Dominant/submissive Lifestyle

In this highly anticipated follow up to The Master's Manual, author Jack Rinella continues his in-depth exploration of Dominant/submissive relationships. **$15.95**

Learning the Ropes
A Basic Guide to Fun S/M Lovemaking

This book, by s/M expert Race Bannon, guides the reader through the basics of safe and fun s/M. Negative myths are dispelled and replaced with the truth about the kind of s/M erotic play that so many adults enjoy. **$12.95**

My Private Life
Real Experiences of a Dominant Woman

Within these pages, the author, Mistress Nan, allows the reader a brief glimpse into the true private life of an erotically dominant woman. Each scene is vividly detailed and reads like the finest erotica, but knowing that these scenes really occurred as written adds to the sexual excitement they elicit. **$14.95**

Consensual Sadomasochism
How to Talk About It and How to Do It Safely

Authors William A. Henkin, Ph. D. and Sybil Holiday, CCSSE combine their extensive professional credentials with deep personal experience in this unique examination of erotic consensual sado masochism. **$16.95**

Chainmale: 3SM
A Unique View of Leather Culture

Author Don Bastian brings his experiences to print with this fast paced account of one man's experience with his own sexuality and eventual involvement in a loving and successful three-way kink relationship. **$13.95**

Leathersex
A Guide for the Curious Outsider and the Serious Player

Written by renowned s/M author Joseph Bean, this book gives guidance to one popular style of erotic play which the author calls 'leathersex'- sexuality that may include s/M, bondage, role playing, sensual physical stimulation and fetish, to name just a few. **$16.95**

Leathersex Q&A
Questions About Leathersex and the Leather Lifestyle Answered

In this interesting and informative book, author Joseph Bean answers a wide variety of questions about leathersex sexuality. Each response is written with the sensitivity and insight only someone with a vast amount of experience in this style of sexuality could provide. **$16.95**

Beneath The Skins
The New Spirit and Politics of the Kink Community

This book by Ivo Dominguez, Jr. examines the many issues facing the modern leather/SM/ fetish community. This special community is coming of age, and this book helps to pave the way for all who are a part of it. **$12.95**

Leather and Latex Care
How to Keep Your Leather and Latex Looking Great
This concise book by Kelly J. Thibault gives the reader all they need to know to keep their leather and latex items in top shape. While clothing is the focus of this book, tips are also given to those using leather and latex items in their erotic play. This book is a must for anyone investing in leather or latex. **$10.95**

Between The Cracks
The Daedalus Anthology of Kinky Verse
Editor Gavin Dillard has collected the most exotic of the erotic of the poetic pantheon, from the fetishes of Edna St. Vincent Millay to the howling of Ginsberg, lest any further clues be lost *between the cracks*. **$18.95**

The Leather Contest Guide
A Handbook for Promoters, Contestants, Judges and Titleholders
International Mr. Leather and Mr. National Leather Association contest winner Guy Baldwin is the author of this truly complete guide to the leather contest. **$12.95**

Ordering Information
By phone: 323.666.2121
By via email: order@DaedalusPublishing.com
By mail:

Daedalus Publishing Company
2140 Hyperion Ave
Los Angeles, CA 90027

Payment: All major credit cards are accepted. Via *email or regular mail*, indicate type of card, card number, expiration date, name of cardholder as shown on card, and billing address of the cardholder. Also include the mailing address where you wish your order to be sent. Orders via regular mail may include payment by money order or check, but may be held until the check clears. Make checks or money orders payable to "Daedalus Publishing Company." *Do not send cash.*

Tax and shipping California residents, add 8.25% sales tax to the total price of the books your are ordering. *All* orders should include a $4.25 shipping charge for the first book, plus $1.00 for each additional book added to the total of the order.

Since many of our publications deal with sexuality issues, please include a signed statement that you are at least 21 years of age with any order. Also include such a statement with any email order.